1986

WORLD WAR I AND THE WEIMAR ARTISTS

WORLD WAR I
AND THE WEIMAR ARTISTS

DIX, GROSZ, BECKMANN, SCHLEMMER

MATTHIAS EBERLE

YALE UNIVERSITY PRESS
NEW HAVEN AND LONDON
1985

Translated by John Gabriel

Designed by John Nicoll
Filmset in Monophoto Bembo and printed in Great Britain by
Jolly & Barber Ltd, Rugby, Warwickshire

Library of Congress Catalog Card Number 85–5173
ISBN 0–300–03557–8

CONTENTS

Preface vi

Introduction vii

1. ELEMENTAL FORCES AND MECHANICAL POWER 1

2. OTTO DIX: FIGHTING FOR A LOST CAUSE
 Art versus Nature 22

3. GEORGE GROSZ: THE IRATE DANDY
 Art as a Weapon in the Class Struggle 54

4. MAX BECKMANN: THE TRAGIC KING
 Art as a Search for Meaning—Transcendental Objectivity 73

5. OSKAR SCHLEMMER: ADAM TRANSFORMED INTO PROMETHEUS
 BY GEOMETRY
 Transcendental Anatomy 106

Notes 128

Index 132

PREFACE

It is a good and usual habit for an author to thank those who have helped him. So I thank Wieland Schmied in Berlin for conversations which clarified much for me. I also thank my employer Werner Hofmann, Director of the Hamburger Kunsthalle, who did not burden me with too many or too arduous tasks while I completed this book. I have to thank Jill Lloyd in London who helped me a great deal. I am grateful to S. Fischer Verlag in Frankfurt for putting at my disposal the rights to the fourth chapter, a version of which they had previously published in German, without any demands or problems. And finally, I thank all those who motivated, encouraged and advised me, and those who helped to put the book into the shape in which it now is.

Hamburg, August 1985

INTRODUCTION

If one examines what is available in English on modern German art, culture and history, it seems that most of the interest is concentrated on twelve years between 1933 and 1945. This period is well known, but the earlier years are being only gradually explored. This book deals with the work of four artists whose biographies are drawn from the previous twelve years. After 1933 they were declared 'degenerate', left Germany or turned in on themselves, into an 'inner emigration'. The culmination of their activity, however, takes place before 1933 and the judgement upon them in that year says less about them than it does about the dogmatic single-mindedness of the new dictators. As the English-speaking public may still be unfamiliar with German art before the First World War and the years of the Weimar republic (1918–32), it may be useful to offer some hints and a few dates.

As a result of the 1870–1 war with France, Germany became a nation state with Berlin as its capital. A wave of long-suppressed national sentiment flooded the country. Artists who were open to foreign, in this case primarily French, influences had nothing to expect from the official cultural policy. It was a risk for German museum directors to acquire paintings by the Impressionists. The officially valued art was philistine or heroic, but in either case traditional. Movements which assimilated French influences separated themselves from the official art world in distinct 'Secessions' shortly before the turn of the century. It took a long time before their painters were represented in the large museums. Among the leading figures were Max Liebermann (b. 1847), Lovis Corinth (b. 1858) and Max Slevogt (b. 1868)—the trio of so-called 'German Impressionists'. They reached the height of their fame after 1918, as painters to the Republic which overwhelmed them with titles and public appointments. In these years, Liebermann became *the* official portrait painter, representing everyone of rank and name, from learned scholars to ministers, and even the presidents of the Reich. Lovis Corinth died in 1925, Max Slevogt in 1932, and Max Liebermann in 1935. Corinth's late landscapes were confiscated by the Nazis as 'degenerate', and Liebermann's paintings, as Jewish art, were withdrawn from the museums.

In the first decade of the twentieth century, an opposition of quite another kind against this 'Post-Impressionism' and the delicate, lyrical *Jugendstil*, had formed itself under the painters of *Die Brücke*. In Dresden, a group had come together in 1905–6, consisting of Ernst Ludwig Kirchner (b. 1800), Max Pechstein (b. 1881), Erich Heckel (b. 1883) and Karl Schmidt-Rottluff (b. 1884), which moved to Berlin in 1910. They turned against the civilized, bourgeois art of the earlier generation. They found their models not in France but in the art of the German late Gothic and in the masks and fetishes of black Africa and Polynesia. Dresden and Berlin possessed great ethnological collections in which the young artists sought the forms of prehistory and 'primitive' people. Franz Marc (b. 1880) and Wassily Kandinsky (b. 1866) formed a loose group in Munich which took its name from the 1912 almanac of the *Blaue Reiter*. It centred itself strongly on modern French art, notably on Delaunay, transforming this influence into its own language.

The four artists, with whom we are here concerned, were affected by these movements in different ways. None of them was a member of an expressionist group. Only slightly younger than the generation of the 'classical Expressionists', they attempted from the beginning to go their own way. We shall follow their careers from about 1912 until the end of the Weimar republic. This applies at least to Otto Dix, George Grosz and Oskar Schlemmer. With regard to Max Beckmann, we can only indicate the direction in which he continued after the shock of his war experience. His paintings are so complex that the thorough analysis of just one requires as much space as the entire outline of another artist's development over several years.

None of the four artists remained untouched by expressionist traits but they were not, however, entirely taken over by expressionism. What characterized them and what made them famous did not originate before the First World War, as with the Expressionists, but in the years afterwards. Their art, their world view, was fundamentally formed by their war experience. While the Expressionists had reacted against the Kaiser's society, the new generation was faced with another world. The political, social and economic system had radically altered. A republic had succeeded the monarchy, and countless parties quarrelled with each other, old hierarchies no longer carried weight, and the patriarchal economic system had broken up. With the currency, which in 1923 dissolved into nothing, some old values also disappeared; successive economic crises gradually turned the middle classes into proletarians, uprooted the farmers and radicalized the working class.

The four artists had all volunteered in 1914 for different reasons. What they experienced will be dealt with in the following chapters. In the year of the Armistice, 1918, George Grosz was in Berlin, Beckmann in Frankfurt, Schlemmer in Stuttgart and Dix in Dresden. Apart from Schlemmer, they were actively involved in political events and assimilated them

in their art. On 3 November in Kiel, the seamen's revolt had broken out and spread like wildfire over the entire country. The old order collapsed almost without resistance. On 10 November Wilhelm II, the last German Kaiser, went into exile in Holland. On 11 November the Armistice had to be ratified. The German armies surged back into a starving, bleeding and impoverished country. Some of the troops joined with the revolutionary forces, others offered resistance to them. In many towns, it came to bloody and costly battles which reached their climax in the Spartacist revolt in January 1919 in Berlin. The Spartacist leaders, Rosa Luxemburg and Karl Liebknecht, who were hoping to set up a new system on the Soviet model, were assassinated on 13 January by soldiers of the Reichswehr. George Grosz referred to these events in his drawing *Cheers Noske! The proletariat has been disarmed* (Plate 55), where an officer toasts his minister after his day's labours. Beckmann assimilates the civil war, amongst other things, in his painting *Night* (Colour Plate 16), in which a family is destroyed between the battling forces. Before the painting was finished another attempt to revolutionize society, the Münchner Räterepublik (the Soviet republic in Bavaria) had been wound up. In February 1919 Friedrich Ebert was elected as president of the new republic, whose civil representatives had to sign the Treaty of Versailles, thereby clearing the army of the 'slur'.

Much blood was still to flow before the young republic consolidated itself in 1924. This consolidation shows strongly in the lives of the four artists. Dix had a chair at the Dresden Academy, Beckmann became professor in the Frankfurt Städel-Schule, Schlemmer taught from 1920 for a pittance at the Weimar Bauhaus, with which he moved to Dessau in 1925. When the school drifted further and further to the left at the end of the Twenties, before it was closed by the Nazis in 1930, Schlemmer left it and went to Breslau. The international economic crisis forced the Prussian government to close the academy there shortly afterwards. With the Nazis' assumption of power, the three painters lost their positions. George Grosz, who had lived as an independent artist, went straight to New York where he did very little. In 1959 he returned to Berlin where he died the same year. Dix lost his professorship in Dresden in 1933, was declared 'degenerate', and settled in a small village near Lake Constance. He was prohibited from exhibiting and painting. After the Second World War, he did a good deal of decorative art and portraits on commission. Why his later work is of little interest is also the subject of the second chapter. Beckmann was also expelled from his teaching post in Frankfurt in 1933. He moved to Berlin to find some security in the anonymity of the big city. A day after the opening of the notorious exhibition of 'Degenerate Art' in Munich in 1937, in which his work was also disgraced, he left Germany for Amsterdam where he spent the Second World War and the Occupation. In 1946 he moved to the United States. He was offered various posts in Germany but refused to return and died in 1950 in New York. Schlemmer was also forced to leave his post in Berlin and become a 'degenerate' artist. He left the city and tried to make his life in the country in southern Germany. He suffered terribly from the lack of recognition, did decorative art also, and died in 1943.

This brief outline of the period and of the artists' lives must here suffice. The following five chapters do not claim to provide a profound and complete picture. It was not my intention to write a history of the *Neue Sachlichkeit* (the New Objectivity) or of the art of the Twenties in Germany. This has already been done by others. Here, the emphasis is on how the artists went into the war, how they assimilated their war experience, and what consequences this experience had for their art. What we are concerned with is a brief period in the history of the art of the Weimar republic, centring above all on the attitudes and positions which the artists held in a revolutionary situation. I hope that the following five chapters will succeed in awakening or deepening the reader's interest in the art of the period.

1. ELEMENTAL FORCES AND MECHANICAL POWER

During the night of 14 and 15 April 1912, the largest and most modern passenger liner in the world sank in a calm sea after colliding with an iceberg. Over 1500 people died in the cold North Atlantic that night. The ship, a technological wonder and symbol of progress defiantly christened *Titanic*, did not have enough lifeboats, for it had been thought unsinkable; yet it had succumbed to the force of the elements.

Almost a century earlier another titan who had been considered invincible succumbed: Napoleon, exiled to St Helena, compared by Goethe to Prometheus bound. Prometheus, Napoleon and the *Titanic* all had one thing in common: they defied the gods, the old order, the elements. Their grandeur infused some men with hope, others with fear, and their defeat brought disappointment or satisfaction. Their success might have changed the world; their failure doubtless had lasting effects. The effort and challenge they embodied were too great to be ignored. The mere possibility of such endeavours shook traditional values so deeply that life simply could not go on as before. Dramatic events of this kind have always provoked opposing reactions—conservatism on the one hand, or a belief in progress on the other. While some praise the courage behind such actions, seeing even failure as an impetus to risk the challenge again, others seek security in lasting values, or, longing for a lost world, turn away from the changes that the future would bring.

Max Beckmann was one of those who saw a portent for industrial civilization in the sinking of the *Titanic* and he painted its survivors fighting to get into the lifeboats (Colour Plate 1). The newspaper he usually read commented on the disaster as follows:

> The engineers called their achievement Titanic, and titanic it certainly was . . . especially their brazen mockery of the elemental forces of Nature . . . Titanic? Oh, you poor sons of Gaea, ever since your first battle with the cloud-enshrouded Zeus you have been on the losing side. And Zeus has smashed your pride once again. . . . Great goals demand great sacrifices. All of those poor mortals who have lost their lives in the raging storm of modern transport, in the intoxication of flight or in the opulent staterooms of a miraculous ship, are martyrs to a future which we nevertheless will conquer. We shall be forced to look on in horror again and again as Nature inexorably crushes human pride and human works; yet our battlecry will remain: Onward![1]

For Max Beckmann, who shortly before had announced his intention to paint the gods and heroes of his age, the *Titanic*

disaster was decisive. Reading about it in the Berlin papers, he immediately decided to attempt a painting. Though it was not his first picture of a catastrophe, nor the largest he was to do, it remains one of the most significant. When it was exhibited at the Berlin Secession show in spring 1913, the huge canvas enraged the critics. For a time it looked as though the young artist's career had foundered on the iceberg of public opinion. He was accused of callousness, told that his picture lacked the pathos and hope of salvation that made Géricault's *Raft of the 'Medusa'* great. Beckmann's canvas, they said, might serve for a fair-ground booth or a film poster, but it was certainly out of place in an art exhibition. The critics could not grasp that to the artist, the victims' fight for life was a central theme, necessary and inevitable. He was convinced that modern man had the chance to shape his own destiny, and here as in other contemporary paintings, his belief that the future of mankind was decided by a battle of each against each was paramount. According to Beckmann, civilization and technological advance repressed natural impulses and human freedom. It was therefore illogical for the critics to seek in his painting an ultimate authority, one which the name of the great ship itself had defied. There was no rational justification for expecting to find in it an ethos that presupposed a faith in that very authority. Géricault had depicted the successive phases of apathy, anxious expectation, and riotous hope that passed through the survivors of the *Medusa*. A growing euphoria and agitation infused the group as the prospect of rescue, of a return to civilization, drew near. For Beckmann, too, the theme of shipwreck held hope, but it was a hope mitigated by fear, since for him it lay precisely in the ship's demise. It was not the ship on the horizon which embodied hope but the life-and-death struggle of the men and women who had blithely trusted in its security.

The *Sinking of the 'Titanic'* must have held a key place in Beckmann's image of himself and the world, judging by the prominence he gave it in the arrangement he set up in his Berlin studio soon after it was finished (Plate 1). The scene was composed for the photographer with great care. To Beckmann's right, leaning against the wall, is his *Large Death Scene* of 1906 in which he lamented the death of his mother. That same year, as if in defiant reaction to this loss, he had married; his reputation as a painter was on the upswing. Two years later his son was born. At the left in the photograph, propped against the *Sinking of the 'Titanic'*, is a female nude, a figure striving upwards, towards the light. Still further left stands an empty easel, draped with the artist's hat and coat. Beckmann is seated before the lower right corner of his painting

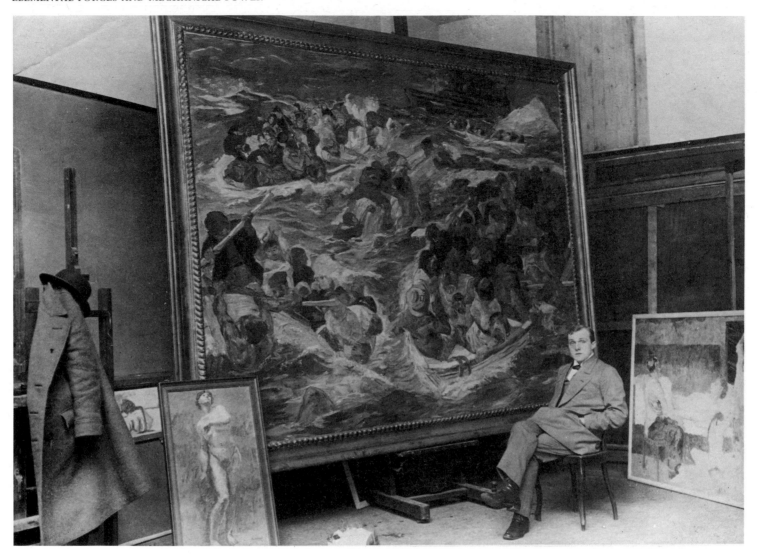

1. Max Beckmann in his Berlin studio, 1913. Photograph. Max Beckmann Archiv, Munich.

of the catastrophe—at the very point where a man is attempting to clamber into an already overcrowded lifeboat.

One observer, viewing this studio portrait in the traditional terms of art history, reads it as a triptych with Death to the right, the Last Judgement in the centre, and the Resurrection to the left.[2] A second observer, a journalist, agrees that the photograph might well be interpreted in this way, but suggests another, equally convincing sequence. Starting from the left, he sees the nude as a symbol of birth, the beginning of life; the disaster as life's struggle; and the body on the deathbed as signifying the end of life.[3]

These two readings are not so different as they might seem. The life cycle which the art historian sees culminating in heaven, the journalist brings back down to earth, where it belongs.

Beckmann himself frequently equated the plan of Christian salvation with the human life cycle, filling its traditional forms with modern meaning and replacing God in his cosmogony with fate. He believed that men lived and died here and now, not in the hereafter, and that they created the conditions for their resurrection—their ability to go on living—in a struggle whose issue decided on damnation or salvation in this world.

This is Beckmann's central theme in the *Sinking of the 'Titanic'*. To interpret it as a Last Judgement would be to posit eternal powers which avenge themselves for men's hubris. Yet since Beckmann did not accept a universal scheme, his day of judgement necessarily became a naked struggle for existence. In the absence of an ultimate arbitrating authority, men must pass judgement themselves. As early as 1796, Schiller wrote that world history is the final arbiter of the world, a view which has informed later philosophies of history not only in

Germany. The verdict is reached here and now, in the midst of disaster caused by the failure of a false titan, the machine. Its downfall reveals the spuriousness of all the factors from which middle-class ideology, including that of an industrialized German Empire, derived its confidence and claim to validity—civilization, scientific progress, industry. Seen in this light, catastrophe takes on a positive aspect, since it liberates elemental human forces. Beckmann expresses with great pathos this notion of men being condemned to freedom. The victims of the *Titanic* are the modern gods and heroes he wanted to depict, and in portraying them he questions both classical and Christian traditions; for the gods and heroes of the modern age are beings who shape their own destiny, create their own laws and values. They might not question creation itself, but certainly they question tradition—as does Beckmann in his arrangement: he extracts a new, personal meaning from a triptych implying the doctrine of salvation. Yet still he seems to be convinced that creation follows a pre-ordained plan. He merely translates this plan into his own terms, relates it to his personal life, his experience, and his philosophy, which at that time was certainly influenced by Nietzsche.[4]

The same need to assert personal autonomy in the face of a pre-ordained universe characterizes the programme of a Russian painter then living in Munich—Wassily Kandinsky. His book *On the Spiritual in Art* appeared in April 1912, the month the *Titanic* went down. In this book Kandinsky symbolizes intellectual life as a narrow triangle with free minds at the top and the unenlightened mass at the base. Blind atheists, republicans, socialists, artists and scientists are placed towards the top:

> In these upper ranges, despite their obviously high degree of order and security, and despite infallible principles, one nevertheless finds a covert anxiety, a confusion, a vacillating insecurity of the kind that troubles the minds of passengers on a large, safe transatlantic steamer on the high seas, when firm land has been swallowed in fog, dark clouds gather, and the gale piles the water into black mountains.[5]

Here, the ship stands for concepts, categories, patterns of orientation, beliefs. What is in doubt is its ability to weather the storm, and what will happen to its passengers if it capsizes.

'When religion, science and morals are shaken—the last by Nietzsche's strong hand—and when external supports begin to topple, men turn their eyes away from externals and *towards themselves*.'[6] Abandoning material cares, men would face their problems and turn to the purely spiritual, to their inner urge. For artists, said Kandinsky, this meant a search for the means intrinsic to their medium, the essentials of colour and form, painterly and graphic means. Nature, the fallible creator, would be replaced by the artist in control of colour and form. In accord with his inner urge he would shape a new creation—his own.

This development could go in two directions, two possibilities presented themselves: 'Pure abstraction (i.e., a greater degree of abstraction than that of geometric form) and . . . pure realism (i.e., a heightened imagination—imagination cast in the most durable materials.'[7] Kandinsky defined these terms more clearly in an essay, 'On the Question of Form', published in the 1912 *Blaue Reiter* almanac. By abstraction he meant the 'purely artistic', and by realism the 'objective'. Both elements, he said, had always been present in art and they had always complemented each other perfectly. Together they strove for the ideal. But today the ideal had lost its attractions as a goal, and the two elements had diverged. Free emotion could no longer bind itself to this traditional search for the absolute. So, on the one hand, the abstract was robbed of its objective supports,

> leaving the observer up in the air. Art has lost its firm footing, as the phrase is. On the other hand, the objective has lost touch with . . . the idealization of abstraction (the 'artistic element'), and the observer feels as if he were nailed to the ground. Art, we say, has lost its ideal.[8]

In a certain sense, this distinction applies to both Kandinsky and Beckmann. Kandinsky freed himself from the object, and Beckmann from the ideal—as the criticism of the *Sinking of the 'Titanic'* shows. Kandinsky's quarrel was with real objects, even with all of creation itself; Beckmann questioned the underlying laws of creation. He was able to recognize neither the goal—God—nor the path. His argument was with the traditional doctrine of salvation; later, he would even chastise God for all the things He had done wrong. Kandinsky, also a Nietzschean, made a clean sweep. He negated all of nature, all external appearances. Only the artist's inalienable means, form, colour and their inner laws, still held validity for him. He ceased depicting what he saw and, on the flat surface, began to combine signs expressive of his 'inner urge', his subjectivity.

Characteristic of both artists, however, was the question of which inviolable values would remain after a catastrophe, like the foundering of a great ship. In such circumstances, men would not know where to turn when the solid ground began to shift. Beckmann's answer was that they would begin to grasp their true nature, would begin to struggle, and in this struggle be thrown back on their elemental core. They would find ultimate support in the force of their physical nature. Similarly, Kandinsky's shipwrecked survivor would revert to his 'inner urge', his subjectivity, thus finding his spiritual nature. Both artists, in other words, broke with the tradition that had attempted to unify mind and body. Self-knowledge and knowledge of the world split apart; and that is why each artist chose a different form, different materials and methods, to give expression to his perceptions. 'This desire to create new

things has something of a jealous contest with God about it,' wrote Carl Einstein about modern German artists before the First World War:

> They attempt to liberate themselves from what is given, or add something new to it. All of this is the opposite of the humility of the man content merely to depict things. They begin to emphasize the man-centred, subjective factor, some-times out of a pessimistic denial of nature, sometimes out of an optimistic idealism that would bring it to fulfilment and enrich it.[9]

Kandinsky, a synaesthetic, heard colours as musical notes and saw notes as colours. Beckmann, the vitalist, saw a modern day of judgement in the struggle of life. While Kandinsky took the path of pure abstraction, Beckmann was haunted by imagination, compelled to 'cast it in the most durable materials'. Especially after 1918, when he himself had begun to feel the earth shaking beneath his feet, Beckmann painted his visions with cool colours and 'lines as sharp and clear as glass'. These made him a precursor of Neue Sachlichkeit, the new objectivity that approached more closely to pure realism than he himself ever did.

In the photograph of Beckmann in his studio, he sits before his painting of the shipwreck. He is an artist; the product he makes must hold its own on the market-place, stand up to criticism. If it does, it will survive—the artist will have made it into the lifeboat. If he goes down, his work will go with him, and vice versa. What then remains would be merely an empty shell of existence—the hat and coat on the easel to the left. The world's verdict will be passed on his struggle as well.

When the First World War broke out a short time later, Beckmann called it the 'greatest national catastrophe' imagin-able.[10] This was apparently precisely why he could not resist its fascination. As an eye-witness to the battle of Tannenberg in October 1914, the sinking of the Titanic and Day of Judge-ment again appeared to his mind's eye: 'It's like the gates of eternity bursting open,' he wrote, 'when a great salvo like this sounds across the fields. Everything evokes . . . infinity. . . . Masses of men, "soldiers", continually streamed towards the centre of this melody, towards the decision over their lives.'[11] Artillery fire was angels' trumpets; the battle divine judgement. The arrangement set up in Beckmann's studio concerned not only the artist himself but the entire German nation. Its fate, too, was to be decided in battle.[12]

This is not the place to enter the historians' debate about the precise extent of Germany's responsibility for the outbreak of the First World War. Yet it is common knowledge that an entire generation welcomed the war enthusiastically, partly out of that very mistrust of externals, material values and super-ficiality which Kandinsky expressed so radically, partly out of

those same reservations towards civilization and technology expressed in Beckmann's Sinking of the 'Titanic'. Widespread at the time was the longing for a catastrophe that would clear the air, purify humanity, and throw it back on primitive slumbering forces.

Thomas Mann voiced this desire in a particularly convincing manner. Culture and civilization, he wrote in 'Thoughts in Wartime' in 1914, were by no means synonymous, but merely a particular form assumed by the eternal opposites of nature and mind. Culture, he believed, involved magic, art, war and genius. Civilization, on which the Western nations, France above all, prided themselves, and which they presumed to preach to the Germans, was 'reason, enlightenment, mildness and manners, scepticism, dissolution—mind. Yes, the mind is civil, bourgeois: it is the sworn enemy of the instincts, the passions; it is anti-demonic, anti-heroic; and I am only appar-ently contradicting myself when I add that it is, moreover, anti-genius.'[13]

Art, for example, an important aspect of culture, was not civil in the least, according to Thomas Mann. Artists had all the virtues of warriors—one is reminded of the inverted commas in Beckmann's 'masses of men, "soldiers" '—virtues which were

> integrity, precision, circumspection; bravery, an unflinch-ingness in the face of hardship and defeat in the struggle against obstinate matter; a disdain of what in middle-class life is known as 'security', a favourite word and most strident bourgeois demand; and an ability to get used to leading a dangerous, tension-filled, aware life.[14]

The motifs of Beckmann's pre-1914 paintings reveal a similar disdain of middle-class security. The Titanic, everyone believed, was unsinkable. Yet a lone iceberg was enough to show the world how unfounded and arrogant this claim was. And the victims' struggle to get into the boats showed just as clearly how thin the veneer of civilization was. Hence even Thomas Mann could welcome the war as a liberation from a 'horrid world'. Men who thought solely in political terms were not capable of recognizing the inevitability of the European cata-strophe. 'But as moral beings—yes, as such we could have seen this trial coming, even more: we would have wished it in some way, would have felt in the depths of our hearts that the world, our world, could not go on like this any longer.'[15] As far as art was concerned, Kandinsky agreed. And Beckmann, as far as war was concerned, was not averse to the idea.

This dissatisfaction with the status quo was not limited to Germany. Many intellectuals and artists all over Europe saw things in a similar light. The incredible technological progress of recent decades had brought enormous social change. Tra-ditions had lost their binding force in many countries; new

forms and ideas were being sought in every area of cultural and political life. One of the most radical factions involved in this search were the Italian Futurists; and the sharpness of their protest was probably largely due to the desolate condition of their country.

> Italy vegetated on the margins. Everyone longed insatiably for the past. People ignored each other, ignored the provincial little fellows sitting slumped in the shadow of the cathedral over their coffee . . . everyone was an officially recognized heir, and that ensured the nation's dignity and revenue. It was condemned to be the Great Theatre of the Past. In view of all this, the Futurists were a godsend.[16]

In their manifestos of 1909 to 1913 the Futurists celebrated the dynamism of great cities, the energy and destructive force of modern inventions. The hectic, deafening chaos of a mechanized world would destroy the old morality, the old society, the outmoded human product. They saw the cycle of death and rebirth repeated in men's entanglement with the machine, with electric power and kinetic force. Now it was necessary to tame a very different brand of beast from the lions in wait at the cathedral door, or the centaurs, dragons and steers that roared through Art Nouveau and Symbolism, particularly in Italy. In 1909, not yet free of Böcklin's influence, Giorgio de Chirico could still paint a *Triton and Mermaids*. That same year Marinetti described the automobile as a 'snorting beast' whose glowing teats he caressed. His steering wheel was a guillotine, the speeding car a death-defying instrument. This new attitude to technology turned classical aesthetics inside out: 'A racing car with great pipes running along its body like snakes with explosive breath . . . a screaming vehicle that seems to run on shrapnel is more beautiful than the Nike of Samothrace.'[17] 'We want to glorify war,' he went on, 'the only hygiene for the world— militarism, patriotism, the annihilating deeds of anarchists, the great ideas for which men die, and scorn of women.'[18] The same text also contains a reference to 'adventure-seeking ocean liners', an enthusiastic phrase repeated in the 1913 manifesto, where Marinetti preaches 'disgust at the quiet life, and a love of danger and heroism in daily life'. He advocates 'destroying the idea of life after death and the exaggerated value placed on the individual who wishes to live his own life'. People's view of war, 'which has become a bloody and necessary test of a nation's power', had to be changed.[19] These words were written at almost the same time as Max Beckmann posed for the studio photograph. In Berlin in 1912 the Futurists held their first exhibition, where they also distributed their manifestos.

For all the similarity of their basic stance, Marinetti and Beckmann obviously differed in one important respect. Beckmann did not glorify technology, he abhorred it. While Marinetti wrote paeans to 'adventure-seeking ocean liners',

Beckmann was drawn to the human beings whose trials began once those liners sank. Instead of the titanic power of machines, he depicted the titanic human strength set free by their demise. For the Futurists, no contradiction existed between titan and *Titanic*. Beckmann saw this difference: the people on the *Titanic* became titans only in the icy sea. In the Futurists' eyes, technology increased human potentialities, raised the old struggle between strong and weak, man and woman, to a new, modern level, making it more glorious, adventurous and violent than ever. Beckmann, who again and again focused on the human body, the individual, unique, clearly contoured figure, seems almost antiquated by comparison.

Yet though his notion that human beings defined themselves by resisting the civilized, technological world may have been archaic, Beckmann was by no means alone among the artists and intellectuals of his generation in thinking this way. Much of the German artistic vanguard held similar views.

A comparison of any Futurist painting of 1912, whether by Boccioni (Plate 2), Severini or Carrà, with one of Kirchner's street scenes of the same year (Colour Plate 2) is illuminating. While the Futurists merge the human figure with the teeming motion of a modern city or the mechanical gyrations of a machine as if both consist of the same substance, Kirchner, like all the Expressionists, distinguishes clearly between figure and surroundings. He also places a different value on the dynamism of urban life. For him, it is apparently subject to two separate forces—the traffic and noise, harassing people and confusing them; and an aggressive eroticism equally, if differently, disturbing. Women and cars on the prowl seem to keep everything in nervous agitation—the former certainly more so than the latter. A free and natural relation between the sexes, something Kirchner depicted in so many paintings, seems impossible in the big city. Human beings and nature irreconcilably confront civilization and technology. This confrontation may be exciting, it may be a fascinating issue, may even help overcome conventions, but it does not allow people to find themselves and their true natures. This can happen, it appears, only outside the city, outside civilization, in the primitive untouched paradises of the world— in the south Pacific, which attracted Pechstein and Nolde, or at the Moritzburg lakes or island of Fehmarn in the Baltic where Kirchner went to paint.

Expressionist painters did not see their task as bringing these opposites together into an all-encompassing whole. The Futurists attempted just such an integration. Their conception of painting, which involved dividing reality into pictorially convincing elements regardless of their source, brought them close to Cubism, from which they learned and borrowed a great deal. Cubists and Futurists may not have agreed on whether to depict the different aspects of an object at rest or in motion, but they shared a basic acceptance of the modern world with all its

contradictions. The Cubists constructed their images out of geometric signs for natural objects and painted or real manufactured products (newspapers, pieces of wallpaper, cigarette packages, matchboxes). Their combinations were arrived at by abstraction; at all events, the final image diverged from everyday experience. Kandinsky's opposition between abstraction and realism did not exist for the Cubists; they brought the two poles together. The Futurists, by contrast, adhered more closely to the way objects appear, imitating, for instance, the functioning of a film camera:

> The cinematographer shows us objects dancing, dividing and recombining without human intervention. . . . He shows us human beings moving at 120 miles an hour. Matter in motion of all types, not subject to the laws of intelligence and much more significant for that very reason.[20]

German artists, not tempted by the camera, emphasized the qualities of their medium: 'Precise depiction has become the realm of photography in our day. This has liberated painting, given it back its original freedom of movement,' wrote Kirchner in 1913, almost simultaneously with Marinetti.[21] Here again is the familiar contrast between free, original subjectivity and technological process. The Expressionist view of civilization and urban life may often have been ambivalent, but it was certainly always negatively tinged. When Ludwig Meidner attempted to depict the noise, movement, and surging traffic of the big city, the result was an *Apocalyptic Landscape* (1913; Plate 3). This was a world on the brink, a world that drove people mad. Not untypically for the older generation of German artists, Gerhart Hauptmann noted in 1908:

> Here in Berlin—impression of frenzy and the anxiety it gives rise to—brutalization by sanguinary sensations. . . . This city is terrible—loved by few of those who are forced to live here. The sound of endless hollow thunder. The rattling and honking of vehicles. If one could only call this mad orgy to a halt. The human race spreads like a plague.[22]

The only way to escape chaos was to leave the city, a desire out of which an entire youth movement grew: the first youth hostels were built in 1910, and the German Boy Scouts founded a year later.

Braque and Picasso, though they may not have painted urban motifs around 1912, did not paint unsullied nature either. They celebrated neither the city, like the Futurists, nor the country, like the Expressionists. They locked subject and picture plane, figure and ground into a system that maintained its separation from the outside world, and thus its integrity, by making a comparison with reality impossible. Cubist paintings became autonomous objects, their imitative function denied. Man and the world, nature and the city, time, space, fate, feelings—all

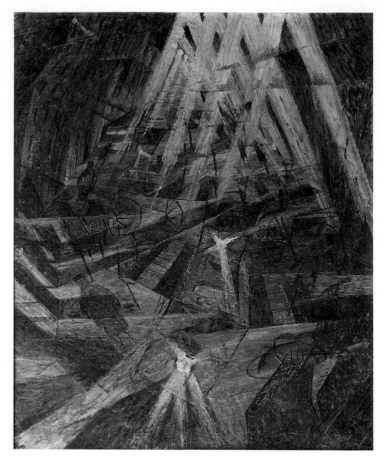

became formal problems exclusively. If Thomas Mann could speak of the eternal opposition of mind and nature, the Cubists knew only the difference between image and nature. If Expressionists painfully felt the gap between ideal and reality, their Cubist counterparts emphasized that between image and reality. While the Expressionists believed that an object or human figure, emotionally charged, would itself bring forth new colours and forms on the canvas, the Cubists devised a self-sufficient system in which new forms and colours arose out of an acceptance of the picture plane and an interaction of pictorial elements. While German artists felt the necessity of depicting reality or experiencing it in a new way, the Cubists worked out a pictorial organization capable of inherent logical development.

Cubism projected a system of forms and volumes that lay half-way between the interior and exterior worlds. The observer experiences the chronic incompatibility of the two realms and is challenged to deal with it. Reality, instead of being divided into wholesome and evil influences, appears in Cubist paintings as a function of general concepts and ideas, and their translation into means adequate to the image. Yet since Cubism so radically distinguishes between image and reality, between

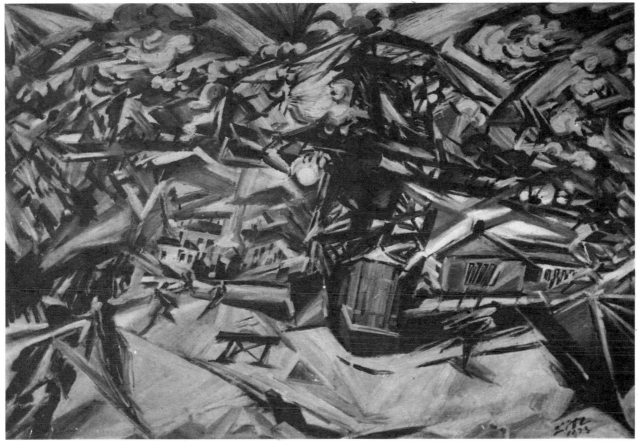

2. Umberto Boccioni. *The Power of a Street*, 1911. Oil on canvas, 99.5 × 80.5 cm. Kunstmuseum Basel, Deposit.

3. Ludwig Meidner. *Apocalyptic Landscape*, 1913. Oil on canvas, 86 × 116cm. Saarland Museum, Saarbrücken.

the experience of a painting and everyday experience, it cannot be said to have projected a counter-image to civilization. It created a system that accepted the increasing alienation of the individual from his environment and found a productive application for it. In this sense, Cubism bears a greater affinity to technological civilization than any other style of the period.

Expressionism, by contrast, definitely produced counter-images, alternative views of the world.

> The pictures of the first 'Expressionists' show nature in poetic terms, conceived as pathetic, innocent idylls out of protest against the city; they might be called a kind of urban eclogue, a primitiveness derived of revolt and almost moralizing in tone, in quest of the Whole Human and an attitude of great and noble simplicity.[23]

The Expressionists did not so much encourage people to reflect on their condition as to liberate themselves from it by some courageous act. They called their journals Storm, Action, Outcry. Though Expressionism may have deformed the image of man, it deformed it through emotion, through nature. It showed men and women to be grotesque, wild, primitive, joyous creatures—creatures of nature. Its motifs speak for them-

selves: animals and natives, bathers at the seashore, voluptuous women, tumultuous city squares, gaudy vaudeville shows. Life could be modern, natural in a new way, but this modern life was to be free of the machine. Rilke expressed this feeling in the line: 'All living things are threatened by the machine.'

Of course Expressionism was not Germany, Cubism France, or Futurism Italy. There were other movements in France and Italy that bore closer affinities to developments in Germany, the Fauves, for instance. Yet there was nothing in Germany to compare with Cubism, and hardly anyone who shared the Futurists' radical attitude. If the artistic vanguard is indicative, then the war fever that led tens of thousands of Germans to volunteer in 1914 was in part a revolt against industrial society. Artists and intellectuals in particular, people who thought of themselves as the last representatives of genius, of classical education and craftsmanship, profoundly mistrusted civilization, technology and progress, and welcomed the war as a great purge. Artists in less industrialized countries, such as the Futurists in Italy or Russia, might celebrate technology, but the Germans felt it to be essentially alien. Against modern life they set basic human instincts, which the Cubists had overlooked. Their central theme was nature and instinctive humanity versus

7

technology and civilization. Franz Marc, for example, saw the Great War as the purgatory from which Europe would emerge cleansed, its culture purified. Shortly before his death in battle he wrote:

> The decisive moment in Europe's spiritual transformation will come when modern man realizes in a flash that 'technological mastery of the world' cannot be the final aim of centuries of tremendous intellectual effort. The moral and irony of the Great War that makes us ponder most is probably the fact that it was precisely the miraculous triumphs of our 'war science' that has thrown us back farthest, to the level of the most primitive of cavemen.[24]

Many saw in just this retrogression the promise of a new beginning. Thus Gerhart Hauptmann, during the battle of the Marne on 15 August 1914, could exclaim: 'Why are clergymen exempted from war service? It's not right!—The elemental must be helped to its breakthrough here as elsewhere.'[25] How Otto Dix envisaged this 'breakthrough of the elemental' we shall see later. The mood of the day is captured by Ernst Jünger:

> We lived together in the arms of an insane culture, fragmented in business deals and passions, blasting through glittering intersections and subway tunnels, surrounded in cafés by mirrored brilliance; the streets ribbons of coloured light, the bars packed with shimmering liquors, conference tables and *dernier cri*; every hour something new, every day a problem solved, every week a sensation.

Urban life with its glare and hectic activity would never have been considered an 'insane culture' by the Futurists whose great theme was fragmentation. And the Cubists would certainly have been unable to follow Jünger's distinction between the veneer of commerce and technology and the essential human core beneath. They would have tried to integrate the two. Jünger nursed different hopes:

> Yet beneath the surface polished to an ever finer gloss, under all the costumes we assumed like quick-change artists, we remained as naked and crude as the inhabitants of forest and wasteland. This became obvious when war shattered the community of Europe. . . . Men made up for everything they had done without; their instincts, dammed up too long by society and its rules, became again the sole, sacred, and ultimate rationale.[26]

In the *Sinking of the 'Titanic'* the opulent liner, embodiment of technological progress, shimmers above the waves, before it a cold, unmoving mass of ice. In the foreground, in the boats or thrashing in the water, is the 'ultimate rationale' unleashed, or, as Beckmann wrote in his diary of a very similar motif a few years earlier, 'Savage, cruel, glorious life'.[27]

8

Notions of this kind were also current outside Germany. If in 1909 Beckmann painted escaped convicts attacking innocent bystanders and a man in uniform representing state power in his *Scene from the Destruction of Messina*, and in 1912 chose as his theme the *Titanic* victims' struggle for survival, an American writer combined both motifs a short time later in a novel that has been a bestseller ever since. It describes a mutiny on a ship sailing up the west coast of Africa. The mutineers abandon an English nobleman and his pregnant wife to the wilderness; their son not only survives his parents' violent deaths but rises to become Lord of the Jungle. Edgar Rice Burroughs's novel, *Tarzan of the Apes*, appeared in 1914.

What appeared to many a purge, a liberation from mundane duties, a passionate farewell to comfort and security, struck a Viennese professor, Sigmund Freud, as disappointing in the extreme. It was as if the nations of Europe were somehow incapable of resolving their differences less suicidally, and civilized people were reverting to bloodthirsty beasts on the battlefield. A year after the outbreak of war, Freud, who had placed such great store in the civilizing power of reason, was compelled to conclude that 'In reality there is no such thing as "eliminating evil".'[28] The tighter government monopolies of power grew, and the more human beings were cut off from their instincts, the worse social hypocrisy became. War had now stripped away the 'accumulated deposits of culture to reveal the primeval man within us',[29] that same primitive creature whom the German artistic vanguard held up as an ideal to the bourgeoisie. (As did the Italian Futurists, although they depicted him as a racing driver rather than a radiant hero.) Freud's disappointment was mitigated by the conclusion that his fellow men had 'not sunk as deep as we had feared because they had not climbed as high as we had thought'.[30]

Freud's attitude was widespread in war-shattered Europe, yet the way artists dealt with it differed from country to country. The most direct expression of the war experience is to be found, for an obvious reason, in the work of German painters. German artists had always been more interested than their French or Italian counterparts in depicting natural appearances and many had fervently believed in the liberating force of human instincts. Confronted with mankind's vulnerability, weakness, and mortality, their beliefs and art were more profoundly affected than those of the Cubists and Futurists.[31] The armies and field hospitals of other nations also had their share of wounded and disabled, but they were not made a subject of visual art. Léger, in his Cubist-related compositions, celebrated his army comrades as titanic human machines (*The Card Players*, 1917) who consist of the same material as their guns, while Max Beckmann drew the wounded, disabled and dead, the tortured visions of a man who suffered terribly in the medical corps and finally broke down under his experiences at the front.

The great difference between the attitudes of most French and German artists towards the technological aspect of war might be illustrated by comparing Léger's descriptions with Kirchner's. Léger recalled:

At the same time I was dazzled by the open breech of a 75-millimetre gun in the sunlight, by the magic of the light on the white metal. . . . Once I had bitten into that reality, its objects did not leave me. That open breech of a 75 in the full sunlight has taught me more of my plastic development than all the museums in the world.[32]

And Kirchner wrote in a letter of 1915: 'Military life was not for me. Of course, I learned riding and the care of horses, but cannons left me cold. Duty became too hard for me; I just got thinner and thinner.'[33] That same year Kirchner painted the self-portrait in which his right arm is a bleeding stump. Unable to work, he suffered a nervous breakdown. The war had crippled him mentally if not physically.

By contrast, in 1916, the classical image of man enjoyed an unexpected renascence among Italian and French artists. That year, the committed Futurist and frontline soldier Gino Severini painted a monumental *Maternité* (Plate 4), followed by a series of similarly neoclassical figures. Though Picasso remained true to Cubism, in 1914 he also began to draw figures with linear contours (Plate 5), an obvious influence of Ingres that lasted on through the mid-1920s. The artist denied that this change of style had anything to do with the war, saying that he merely wanted to explore what Cubism had neglected. Yet the time at which the change occurred seems significant. He and others possibly reacted to the carnage of the battlefield with a symbol of lastingness—calm, classical form, just as before the war artists had set fragmentation against an ostensibly intact society. In both cases, however, they set form against reality, images against the world. This new classicism had nothing to do with naturalism or even realism. Even the groups that emerged in post-war Italy, *Valori Plastici* and *Novecento*, differed from *Neue Sachlichkeit* in their feeling for form, schooled in the classical tradition. The German artist who bore perhaps most affinity to these styles was Oskar Schlemmer, whose art is discussed in the last chapter.

The hopes and expectations of many German volunteers proved terribly mistaken. The war brought no purification, it did not winnow the bravest and best from those less worthy to survive; it was no purgatory for humanity. It was a barbaric, cruel and, for the first time in history, an industrialized slaughter. Some realized this sooner, some later. Not only the armies of Europe but two contrary principles stood deadlocked in a new, fateful embrace: man and machine. Many a man had gone to the front in the hope that an eruption of elemental force, the 'ultimate rationale', would alter the course of history and trans-

form society. These believers were now compelled to see that men at war were anything but noble, great or beautiful. The drawings that Otto Dix jabbed on paper at the front are images not of supermen but of sub-men. He and others were forced to admit that discipline, courage—the whole ancient gamut of the virtues of soldiers and heroes—had become meaningless. A new power had arisen to change the world, a power against which men had long attempted to protect themselves but which now proved as invincible and fateful as nature itself: technology. Ernst Jünger speaks in his war books not only of the end of the Homeric hero but also of the 'storms of steel' that condemned him to historic obscurity. Writing of an attack made by German volunteers on the British emplacements at Langemark in October 1914, he muses on the fundamental change of outlook that such events caused, at least in his case:

A classic attack breaks down before our eyes, regardless of the strength and will to win that infuses each individual man and the moral and spiritual values that formed him. Free will, a cultivated mind, valour, an intoxicating scorn of death are not enough to break the inertia of those few hundred metres where the spell of mechanized death reigns.

There emerges the unique and truly haunting image of men dying in the realm of pure idea, an end in which, as in a terrifying dream, demonic resistance cannot be overcome, not even by a supreme effort of will.

The obstacle that stops the beat of even the bravest heart here is not man in some qualitatively superior capacity—it is the appearance of a new, frightening principle, an apparition of negation. The loneliness in which the fate of each individual runs its course symbolizes the loneliness of mankind in a new, unexplored world, whose rule of iron they feel to be absurd.

Only the belligerent surface of this process is new; it recapitulates in a matter of seconds a process of destruction observable in great individuals for the past century. . . . What is foretold here is the extinction of a special breed of men, by an attack on their advanced positions. But while the sensations of the heart and the systems of the mind may be refuted, there is no refuting the world of objects—and the machine-gun is just such a 'thing'.[34]

This was the fundamental experience that shaped the approach known as the *Neue Sachlichkeit*, a sobering realization of the power of *things*. In the *Sinking of the 'Titanic'*, painted just two years before the battle of Langemark, the failure of technology seemed to predict a new, primal freedom. Sceptically as Beckmann may have viewed the prospect, he depicted elemental impulse as a corrective to an overcivilized, overmechanized world. Yet now, in war, the 'irrefutable thing' had triumphed—the principle of technical precision, rational deployment of

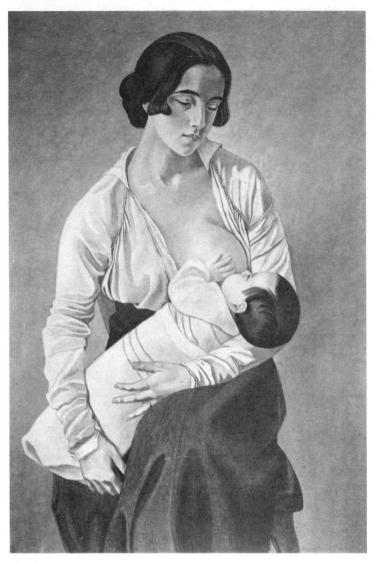 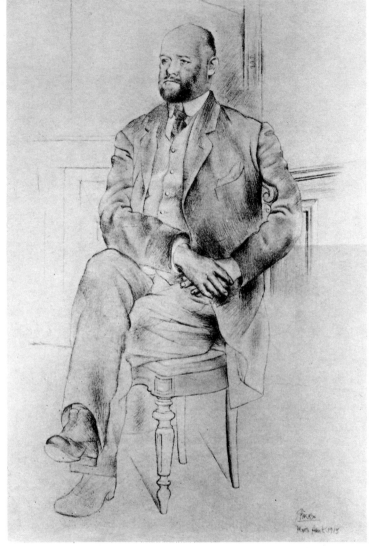

war *matériel*, not man in a state of nature or his 'will to power'. The war had shattered these illusions, and not only because the Expressionists' New Man had been overestimated, but because Germany had underestimated the Allies' industrial potential. Natural man was the loser, not the process that had created the *Titanic*.

Beckmann's etching *The Grenade* (Plate 6) gives an idea of the shock he suffered at the war's technological, inhuman character. Made only two years after the *Sinking of the 'Titanic'*, it completely reverses the relationship shown there between man and machine. This murderous device, unlike the ship, fulfils its function perfectly.

The generation of war veterans can be characterized by the ways in which they dealt with their experience. To speak only of the visual artists, it seems quite clear why many of them felt

that Expressionism had lost its meaning. The style was not dead; it was simply that the world from which it drew its sustenance had changed profoundly. As a vehicle for anger, despair or mourning, Expressionism might still serve, but their emotional sequels in a post-war world were beyond it. After the short intermezzo of Dada, three movements appeared which lent the Weimar period its look of cool modernism. These were, in architecture, *Neues Bauen* or Functionalism, and in painting and sculpture, Constructivism and *Neue Sachlichkeit*. Basically, all of these tendencies united quarrelling siblings in a kind of mutual preservation society, in which each reacted in a pointedly different way to the challenge that faced them all. The triggering impulse, their experience of mechanized war, was the same, and all had to deal with its consequences: Germany's defeat, the downfall of the old social order,

4. Gino Severini. *Maternité*, 1916.
Oil on canvas, 92 × 65cm.
Museo dell' Accademia Etrusca,
Cortona.

5. Pablo Picasso. *Portrait of Ambroise
Vollard*, 1915. Drawing, pencil,
46.7 × 32cm.
Metropolitan Museum of Art,
New York, Elisha Whittelsey Fund.

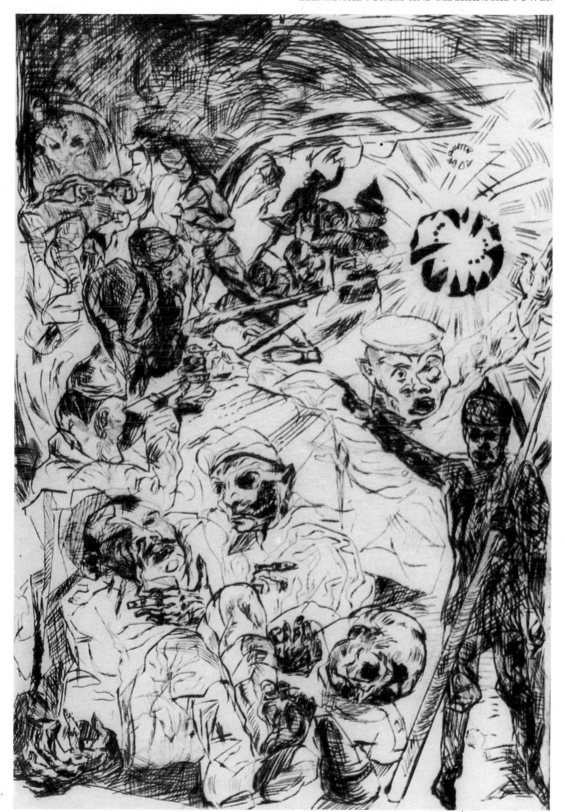

6. Max Beckmann. *The Grenade*, 1915.
Etching. 43.5 × 28.8cm.

revolution, profound social and economic change. In his book *Mechanization takes Command*, Sigfried Giedion calls the period between 1918 and 1939 the epoch of incipient 'full mechanization':

> At one blow mechanization took over the personal sphere. What had taken shape over the previous 150 years, particularly since the mid-nineteenth century, suddenly emerged full blown and engulfed life with terrific force.[35]

Germany was hit particularly hard, since its defeat on the battlefield had brought down the monarchy and weakened, though not dispossessed, its governing class. The country faced mechanization unprotected. Industry not only adopted new production methods such as the assembly line but began precipitately to concentrate as large corporations were established. The market was glutted with an unprecedented range of products, altering the face of German cities almost overnight. Women, hired in ever greater numbers by business and industry, began to question their traditional role; family hierarchy wavered; the emancipated 'new' woman had appeared on the scene.

This naturally affected artists' personal lives as well. Christian Schad depicted himself with just such a self-assured woman in a portrait of 1928 (Colour Plate 3). She lies on the rumpled sheets *après*; he wears a transparent shirt, apparently signifying that he has not completely shed his male armour. The lady, according to Schad, is not a portrait of a particular individual but a composite of several impressions. The scar on her cheek is a motif the artist picked up during a stay in Naples, where, he says, jealous lovers sometimes disfigure their girlfriends in this way to discourage competition. The women apparently wear their scars proudly. The woman in Schad's portrait, it may be concluded, remains an object of male domination.

Anton Räderscheidt, in his self-portrait of the same year, likewise represents a woman as his property, even his product (Plate 7). In earlier pictures, females, strong, naked and active, had still kept the male on the defensive. Here he stands legs apart and self-satisfied before a schematic female figure of his own devising. A threatening presence no longer, she has been tamed, relegated to the two-dimensional image.

One goal shared in common by Functionalism, Constructivism and *Neue Sachlichkeit* was surely to bring primal impulses under control, whether in man or his environment. These styles either ignored the human animal and organic materials, translated them into a system of signs, or subjected them to strict control and observation. In the art of *Neue Sachlichkeit* everything organic seems frozen, paralysed, lifted out of the flux of time. Harsh shadows isolate figures and things just as effectively as precise contour and strong local colour. These painters' disciplining gaze penetrated every corner of the

12

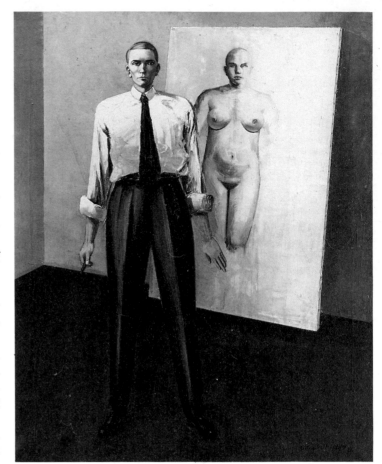

7. Anton Räderscheidt. *Self-portrait*, 1928. Oil on canvas, 100 × 80cm. Private collection.

environment, depicting near and far with equal precision, subordinating perception to lucid awareness. But when things are isolated, emptiness fills the interstices. The painters known as the Magic Realists let this emptiness stand, threatening and uncanny, while the Verists, who believed they had pinned down the enemy, the evil principle, filled it with aggressive moralizing or polemic.[36] In both cases, however, there remained an increment of undigested and unadmitted subjectivity, a free-associating fantasy that the New Objectivity left over for Surrealism to collect.

Another common concern of these various streams was to achieve a new relation to technology and the machine. The New Objectivity made very few programmatic statements on the subject, for an obvious reason: the artists were above all craftsmen and therefore averse to technology by definition; their painting was individual and thus opposed to mass production. The Constructivists entered this debate more enthusiastically. Mondrian, for instance, instead of defending the individual against the increasingly abstract relationships of industrial

society, believed that the latter could provide him with a wider, universal view. As a point of departure, he took a position which the German Realists deplored. The latter valued the individual first and foremost. For Mondrian, individual perceptions and feelings represented a disturbing factor. The Neo-plasticism or New Design he envisaged was not to hide behind the veil of

> individual characteristics, natural forms and colours, but must be expressed through abstraction—through straight lines and clear primary colours.

That is why he did not consider his art

> a denial of life's diversity; we consider it to be a reconciliation of the duality of mind and matter. . . . Only when the individual no longer stands in the way, can the universal take pure shape.[37]

Mondrian believed that the 'inner spiritual imbalance' characteristic of the age could be overcome by abstracting from personal sense-impressions and emotions which remained bound to dark and elemental forces. The idea was shared by Kandinsky, though he would not have gone so far as to put even the artist's subjectivity under strict control. What Mondrian attempted to achieve with the aid of geometric compositions, an 'absolute equilibrium' symbolic of a cosmic order, others already saw embodied in the machine. Taken as a model, it could open new paths to creativity. Laszlo Moholy-Nagy, a Hungarian artist who had arrived in Germany in 1920 and later taught at the Weimar Bauhaus with Kandinsky, Klee and Schlemmer, justified his approach in 1922 by asserting:

> Reality is the measure of human thought. We orientate ourselves in the universe with its aid. . . . And the reality of our century is technology—the invention, construction and maintenance of machinery. Using machinery means acting in the spirit of the century. . . . Technology knows no tradition and no class consciousness. Everyone can either master the machine or be its slave. Here lies the root of socialism. . . . This is our century: technology, machinery, socialism. . . . Constructivism is the socialism of vision.[38]

If works of art were constructed like machines, a universal equilibrium could be achieved here and now, in the real world. The creative individual, whether artist or artisan, was dead, pronounced Moholy-Nagy, and long live the individual as creator of conceptions, ideas; as a thinking being liberated from the fetters of the elemental.

Quite similar aims were formulated by the Polish artist Henryk Berlewi in his manifesto *Mechano-Faktur*, published in 1924 in Berlin. The new art must possess 'Autonomy of form, disclipine, lucidity . . . schematization, geometrization, precision, to make it easier for everyone who sees the work to put in

order their impressions of it.' The old techniques of craftsmanship were completely unsuited for making works of this kind. In future only

> mechanical techniques derived from industrial methods can be applied, techniques that do not depend on individual idiosyncracies but on the exact functioning of machines. Contemporary painting and art, in other words, must be based on the production principles embodied in the machine. . . . But this does not imply an automation of the creative process itself. Quite the contrary: a mechanization of means will permit greater freedom of creation, greater opportunities for invention.[39]

It may seem absurd to say that these dicta also basically characterize the painting of the New Objectivity. A similarity of basic assumptions is certainly evident. The New Objectivity also involved accepting the reality of an industrial, technological age. But the painters who worked in this style, as their motifs and methods show, took a different attitude from the Constructivists towards this reality. They too were disciplined, precise and lucid, often becoming even schematic or geometric; their art, also, was meant to be understood by a wide public. Yet the first decisive difference was this: they never renounced the object. Like the Constructivists, they promised themselves 'greater opportunities for invention' by adapting their painting methods to the realm of mechanism. Many of the New Objectivity artists polished their paintings until they indeed resembled industrial products. Yet while they derived precision and brilliance from machinery, they did so—and this is the second fundamental difference from Constructivism—in order to defend individual skill and craft against the growing hegemony of technology. As individuals, outmoded brush in hand, they entered competition with the machine.

The most serious mechanical competitor for a painter who still depicted natural appearances was the camera, whose mass distribution and use increasingly shaped men's image of reality. A painter could outdo this apparatus in two ways: first, by providing a picture in full colour, which photography could not yet do; and secondly, by combining the objects of perception in a much freer way than any mechanical process. As Franz Roh noted in 1926, 'The new art involves an ultimate visualization of a mental image in terms of external appearances.' But as soon as this new art 'succumbs to mere imitation, [its] significance will decline and all painting will be overrun by those glorious machines (photography and film) which as far as imitation goes rake in all the superlatives'.[40] Sharper polemics against photography arise in the case of Otto Dix.

Christian Schad once called a series of experimental works 'photographs sans camera' (Plate 8), a phrase that also paradoxically describes his realistic, painted portraits of the 1920s

(Colour Plate 3). The methods he used were as different as the results, but in both cases the images disclose a reality which the camera by itself could never have captured. The painter's eye surpasses the camera's lens. And as Curt Glaser, writing of Otto Dix in 1927, realized,

> the artist's eye now focuses itself in a different way, like the lens of a photographic apparatus. Instead of seeing primarily halftones and relationships of colour, his eye records all the plastic nuances of form, no longer veiling but unveiling them.[41]

Artists, in other words, had now begun to come to terms not only with the image produced by the camera but with its function as well. In the nineteenth century, they had felt challenged by the photographic image and the photographer, but not yet by his optical equipment. Impressionist paintings, influenced by photography, often resembled unposed scenes, slices of life as if framed by the camera. But the New Objectivity's mechanical, dispassionate, cool and sometimes even cruel gaze through the view-finder was unprecedented. The tribute these artists paid to industrial civilization with their frank, 'objective' gaze in turn allowed them to let subjectivity and artistic imagination enter into the execution and composition of the image. The very faults their pictures evinced in comparison to photographs represented a conscious and hard-won triumph over the competing medium.

> Hand work is not more perfect than machine work, it is less perfect. Therein lies its charm. What we value in Persian carpets are precisely those imperfections in the knotting which the mechanical loom cannot imitate; and in our own day, strangely enough, the remarkable phenomenon of Magic Realism in painting has managed to express the inherent

8. Christian Schad. *Schadograph*, 1918. 5.6 × 8.4cm. Private collection.

precision of machinery better than machines themselves. No wonder—the idea of precision must be more precise than precision itself, must it not? Hand work leaves many . . . a nook and cranny where imagination can creep in.[42]

The Futurists had already before the war become involved with the image of reality provided by the film camera, attempting to capture phases of movement in a simultaneous image. A link between their concerns and those of the Cubists can probably be seen in Marcel Duchamp's *Nude descending a Staircase* of 1912, which was likewise a depiction of sequential movement fixed in time. German artists' involvement with photography began in 1918, the year Christian Schad created his *Schadographs* (Plate 8) and John Heartfield invented photomontage. In spite of their differing methods and aims, these two artists shared a basic concern, to assert their individual creativity in the face of a dominant mechanical medium and the ostensibly absolute authenticity of its imagery. Their procedures ambushed photography from behind, so to speak, stealing an aspect of reality from it which it would never have voluntarily produced. Raoul Hausmann once described the task of photomontage as 'wrenching from the chaos of war and revolution a visually and intellectually new mirror image' of reality.[43] Chaos ebbed, but the problem remained, of how an artist could come to terms with all-powerful technology.

The predominant motifs of the New Objectivity also suggest that it was basically hostile to technology. These artists frequently depicted machinery or industrial scenes, yet the views they chose—Carl Grossberg's are typical (Plate 9)—tended to emphasize the forbidding, inhuman aspect of factories and industrial areas. The American artist Charles Sheeler took a much more positive view of similar scenes. Fernand Léger not only constructed his paintings like machines but reconciled realms that for most of the German Realists remained incompatible—nature, man and technology. Utopias of this kind were rare in the New Objectivity, though Karl Völker and Oskar Nerlinger sometimes tended in this direction. In literature, Ernst Jünger probably came closest to utopian optimism in *Der Arbeiter* (The Worker) which, however, did not appear until 1932, when Léger had already abandoned his utopian dreams of the early 1920s. With the few exceptions named, technology, industry and machinery appeared in the New Objectivity not as life-enhancing but as life-threatening powers. A good example is the painting by Georg Scholz entitled *Flesh and Iron* (1923; since lost or destroyed; Plate 10), which showed two undressed women standing in a machine-shed next to a highly polished flywheel. A contemporary observer described this image as an exciting combination of 'sheer nakedness and gleaming steel cylinders in a finely-honed vision of that which moves our world'.[44] Yet though women and machines may

keep the planet rolling, the former also threaten the male's independence and the latter his craftsman's skills. The tightness and polish of Scholz's style may imply that both should be kept under strict control. For Léger, who assembled his paintings of standardized forms which might have come off a conveyer belt—'I mass-produce my canvases always; so . . . I'm working on a dozen simultaneously,' he said[45]—women and machines were not incompatible at all. He saw and painted women like machines and machines like women. The best-known example is probably *La Femme* of 1923 (Plate 11), in which a Renault motor cylinder provided the model for the female figure (Plate 12). The power and beauty of the machine, Léger thought, would lend harmony and inner coherence to his image of woman. At a dance, he once pointed out a pretty girl to his friend, whispering, 'Look, she's beautiful—like a gas meter!'[46] The realms of nature and technology, combined by Léger into a new classicism for the machine age, remained in irreconcilable opposition for every painter of the New Objectivity. It is enough to compare his *Card Players* (1916) or *Mécanicien* (1920; Plate 13) with Dix's pictures of war cripples (Plate 39) or the 'machine-men' of Heinrich Hoerle (Plate 14). In the former, men's similarity to machines or robots increases their power; in the latter, their mechanical limbs merely degrade them, turn them into caricatures of the human.

The New Objectivity mistrusted primal force as much as mechanical power. The war, as Freud remarked, had not only revealed the depths of human nature but also its capacity for evil. Horrified, shaken and profoundly insecure, post-war artists dropped the cult of noble savagery which the Expressionists had celebrated. A means of maintaining artistic individuality, however, was to emphasize craftsmanship. This perhaps explains why many painters returned to techniques and types of composition developed at periods when artists had just begun to assert their individuality, or when they had tried to stem the tide of secularization—the Renaissance and the early nineteenth century. Christian Schad, distantly related to Carl Philipp Fohr of the German artistic colony in Rome, went back to Raphael; Dix studied Grünewald, Dürer and Holbein; Beckmann sought models in northern late Gothic, and Georg Schrimpf in the Trecento and the Biedermeier—the list could be extended. Common to all of these artists was a craft ideal opposed to the reigning machine ideal.

This explains the negative attitude of most of the New Objectivity painters toward technology-orientated motifs. They concentrated on the private and semi-public spheres. Almost without exception, their pictures record the fact that this intimate world was jeopardized. These craftsmen felt isolated, their individuality threatened, and they projected this feeling into the figures and objects in their paintings by physically isolating them. It is not surprising that the New Objectivity

9. Carl Grossberg. *Dream-Painting Rotor*, 1927. Oil on canvas, 68 × 88 cm. Private collection.

10. Georg Scholz. *Flesh and Iron*, 1923. Painting. Destroyed.

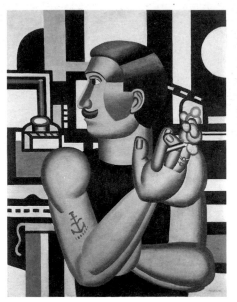

11. Fernand Léger. *La Femme*, 1922. Perls Gallery, New York.

12. Illustration from *Omnia*, Paris, 1922.
(Comparison taken from Christopher Green, *Léger and the Avant-garde*, London, 1976, p. 241)

13. Fernand Léger. *Le Mécanicien*, 1920. Oil on canvas, 115.5 × 88.3cm. National Gallery of Canada, Ottawa.

14. Heinrich Hoerle. *Machine-Men (The Home-Comer)*, 1930. Oil on wood, 100 × 50cm. Private collection.

was an art of lone individuals who seldom came together in groups[47] and who, in studios scattered all over Germany, created images symbolic of their lack of orientation, detachment and helplessness in an alien world. A central motif in their work was the individual portrait. They painted outsiders, the mal-adjusted, dropouts and waifs, people marked by courage or melancholy. Almost none of these portraits was commissioned. They record a search for human beings somehow similar to the artist, individuals in reaction against prejudice, conformity and convention, allies for the craftsman-painter whom indus-trial society had put on the defensive. That is why the politically or morally committed artists of the time attacked capitalism, which degraded workers to industrial automatons (Hoerle and Seiwert), prostituted women to sexual objects (Dix; Plate 45), or reduced yesterday's men to robots of patriotism or middle-class conformity (Grosz; Colour Plate 11).

The New Objectivity depicted a world in which the indi-vidual was threatened in the extreme, if not already obsolete. It portrayed people whose claim to individuality made them seem merely ridiculous or isolated them from their fellow men. The painters shared this fate, though they frequently saw them-selves in the role of prophet (Dix) or admonisher (Grosz; Plate 62). They were no longer able to depict the world as a meaning-ful, coherent whole, only the inroads on humanity that led to the degradation of people to automatons. This approach limited the scope of their work and manifested itself in the general

treatment of the human figure, which often comes alarmingly close to being an artefact, a mere utile object.

The attitude that characterizes the New Objectivity emerged from the shock of war. Beckmann changed his style as early as 1915, the others somewhat later. For Otto Dix, the change came with his drawings of 1919 and 1920; Christian Schad painted his first disillusioned, 'sober' picture in 1923. Thus the main proponents of the movement had found their style even before the Weimar Republic had achieved relative stability in 1923–4. Their new style expressed the hope that thinking men, through self-control, scepticism and discipline, could still master both mechanization and the darker side of human nature. This hope disappeared with the style when political mass move-ments began to whip up hatred of nonconformity and indivi-dual freedom of thought. The Communists' compulsory optimism was just as detrimental to the objective view as the Nazis' idealization of the People and the Master Race. Stereo-type, automaton and slogan defeated the open mind and eye. George Grosz was a prime example of how the burgeoning of left-wing sub-men slowly but surely compromised artists' criticism of right-wing politics.

The New Objectivity in the visual arts differed subtly from the then predominantly matter-of-fact attitude towards life. People were disillusioned, mistrustful of emotion, and deter-mined to survive the economic crisis. It was a no-nonsense outlook that justified unscrupulousness, tight-fistedness, egoism

16

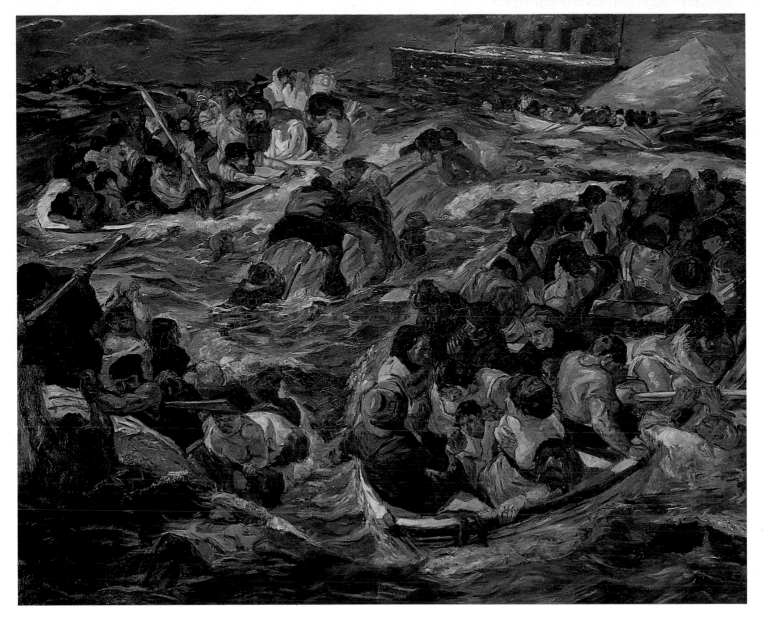

Col. Pl. 1. Max Beckmann. *The Sinking of the 'Titanic'*, 1912–13. Oil on canvas, 265 × 330cm. Saint Louis Art Museum. Bequest of Morton D. May.

and cynicism. These traits were certainly reflected in the painting of the New Objectivity, but it did not advocate them. This brand of realism, unlike the realism of the small clerk who conformed in order to survive, marked the stance of creative individuals attempting to assert their worth in a mass society.

The model for this stance, the metaphysical painting of Giorgio de Chirico and Carlo Carrà, was brought to Germany in the early 1920s, through a series of exhibitions and publications. By about 1910 de Chirico was already painting in the style that was so profoundly to influence both French Surrealists and German Realists: 'In no other work of the time was such a strong tension evoked between nostalgia for a past that had just come to an end on the brink of the twentieth century . . . and a presentiment of the future world of technology and industrialization.'[48] Between the two extremes hovered de Chirico's statues and monuments of great individuals from the past, lost in space and time. In his *Autumn Meditation* (Plate 15), executed in about 1912, a mourning figure carved in marble is seen from the back, standing beyond the converging perspectives of two arcades. This figure, as has often been noted, was inspired by Böcklin's *Odysseus and Calypso* (Plate 16). Odysseus,

17

standing motionless on the shore, his glance turned away from Calypso and towards his distant homeland, provided the model for all de Chirico's averted figures. Homer's hero was the first character in European literature to express his consciousness of individuality—'I am Odysseus,' the castaway admitted in the land of the Phaecians. By the twentieth century he had become an anachronism. De Chirico would later logically replace him with *manichini*, tailors' dummies whose shape was the only human thing about them. Ernst Jünger's post-war lament at the death of the Homeric hero was presaged by de Chirico, who in 1917 depicted Hector's parting from Andromache with two puppets posed on a stage (Colour Plate 4). This scene, like many he may have witnessed at railway stations in wartime

Italy, he petrified into an arrangement to which an artificial scaffolding lends stability. One of his best-known figures, the *Great Metaphysician* (Plate 17) of 1917, recalls words spoken by the hero of the artist's novel of ten years later, Hebdomeros:

> In face of the increasingly materialistic and pragmatic orientation of our age . . . it is not obtuse to imagine a future social order in which those who live only for intellectual pleasures will no longer have a right to their place in the sun. The writer, the thinker, the dreamer or poet, the metaphysician or observer of life . . . whoever asks riddles, evaluates . . . will have become an anachronistic figure, doomed like the ichthyosaurus and the mammoth to disappear from the face of the earth.[49]

15. Giorgio de Chirico. *Autumn Meditation*, 1912. Oil on canvas, 55 × 71 cm. Private collection.

17. Giorgio de Chirico. *The Great Metaphysician*, 1917. Oil on canvas, 104.5 × 70cm: Museum of Modern Art, New York.

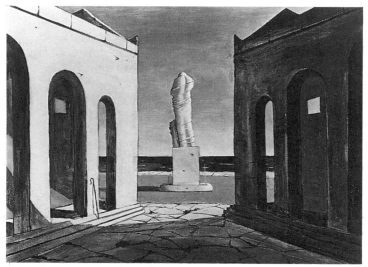

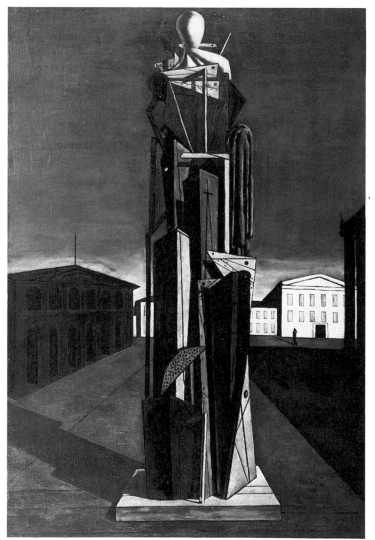

16. Arnold Böcklin. *Odysseus and Calypso*, 1883. Tempera on wood, 104 × 150cm. Öffentliche Kunstsammlung, Kunstmuseum Basel.

This realization also weighed upon the painters of the New Objectivity, frequently leading them to choose types of composition and motifs related to those of de Chirico, though the influence was not always direct. None of them, however, was able to match his visionary force, philosophic profundity, or richness of metaphor and symbolism. What they lacked was the historical view, concentrating on their own surroundings and contemporaries, a mundane post-war world into which memories of the past hardly entered. This limited their range, and was to their disadvantage. They fixed their gaze on the two extremes in the modern world that threatened the creative individual: elemental forces and mechanical power. Yet instead of reflecting on these dangers, most of the New Objectivity painters blindly attacked them. One of these two extremes even lies hidden behind the targets of the politically committed artists. George Grosz, like many other critics of Weimar, held capitalism responsible for the mechanization of man and his environment, and he relegated human vitality and sexuality to the other political camp. Instead of thinking through the problem, he merely shifted the guilt onto the shoulders of others. Otto Dix wrestled with his prime antagonist, nature, until it had a hold on him which he could not break; others kept their distance, finding a solution in geometry which proved to be too facile. Hence, though all of these artists produced brilliant paintings, none really found a philosophic solution to the dilemma or a conception of the image capable of development beyond their time.

If Beckmann's *Sinking of the 'Titanic'* is read as a symbol of the European catastrophe, the roles which the four artists were compelled to play in it might be described as follows. Otto Dix fought bravely in the front line; when the end came, he saved himself in one of those lifeboats. Cynically, he asked the other survivors how they had found the strength to climb in with him—cynically, because he blamed the disaster on just that impulsive human strength. George Grosz thought the next war could be averted if the representatives of the old order could be thrown overboard. When he discovered that the representatives of the new order were no better, his art lost its *raison d'être*. Max Beckmann found a lifeboat all to himself; then began a voyage to unknown shores, the continuation of his search for a metaphysical code. Towards the end of his life he seems to have found it; his paintings mark the stations of the cross of that arduous journey. Oskar Schlemmer, finally, tried to construct an invincible, unsinkable image of man. When the Bauhaus, the community that shared his optimism, was scattered all over the globe, he lost faith in his ideals.

Four artists, four paths, four attempts to grasp and express the experience of war and to cope with the disorientation brought about by modern technology. The real themes of this study are those attempts that failed, misguided from the start, and those which led to a long and productive heritage whose results still command respect. Because some of the positions which they formulated are still discussed today, this subject is of more than just historical interest.

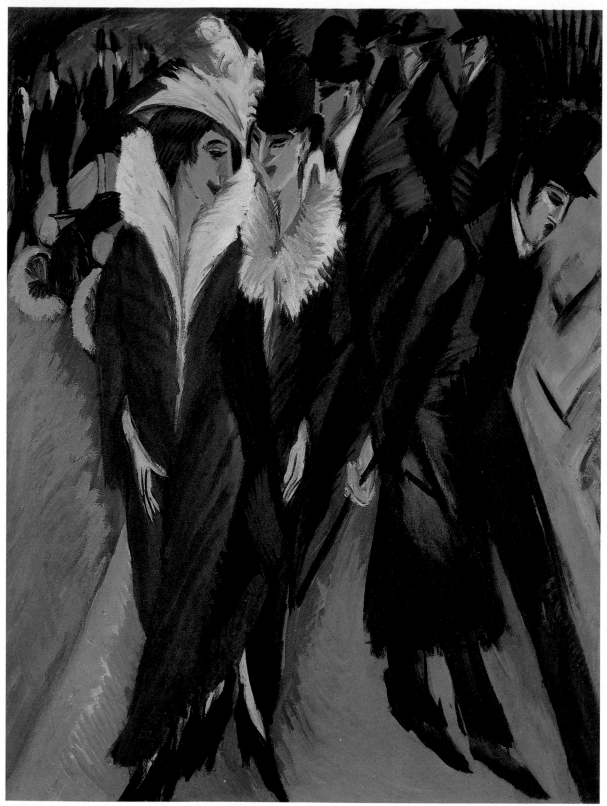

Col. Pl. 2. Ernst Ludwig
Kirchner. *The Street*,
1913. Oil on canvas,
120.6 × 91.1 cm.
Museum of Modern
Art, New York.

Col. Pl. 3. Christian
Schad. *Self-portrait*,
1927. Oil on wood,
76 × 71.5 cm. Private
collection.

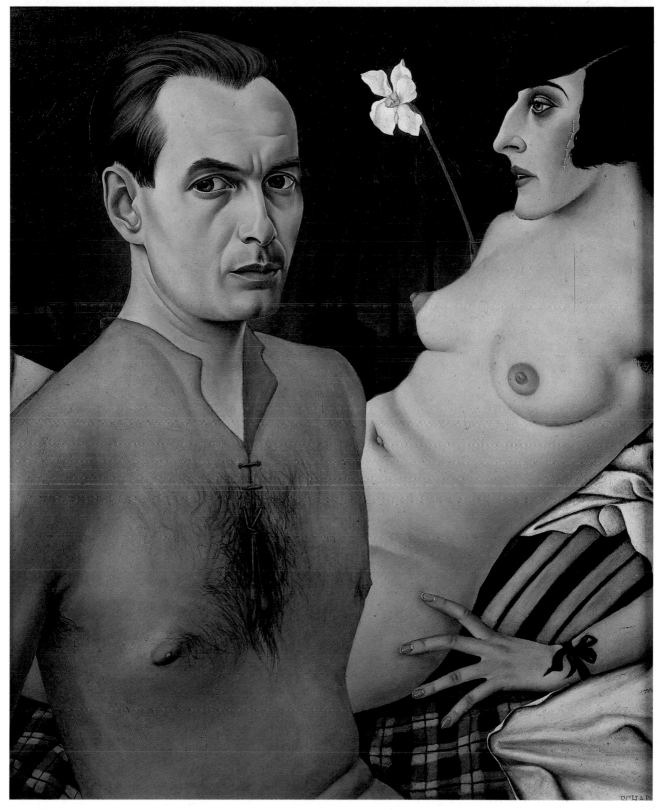

2. OTTO DIX: FIGHTING FOR A LOST CAUSE
Art versus Nature

Otto Dix enthusiastically volunteered in 1914, and later became one of the best-known artists of the New Objectivity. Born in 1891, the son of a foundry mould-maker, he studied at the Dresden Art Academy. His early self-portraits in the manner of Dürer show him to have been very self-assured even then. Nietzsche's philosophy, which he began to read in 1911, shaped him lastingly. His art, at first orientated to the precise graphic tradition of the Academy (Otto Müller and Max Klinger), passed through a brief van Gogh phase and then, shortly before the outbreak of war, took on features of Italian Futurism, a style with which Dix had become acquainted in an exhibition at the Galerie Arnold in Dresden.

In August 1914 he was trained first as an artilleryman and then as a machine-gunner. By the autumn of 1915 he was on the western front, where, after service in Russia, he returned as a volunteer aerial observer in 1918. Wearied by trench fighting, he wanted to see the world from the air. During his training, Dix painted a number of self-portraits which reveal much about the young warrior's view of himself.

In *Self-portrait with Artillery Helmet* (Löffler 1914/4; Plate 19[1]), Dix has portrayed himself in military posture, his chin pulled in, his uniform buttoned to the neck; but against the austere, dark blue cloth, bright red braid, epaulettes and brass buttons gleam, a yellow repeated in the ornaments of the helmet. The eyes glance furtively from a dark-skinned, violet-tinged face with red cheeks and a broad-lipped mouth. The helmet is surrounded by a halo of brilliant red that concentrates the light and shadow of the background on the figure. If the shadowy silhouettes to the right are taken to represent other soldiers, then this man differs from them in possessing an inner fire, an almost savage sensuality which bears the uniform only with difficulty. How torn Dix must have been between compulsion and a need to escape, between martial enthusiasm and malaise, can be deduced from the way he signed the painting. At the upper left, on the border between light yellow and red, he wildly scrawled the name Dix, letting the thin paint run down half the surface. And diagonally at the lower right he set the ominous date 1914.

On the verso, it is as if the force which uniform and posture had just been able to contain breaks out, the brute nature of man. One observer has doubted whether this *Self-portrait as a Soldier* (Löffler 1914/5; Colour Plate 5) actually represents Dix himself.[2] This question need not be discussed here, since what is of interest is the image which the twenty-three-year-old

volunteer painted on the back of what is definitely a self-portrait. It shows a hairless fellow with almost mongoloid features—protruding knots over the eyes, pug nose, full, sharply contoured lips, and thickly muscled neck. The image is painted with a broad, full brush in violent, curving strokes of fiery red. Whoever it represents, it gives the impression of a wild animal, a Hun, Attila or Genghis Khan in person—the scourge of God, his enemies and probably middle-class timidity into the bargain. This creature, with a huge '14' and 'DIX' breathing down his neck, has been cornered like a bull, and is ready to defend himself with all the energy and cruelty he can muster. Fifty years later, as an old man, Dix could still admit, 'I'm scared of my own temper.'

He made this confession in a tape-recorded interview during which he also described why he felt compelled to 'go out' in 1914:

> The war was a horrible thing, but there was something tremendous about it, too. I didn't want to miss it at any price. You have to have seen human beings in this unleashed state to know what human nature is. . . . I need to experience all the depths of life for myself, that's why I go out, and that's why I volunteered.[3]

Dix jumps from the past tense to the present and back again, a sign that the old artist's attitude had remained basically unchanged since his days in the trenches. He wanted to experience the 'depths of life', those abysses which Freud saw revealed in battle, and which Jünger called the 'sole sacred and ultimate rationale' in the fight for survival.

This belief in the power of life, procreation and death, in building up and tearing down, in growth and decay as necessary to the survival of the species, came from the philosophy of Friedrich Nietzsche. Dix's interest in Nietzsche began in 1911 and, like Beckmann, he had *The Joyous Science* along with the Bible in his knapsack. Nietzsche describes in his preface how wonderful it is to recover from long illness and see the world in a new light. He writes of his return 'from the sickliness of profound suspicion' to a new enjoyment of life and of art, 'reborn, having shed the old skin and become more ticklish and mischievous'.[4] Convalescence had made him feel naïve and yet sharpened his intelligence tremendously, filling him with disgust at what others thought of as culture, education and manners.

18. Otto Dix. *Skull*,
1924. Etching,
25.7 × 19.5 cm.

Col. Pl. 4. Giorgio de Chirico. *Hector and Andromache*, 1917. Oil on canvas, 90 × 60 cm. Private collection.

Col. Pl. 5. Otto Dix.
*Self-portrait as a
Soldier*, 1914. Oil on
paper, 68 × 53.1 cm.
Galerie der Stadt
Stuttgart, Stuttgart.

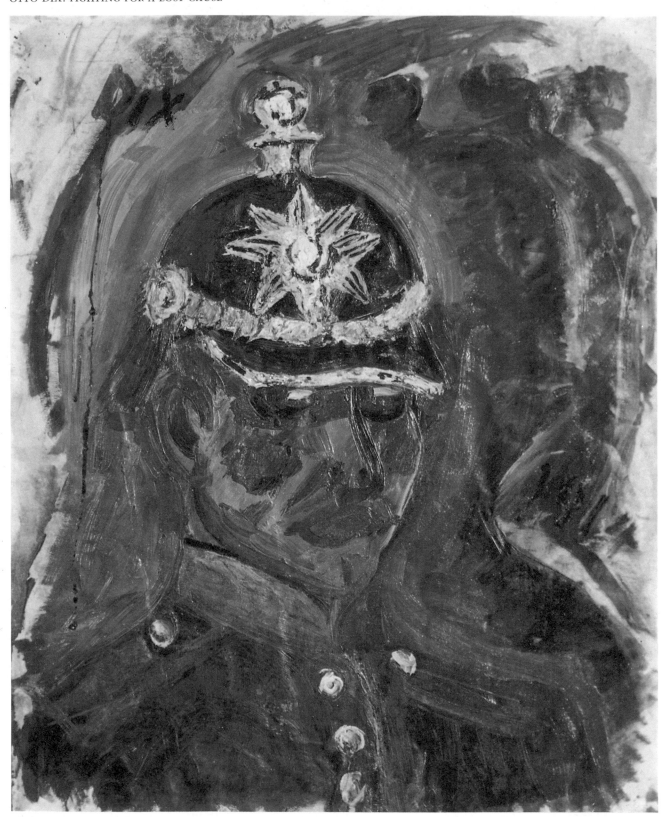

Oh, how abhorrent that enjoyment now seems, that crass, dull, dun-coloured enjoyment of people trained to enjoy, the 'educated', the rich, and all those who govern us. How maliciously one now listens to that great fair-ground hubbub with which the 'cultivated man' and big-city dweller lets himself be tortured into enjoying, not without the aid of liquid pleasures, the 'intellectual pleasures' of art, books, music. How that melodramatic scream of passion now hurts one's ears, how alien to one's taste has become all that romantic excitement and confusion of the senses which the educated *hoi polloi* love, including their aspirations towards the sublime, high and high-strung. No, if we convalescents still need art at all, it is a different art—an irreverent, light, volatile, divine, unsullied art . . . that leaps like a bright flame into a cloudless sky.[5]

It is easy to see how strongly these ideas and language influenced the passage by Ernst Jünger quoted in the first chapter. And as for Dix, he himself confirmed late in life how deeply Nietzsche had impressed him. In 1912, fascinated by the man who 'revalued all values', Dix modelled a bust of Nietzsche and painted it green (now lost; Plate 20).[6] The philosopher's revolutionary ideas entered his painting first under the influence of van Gogh and then of the Italian Futurists. Van Gogh was surely the model for Dix's *Self-portrait as a Soldier*, while the Futurists inspired his *Self-portrait as Mars* (Löffler 1915/1; Colour Plate 6).

This picture, which Dix painted shortly before going into action as a machine-gunner, has been described in the most contradictory terms. It is worth discussing, if only because it shows how difficult it is for a post-war generation to understand the fascination of war. Diether Schmidt, for instance, described the picture in 1968 as 'a kaleidoscopic overview of war . . . which takes complete possession of men, dismembers and fragments them, crushes their individuality, and scatters them as things among things in the horrifying realm of strategic planning for destruction'.[7] Ten years later, after an intensive study of the painter's work, Schmidt arrived at a somewhat different conclusion. Dix had not depicted himself as a 'chosen man' but 'romantically styled himself as craving experience . . . actively defying the war, even directing its course like Mars, the god of war'.[8] The best description of the image is probably the following:

in this *portrait-histoire*, a historical allegory, Dix portrays himself as Mars, the war god. Both the notion of a cruel, Dionysian principle of chaos, destruction and rebirth, and the notion of a dancing star, derive from Nietzsche. As Zarathustra said, one must have chaos within oneself to be able to give birth to a dancing star.[9]

In the *Self-portrait as Mars*, Dix obviously and painfully feels this chaos at the centre of his being. War has thrust the world back into chaos, the destructive impulse rages, and human instincts are set free. The old world of ordered responsibilities and solid objects has been rent apart, making way for new possibilities and new combinations. Human acts and thoughts split the world into atoms only to rearrange them. Zarathustra's dancing star rotates and glows on the warrior's head and shoulders, heightening and expanding the wild, volatile sen-

19 (left). Otto Dix. *Self-portrait with Artillery Helmet*, 1914. Oil on paper, 68 × 53.5 cm. Galerie der Stadt Stuttgart, Stuttgart.

20. Otto Dix. *Bust of Friedrich Nietzsche*, 1911. Plaster, life-size. Lost.

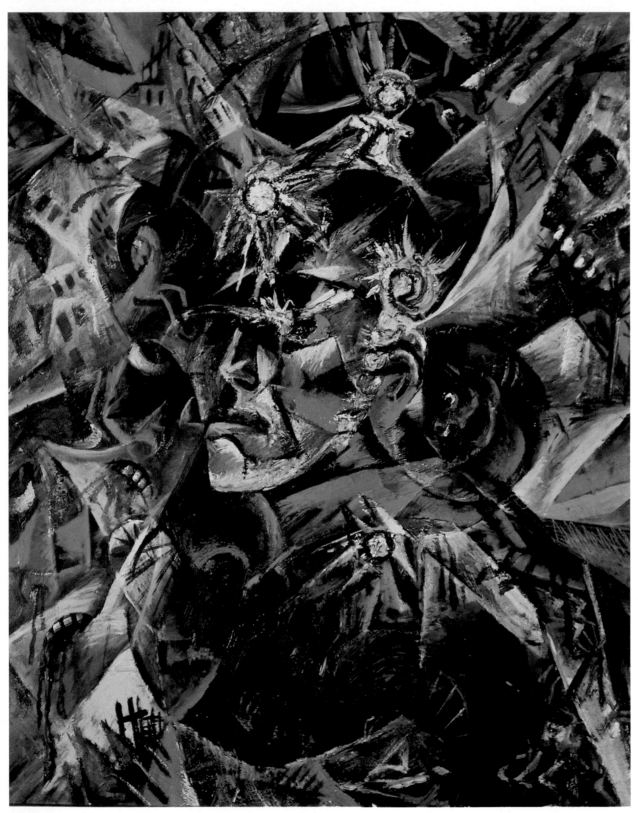

Col. Pl. 6. Otto Dix. *Self-portrait as Mars*, 1914. Oil on canvas, 81 × 66 cm. Staatliche Kunstsammlungen, Gemäldegalerie Neue Meister, Dresden.

Col. Pl. 7. Otto
Dix. *Prague Street*,
1920.
Oil on canvas,
101 × 81 cm.
Galerie der
Stadt Stuttgart,
Stuttgart.

suality of the earlier portraits to a spiritual principle that seems capable of displacing the universe.

Fragmentation and metamorphosis, movement and rotation are the central principles of this image. Rotating stars or suns dance around the soldier's head, a spoked wheel revolves over his heart, a horse rears inwards towards his neck repeating the circular motion, and over his helmet the crest of an antique helmet is superimposed. These pervading motions seem to set the segmented elements around the head and figure in rotation, a tumultuous dance of destruction and transformation. Earth, air and water mingle with fire, a merging of the four elements seen again in Dix's *Flanders* (1934–6; Löffler 1936/1; Colour Plate 9). Men and animals, buildings and elemental matter all spin in the tempest, and the boundaries between them blur. A gaping mouth becomes the span of a bridge, decorations on helmet and epaulettes evoke heavenly bodies, blood and water stream over the ruins of this world, the collar of the soldier's uniform metamorphoses into a rearing stallion. To the upper right, implements and buildings change into faces, and faces become natural elements to the lower left. This is a world of fragments, both witnessed and ruled over by the artist-war god. By depicting them he shows that he is not only the perpetrator of this destruction and transformation but part of it. This warlord wills chaos because he feels it within himself and because he sees it as an opportunity to transform the world. He does not merely face the horror of war but immerses himself in it completely.

The best literary parallel to this painting is perhaps to be found in Ernst Jünger's essay 'Der Kampf als inneres Erlebnis' (Battle as an Inner Experience). Before an attack, Jünger invokes life with the words: 'O life! One more time, just one more time, maybe the last! To gorge, glut and waste, to shoot the fireworks off all at once in a thousand suns and spinning wheels of flame, burning all my stored energy before treading the path to the icy waste.'[10] And later, in the midst of battle, 'which rips all conventions from a man like a beggar's patched rags, the beast, a mysterious monster, rises up from the bottom of one's soul. It shoots up, a consuming flame, an irresistible ecstasy that intoxicates the masses, a divinity that enthrones above the armies on high.'[11] The striking similarities between this language and Dix's pictorial idiom are surely due to their having a common source, the writings of Nietzsche and Max Stirner.

Nietzsche's view of the world as a cruel and Dionysian cycle of birth and death, growth and decay, coloured the young artist's experience of war. Among the 600 or so scenes he rapidly recorded in tense, excited line during lulls in the fighting over the subsequent three years, there are only a few that predict his later and typical anti-war stance. Most of them depict war as a primal experience: soldiers are locked in battle,

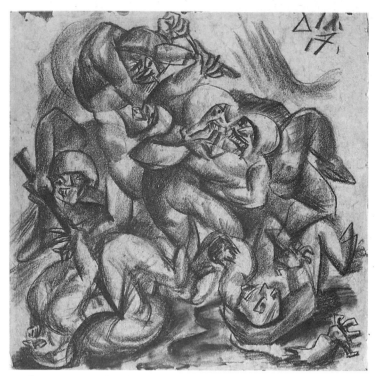

21. Otto Dix. *Hand-to-hand Fighting*, 1917. Black crayon, 39.3 × 39.6cm. Private collection.

22. Otto Dix. *Lovers on Graves*, 1917. Black crayon, 39.5 × 40cm. Graphische Sammlung der Staatsgalerie Stuttgart.

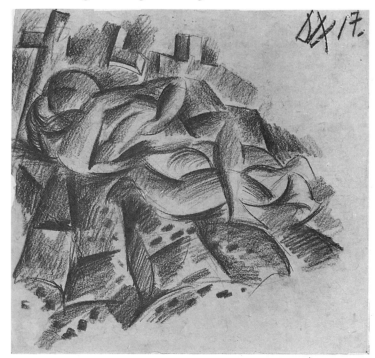

men and women locked in an embrace (*Hand-to-hand Fighting*, 1917; *Lovers on Graves*, 1917; Plates 21 and 22). Soldiers emerge out of the earth as if from the womb, grapple on it in inextricable, organic tangles, sink dying back into the mud (*Going Over the Top*, 1917; *Dying Warrior*, n.d.; Plates 23 and 24). And finally, flowers sprout from the graves and from the decaying body of a man in a devastated field which a helmet-like sun on the horizon raises to a symbol of the universal life-cycle (*Grave, Dead Soldier*, 1917; Plate 25). As Nietzsche wrote in *The Will to Power*, 'The world exists, but not as what will be nor what has been; it has never started becoming and never stopped passing away—it maintains itself in both. . . . It lives from itself: its excrement is its nourishment.'[12] And just as battle includes the possibility of death, death includes the possibility of a new beginning. In this eternal cycle, men and their works merely represent certain special combinations of the matter which makes up the entire universe.

This principle is also revealed in Dix's portrayals of the devastated earth itself. Gaping wounds have been torn in it by shells, but these are like great vulvas evocative of the earth's fecundity. The trenches, gouged as if with a giant plough, transform the front lines into a fruitful field on whose edges flowers and grass already grow (*Shellhole with Flowers*, 1915; *Trench with Flowers*, 1917; Plates 26 and 27).

Not only does war set tremendous human energy free, it also releases the potential force of technology. When a shell explodes, it tears men and emplacements to pieces, as if reducing the earth and organic life to its elementary, geometric constituents. Heavy machine-gun fire splits the air like lines of force, dividing it into angular segments, mercilessly dismembering its victims into spinning fragments (*Direct Hit*, 1916–18; *Falling Ranks*, 1916; Plates 28 and 29). Yet it is from just these fragments that the artist constructs new compositions, a new world.

Dix's imagination was equally fired by the manifestation of the beast in men (*Crouching Man*, 1917; Plate 30) and by the superhuman, almost mechanical energy they developed under extreme pressure (*Charging Infantryman*, 1916; Plate 31). In the young artist's eyes, the universe was dominated by vital and mechanical forces that simultaneously destroyed and created life and matter. This process and the new forms it gave rise to fascinated him, and here again, he was in agreement with Ernst Jünger, who in his war diaries described just this double transformation of men into savage animals and masters of mechanical power:

The spirit of this war of attrition of men and *matériel* . . . gave birth to a race of men the likes of which the world had never seen before. It was a completely new race, an embodiment of pure energy, charged with incredible force. . . .

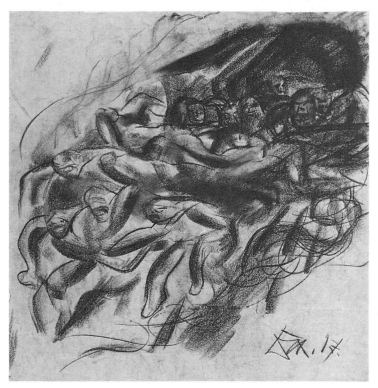

23. Otto Dix. *Going Over the Top*, 1917. Black crayon, 40.2 × 38.2cm. Private collection.

24. Otto Dix. *Dying Warrior*, 1917. Black crayon, 39.4 × 41.3cm. Private collection.

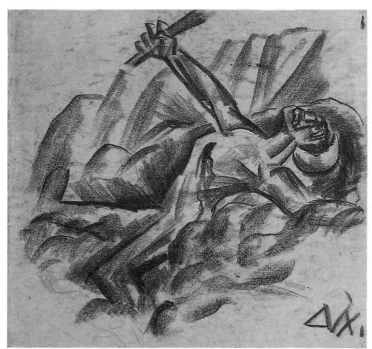

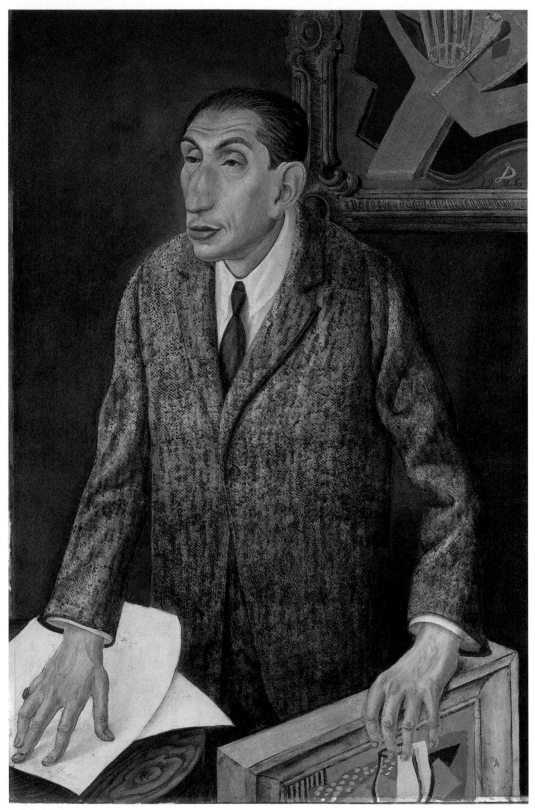

Col. Pl. 8. Otto Dix. *Portrait of the Art Dealer Alfred Flechtheim*. Oil and tempera on wood, 120 × 80 cm. Staatliche Museen Preußischer Kulturbesitz, Nationalgalerie Berlin.

Col. Pl. 9. Otto Dix. *Flanders*, 1934–6. Oil and tempera on canvas, 200 × 250 cm. Staatliche Museen Preußischer Kulturbesitz, Nationalgalerie Berlin.

When desperate troops stormed the smashed emplacements . . . energies never dreamt of broke loose. Jugglers with death, masters of explosives and firepower, superb beasts of prey. . . .[13]

As one writer has said, Dix's war drawings 'would be the best illustrations to Ernst Jünger's war diary *In Storms of Steel*'.[14]

Jünger is today considered a militarist, a glorifier of war, and Dix one of its sharpest critics. But the similarities between the two are so frequent and obvious that one is forced to ask whether such a distinction between them is justified. A closer look reveals a difference in attitude even in their descriptions of events at the front. Dix largely excluded the horror of war from his drawings. Nowhere do we find the mangled, decaying corpses, the worm-eaten cadavers, the grotesquely deformed masses of humanity that are so characteristic of his later etching sequence, *War*, of 1924. Jünger, by contrast, never lost sight of the war's ugliness. Even in the midst of battle, he was able to see war as a symbol of the fundamental condition of the modern world. His imagination was also continually taxed by the horrifying scenes he witnessed under heavy fire in the trenches, but he resisted the temptation to put them out of his mind as too incredible. Unlike Erich Remarque (*All Quiet on the Western Front*, 1929), Jünger accepted these images of

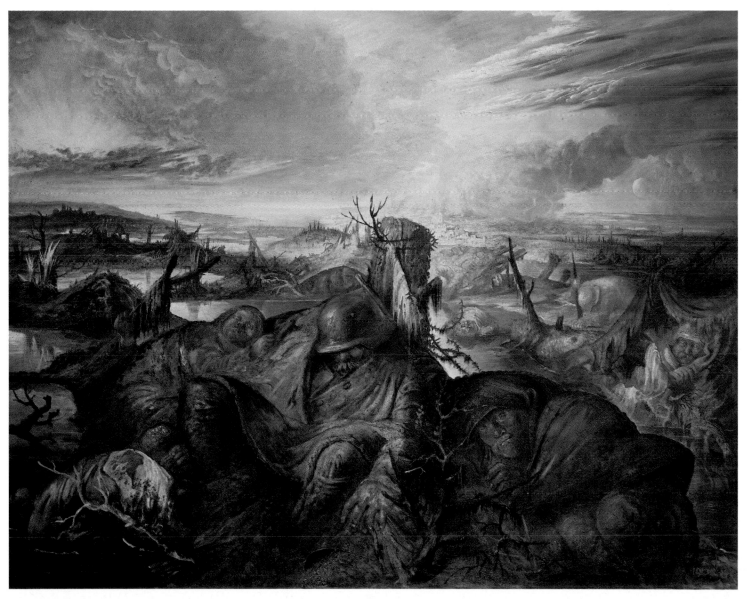

25. Otto Dix. *Grave (Dead Soldier)*, 1917. Black crayon, 39 × 40.4 cm. Kunstmuseum Düsseldorf.

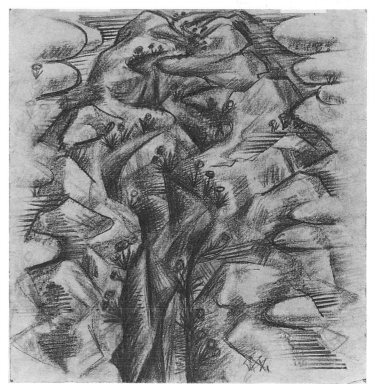

26. Otto Dix. *Shellhole with Flowers,* 1915. Black crayon. Whereabouts unknown.

28. Otto Dix. *Direct Hit*, 1916–18. Black crayon, 40.1 × 39.5 cm. Private collection.

27. Otto Dix. *Trench with Flowers,* 1917. Black crayon, 28.8 × 28.4 cm. Private collection.

29. Otto Dix. *Falling Ranks,* 1916. Black crayon, 40.7 × 39.2 cm. Private collection.

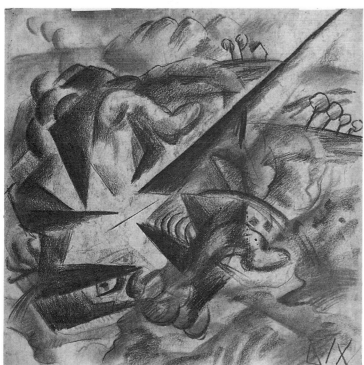

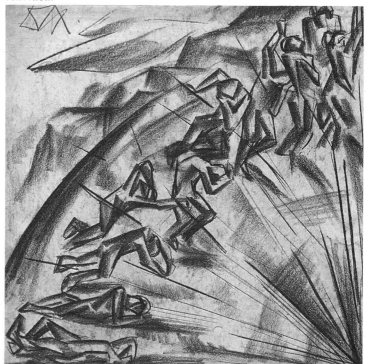

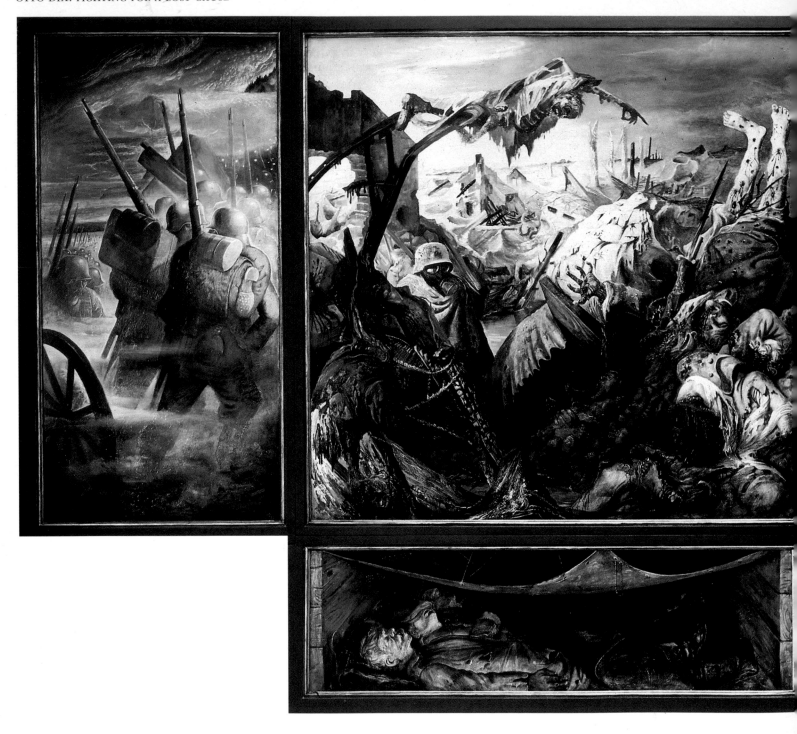

Col. Pl. 10. Otto Dix. *War Triptych*, 1929–32. Oil and tempera on wood, 204 × 408 cm. Staatliche Kunstsammlungen, Gemäldegalerie Neue Meister, Dresden.

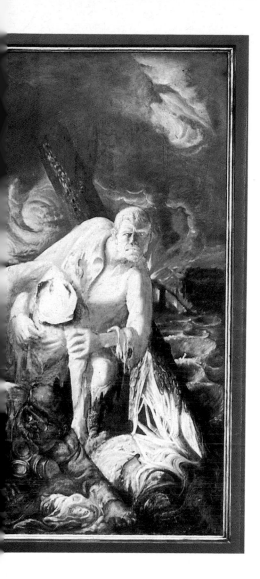

horror 'despite the protest of his brain. Remarque by contrast knew that "horror kills when you think about it".'[15] Since Jünger considered the horror and destruction of war necessary for mankind's future development, he was able to see the war in perspective. Later he described peacetime life in the big city from the same perspective, uncovering the cruelty beneath the surface just as he did in his war diaries. Dix, if his drawings are any indication, initially succumbed to the fascination of war to a much greater degree than Jünger as he did not reflect on what lay behind and beyond it. Though unable to entirely repress the horrors he witnessed day in and day out, years had to pass before he could face them and bring them into the open.

It is for this reason that none of his early drawings bore titles like *Scene on the Bluffs at Cléry-sur-Somme* or *The Mad Woman of Ste.Marie-à-Py*, two etchings from his 1924 sequence (Karsch No. 97 and 104/11).[16] Such titles not only confirm that Dix witnessed these grisly scenes but also include their exact place and date. The drawings made at the front, by contrast, were called *Going Over the Top, Soldier, Charging Infantryman, Direct Hit, Grave*, etcetera. These are transient moments from the overwhelming flux of war, in which the artist felt himself engulfed. The much more precise titles of his later etchings, like their sharper line, correspond to an individuality of faces and figures entirely missing from his early drawings. Six years after the war, Dix the graphic artist had distanced himself from Dix the machine-gunner. Jünger, on the other hand, in a sense remained the soldier he was at the front since from the start his detachment was greater than Dix's. Images of horror pursued him, too, even into the dreams of his later years, but he had already integrated them into his wartime philosophy. It was a philosophy in which the rattling looms of Manchester, the dynamic whirring of factory flywheels, and the growl of machine-guns at Langemark all figured equally as harbingers of a new age.

This new age would unite technology with human nature, which war had so visibly liberated from traditional moral and social restrictions, into a new, dangerous and terrifyingly beautiful world. Jünger was fascinated by this prospect as a young man, though in his maturity he wondered whether the mechanical principle was not opposed to the principle of life. During the 1920s, however, he could still exult:

> Yes, machines are beautiful, they cannot help but be beautiful to those who love life in all its abundance and violence. And machines must be included in what Nietzsche, who found no place for them in his Renaissance landscape, said against Darwinism, namely that life was not merely a debasing struggle for existence but a will to higher and more profound purpose.[17]

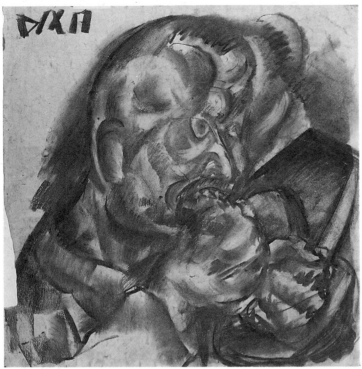

30. Otto Dix. *Crouching Man*, 1917. Black crayon, 40.3 × 39cm. Private collection.

31. Otto Dix. *Charging Infantryman*, 1916. Black crayon. Whereabouts unknown.

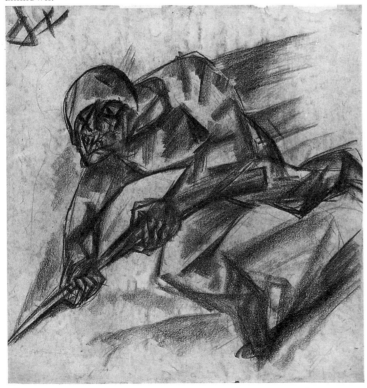

Dix also experienced the violence and power of modern technology at the front and recorded this experience in his drawings, but after the war it ceased to interest him. Technology would not give birth to any new world that could command his respect. In this he differed fundamentally from an artist like Léger, whose war experience led him to celebrate the new technology. Dix in fact never left behind Nietzsche's 'Renaissance landscape', either in terms of technique or in terms of subject-matter and approach.[18] When in later years he depicted technical instruments or apparatus, they served at most to heighten the vital or demonic character of the people who used them. Examples are Dix's two portraits of physicians, *Dr Hans Koch* of 1921 (Wallraf-Richartz-Museum, Cologne; Löffler 1921/13) and *Dr Meyer-Hermann* of 1926 (Museum of Modern Art, New York; Löffler 1926/5), in which the medical instruments seem designed for torture, not for healing.

Dix was immune not only to technological utopias of which the post-war period offered so many varieties, but he had apparently also lost all faith in a better world. He was embittered and disappointed that the war, in which he and many others of his generation had placed such great hopes of vital change, had altered neither men nor their environment. In his pictures of cripples and invalids, Dix attacked with a bitter anger only a veteran could feel, the indifference of civilians to the suffering of the war-victims. Though he still believed that Nietzsche was right in seeing life as a vicious circle of birth and death, he no longer saw it spiralling upwards, urged on by human liberty, to some higher, better state. There emerged from the part of this process called war not the free, liberated superhuman but the cripple. All the rest remained as it had always been. The realization led Dix to retreat from the actions of men and society.[19] He was beginning to see the process of life as an inescapable, horrifying and yet fascinating rhythm which free will, and therefore human morality, was incapable of influencing. What remained was a mere survival instinct, grotesquely impelling all forms of life including mankind. This life-force assumed drastic shape where the veneer of civilization—Freud's 'accumulated deposits of culture'—had been stripped away. On the margins of society, in bordellos, the red-light districts of big cities, nightclubs and cabarets, the poor quarters of town, along the streets and in the gutters, the horrifying and incredible force of life revealed its grandiose beauty. Dix now began to record this force untiringly, and the better he got to know it, the greater his fascination grew. When five years after the armistice he began to digest the nightmare of his war experience, these new impressions mixed with the old. War had not changed society, but it had changed individuals, among them the artist himself. In retrospect, he no longer saw the primal force of humanity set free in war but individual men's weakness, presumption, their wild, grotesque

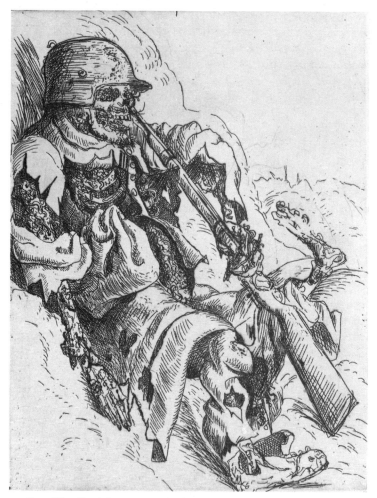

32. Otto Dix. *Dead Sentry*, 1924. Etching, 19.8 × 14.7cm.

33. Otto Dix. *Feeding-time in the Trench*, 1924. Etching, 19 × 29cm.

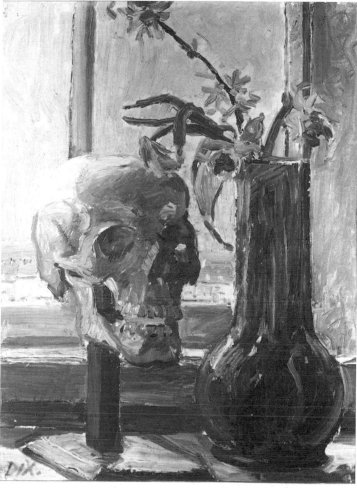

34. Otto Dix. *Blossoming and Decaying*, 1911. Oil on canvas, 63.5 × 42.5cm. Museum der Stadt Bautzen.

greed for life, and the grisliness of their lifeless bodies in decay. In short, the war had not changed human morality but human flesh, 'human matter', as Dix called it. From a distance of several years Dix seems to have considered this one of the main results of the war. Of the preparations for his portfolio of war etchings, he recalled, 'Goya, Callot, and earlier still, Urs Graf—I asked to be shown prints of theirs in Basel. It was fabulous . . . how human matter was demoniacally transformed.'[20]

This insight perfectly characterizes Dix's painting *The Trench* (1922–3; lost) and his print sequence *War* (1923–4). Many of the etchings treat this demoniac metamorphosis in a grotesque, vitalistic manner. Any of the Baroque *mementi mori*, those bald skulls in significant surroundings, can be compared with Dix's versions of the theme. In his etching *Skull* (Karsch 100; Plate 18), a piece of scalp with tousled hair still clings to the bone, and the skull is alive with maggots and insects. This particular

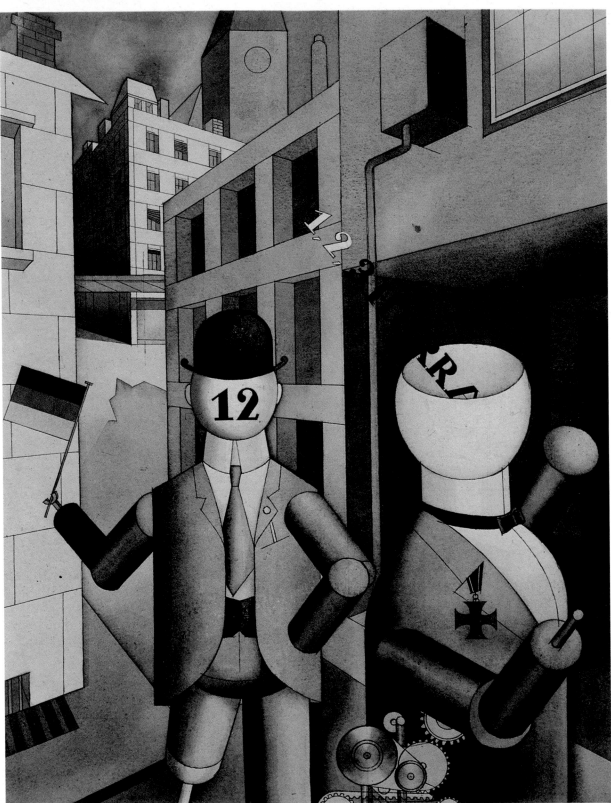

Col. Pl. 11. George Grosz. *Republican Automatons*, 1920. Watercolour and pen on cardboard, 60 × 47.3 cm. Museum of Modern Art, New York.

35. Otto Dix. *Shellhole with Flowers*, 1924. Etching, 14.8 × 19.8 cm.

36. Otto Dix. *Rape and Murder*, 1922. Etching, 27.5 × 34.6 cm.

human being is definitely dead, but life goes on. Life has no respect for human form, important as it may be to man, nor for individuality, of which here a few hairs of a once magnificent moustache remain. The same is true of the *Dead Sentry* (Karsch 87; Plate 32), whom the worms consume with the same merciless greed as the infantryman in *Feeding-time in the Trench* (Karsch 82; Plate 33) swallows his rations, oblivious to the skeletons of his dead companions around him. A comparison of *Skull* with one of his first paintings, the still-life *Blossoming and Decaying* (Löffler 1911/1; Plate 34), shows that Dix's outlook, his categories and images, remained basically unchanged. The blossoming flowers in the painting stand for the same principle as the maggots in the later etching; despite the shift in meaning the theme is the same.

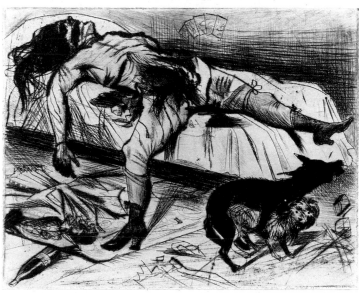

Dix never publicly exhibited the drawings he did during the war; they were not rediscovered until 1962. The more popular he became as an anti-war artist, the more he tried to cover his tracks. His later war paintings not only showed its horrors but uncovered the cruelty of life itself, of which war was only one part. In his war diary he noted that 'war, too, must be considered a natural event'.[21] Reflecting on the driving force behind this natural event, he concluded that 'Ultimately all wars are fought over and for the sake of the vulva.'[22] Dix lying in the mud under artillery fire on the Somme, then quotes Jeremiah: 'Cursed be the day on which I was born; the day on which my mother gave birth must have been unblessed.'[23] To paraphrase another passage he quotes, his philosophy of life might be reduced to this: all emerge from the vulva and all are drawn back to it in the end.

If Dix experienced the cruelty of the life-force in wartime and saw woman as its source, peacetime showed him its true face, the wasted face of the streetwalker. His countless depictions of prostitutes seem to have been made under some inner compulsion. Their bodies are just as nauseatingly alive as the damp belly of the earth, torn open in his etching *Shellhole with Flowers* (1924; Karsch 93; Plate 35). One begins to understand how Dix arrived at those brutal images of sex murders, one in the etching sequence *Death and Resurrection* (1921; Karsch 44/11) and another disguised as a self-portrait, *Sex Murderer* (1920; Löffler 1920/12; Plate 37). These images represent an attempt, at least imaginatively, to break out of the vicious circle. Yet in art, as in life, the attempt is in vain: next to the prostitute's mangled body in *Rape and Murder* (Plate 36), two dogs copulate. The great wheel continues to turn. Just as the war could destroy only certain of life's configurations but never life itself, here, too, the vital principle triumphs over an individual's action.

Viewing Dix's work in this light, it becomes apparent why instead of inquiring into the social causes of the war he concentrated on the slaughter itself. If he focused not on its perpetrators but their victims, it was because he considered the victims just as guilty. It is evident from his *Self-portrait as Mars* of 1915, and from the pen and ink drawing *This is How I Looked as a Soldier* (Plate 38), the frontispiece to his etching sequence *War* dedicated to Karl Nierendorf in 1924, that Dix saw himself as both perpetrator and victim. It is worth looking more closely at this belligerent machine-gunner, striding towards the spectator with his punctured helmet and torn uniform, cradling his murderous weapon. If it were not for the proud twist of his moustache, cigarette dangling nonchalantly from the corner of his mouth, and his gunner's squint, it would be tempting to read sheer will to survive in this face. Yet it is also proud, defiant, determined, and full of the arrogance of a man who has been through all the horrors depicted in his war

37. Otto Dix. *Sex Murderer (Self-portrait)*, 1920. Oil on canvas, 170 × 120cm. Destroyed.

engravings. Over thirty years later, Dix still believed that

> You have to see things the way they are. You have to be able to say yes to the human manifestations that exist and will always exist. That doesn't mean saying yes to war, but to a fate that approaches you under certain conditions and in which you have to prove yourself. Abnormal situations bring out all the depravity, the bestiality of human beings. . . . I portrayed states, states that the war brought about, and the results of war, as states.[24]

It was saying yes to fate that turned Dix's face to stone, and led him to assume the admittedly somewhat melodramatic role of a hardened warrior as he appears in almost all the self-portraits of the post-war years, with his chin jutting, the corners of his mouth turned down, and eyes closed to slits. He armed himself morally with frank cynicism, and artistically with a brilliant, machine-like technique, as is shown below.

When Dix began to record the consequences of the great slaughter, the fundamental rejection of society which he had

taken from Nietzsche turned to hate. This can be seen from his depictions of disabled veterans of 1920; but it should not be thought, as has been frequently alleged in recent years, that Dix, in holding capitalism responsible for all of its ills, hated society altogether. Human beings remained only human, whether under capitalism or socialism, as far as the artist was concerned. There can be no doubt that the title of one of his best-known drawings, *Prostitute and War Cripple — Two Victims of Capitalism* (1923), was not his own but provided by the Communist editors of *Die Pleite*, the journal for which he made it.[25] Dix's opinion of the German Communist Party was anything but favourable. When his friend, Conrad Felixmüller, asked him if he would like to join, Dix countered by asking how high the dues were. 'Five marks a month,' said Felixmüller, and Dix, 'For that I'd rather go to a whorehouse.'[26]

Dix's treatment of the subject of war veterans reveals just as much scorn of their twisted bodies as anger at the indifference of survivors and non-combatants. And here again, his criticism included self-criticism. In his etching *War Cripples* of 1920 (Karsch 6; Plate 39) he set his signature in the keystone of a window frame past which the sad procession limps. In *Match Vendor* of the same year (Karsch 11/11; Plate 40), an invalid sits before the door of a house with a notice prohibiting begging and peddling. A name plate next to the bell shows that Mr Dix lives here. If *he* were here on the pavement, his predicament would be no better; but fortunately someone else is there instead.

These images also reveal a certain detachment from the technology whose violence so fascinated Dix during the war. Though these men can still get around with their artificial limbs, they use them to march in grotesque belligerence down the street (*War Cripples*) or to play cards at the same table in the same café as before the war (*Disabled Man Playing Cards*, 1920; private collection; Löffler 1920/10). Dix portrays them as diehards who wear their country's decorations with undiminished pride.[27] The acid irony of these pictures is directed not only against society in general. As Bernd Weyergraf says of Dix's *War Cripples*,

> A hook makes a perfect cigar holder, and the shell-shocked veteran's amputated leg has its uses — the last man in the procession with his patented spring joints and bolted jawbone has apparently inherited the right boot his companion no longer needs.[28]

This bitter cynicism, in other words, was probably inspired by a technology that was capable of turning men into cripples but not of making them whole again. Yet Dix was equally cynical about the victims themselves, condemned to lead a grotesque hybrid life, half men, half machines, on the indifferent big-city streets. Being a vitalist, Dix could not help but see them with a

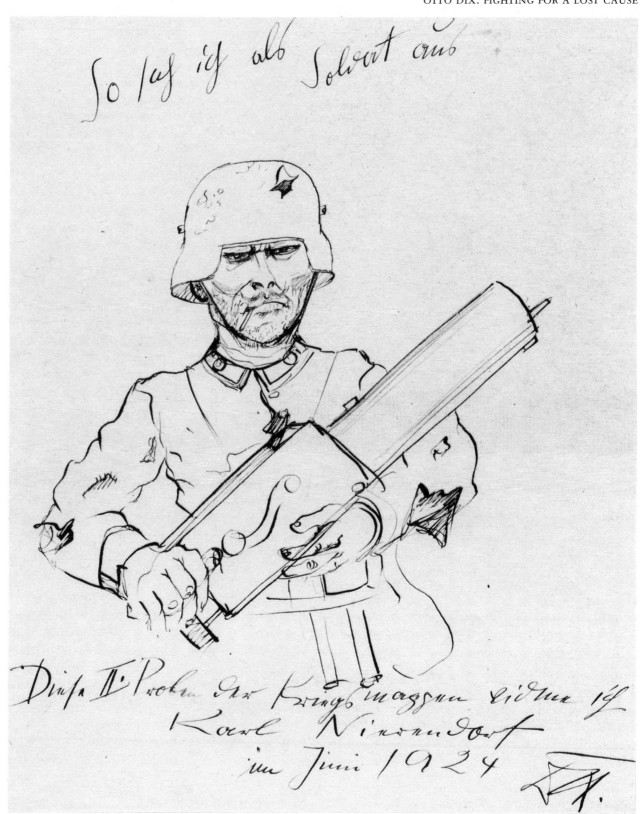

38. Otto Dix. *This
is How I Looked as a
Soldier*, 1924.
Drawing, pen and
ink, 43 × 34 cm.
Galerie Nierendorf,
West Berlin.

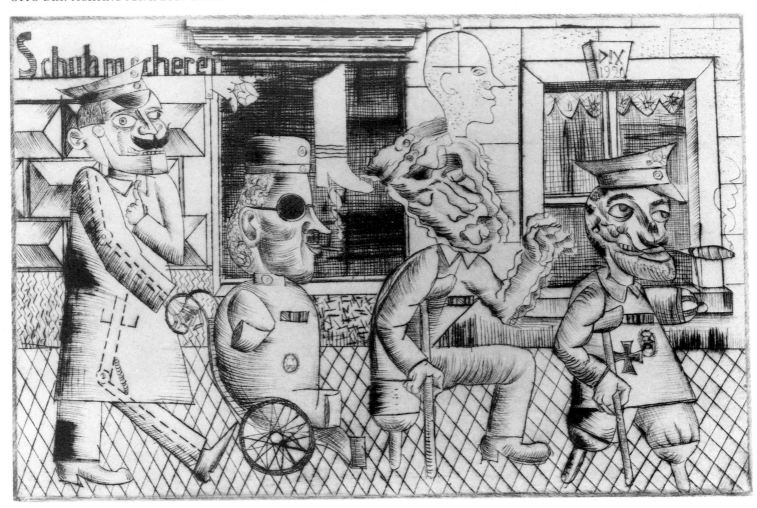

scornful eye, in spite of the fact that their plight was a conse-
quence of war. According to Conrad Felixmüller, this attitude
led Dix to subtitle his image, with a survivor's cynicism, 'four
of these don't add up to a whole man'.[29] Crushed by the
mechanism of war and glued back together by the mechanism
of peacetime, these men have become invisible to the self-
satisfied crowd. The contrast could not be greater between
their deformed bodies and the well-rounded female legs and
backsides parading past them (*Prague Street*, 1920; Löffler
1920/7; Colour Plate 7). The bitter irony of these images is
heightened still further by their montage technique, a careless
patching together of elements from diverse sources much like
the one the men themselves have submitted to. Yet not even
the passers-by are 'whole human beings', as can be seen in
Prague Street. Dix depicts only fragments of these people,
suggesting that the missing parts be supplied from the well-
stocked display windows in the background—wigs, cosmetics,
corsets and more artificial arms and legs. Everyone, maimed
and sound alike, becomes complete only by buying and con-

suming, Dix seems to say. Technology may cripple men by
isolating them from normal life, but the exchange principle
fragments them into purchasable parts. The poor are the
peacetime disabled.

If these images criticize both technology and post-war
consumerism, Dix's contemporaneous drawings of nudes show
him beginning to question the optimistic vitalism characteristic
of his pre-1914 work. Then he had celebrated the healthy,
animal vitality of women. After 1918 his nudes remained just
as full of life, but contained in what ruined shells! Gone were
the Dionysian ecstasies of his earlier drawings, the ample,
inviting abundance of *Sleeping Woman* (1914; Plate 41), spread
out before the observer like the earth itself, or his *Dancer* (1914;
Plate 42). The women he now began to depict had ugly
bodies, terribly fat or terribly emaciated, and their faces were
marked by professional cunning or vice (*Gretel*, 1921; Plate 43;
Nude, 1921; Plate 44). One of the most horrifying examples is
probably the *Girl before a Mirror* (Plate 45), a painting of 1921
that has since been lost (Löffler 1921/8). It showed a woman

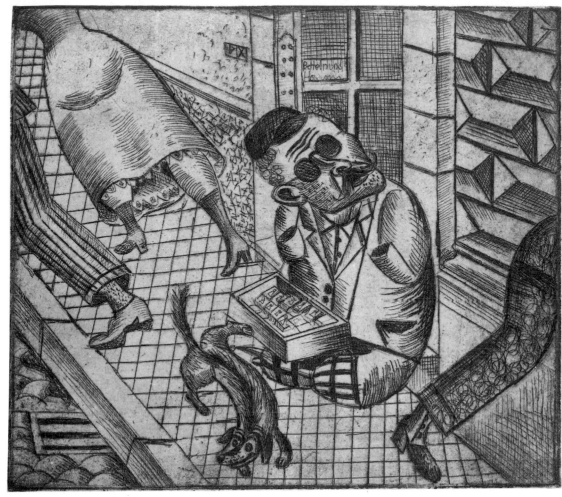

39. Otto Dix. *War Cripples*, 1920.
Etching (25.4 × 30.6 cm.) after a
destroyed painting
(150 × 200 cm.).

40. Otto Dix. *Match Vendor*, 1920.
Etching, 25.9 × 29.5 cm.

with pendulous breasts putting on lipstick, her underclothes gaping. This woman, too, is out to catch a man, she too instinctively seeks love though her body may be desiccated and sterile. This interpretation is underscored by the oval mirror, part of the ancient *Vanitas* motif. It is hard to imagine a more radical criticism of the principle that Dix revered throughout his younger years—under these conditions, in bodies like these, the will to live is perverted into a disgusting vice.

Dix's detachment from his pre-war self and philosophy expressed itself initially in terms of subject-matter, and only later, in about 1923–4, in terms of technique, as the comparison of his war drawings with the etching sequence of 1924 shows. In his oil paintings, the agitated, spontaneous style of 1913 to 1915 gradually gave way to a sharp-focus image built up of fine strokes and old-master glazes. Yet though Dix returned to the techniques he had learned at the academy, they were now informed by new experience. The life-force, he realized, was cynical and absolutely indifferent to human values and philosophies. In this connection, it is worth taking another look at

Skull, in the war portfolio. The teeming maggots, unthinking organic life, make a mockery of human reason, taking over the shell that once contained everything that raises man above insensate matter. This form of life could not care less about what human beings think of it. It usurps its right to exist, feeding on brain and once-bright eye, sensuous lips, eloquent tongue, listening ear. Yet by drawing this grisly scene, the artist has attempted to reassert the power of his intelligence over insentient life, regain some of the lost terrain, and find himself again. This was basically Dix's dilemma, and it was insoluble. As much as he would have liked to, he could not defeat nature; and the more his own vitality waned, the more he was forced to look for some other solution.

The old-master technique Dix developed during his years of stylistic change was a conscious break with the direct, *alla prima* method of the pre-war period and the optimistic vitalism that gave rise to it. In terms of method, Dix's new paintings were out of time. The word 'time' in this connection has two meanings. It implies, first, the flux of time, which is heedless of

45

human beings and their efforts to create something lasting; and second, Dix's own time, the early 1920s, when Expressionism still had a great deal of life in it and the late Impressionists, like Liebermann and Corinth, were respected masters. Dix's paintings were out of synchrony with both natural and human time. Their carefully honed shafts and gears grated and screeched in the machinery of the art world. And the artist had intended them to grate and screech: 'By running stylistically counter to the developments of the period, his pictures visibly deflected the stream of time.'[30] Or, as a contemporary of Dix put it,

> The penetrating, even piercing quality of their effect is heightened to the utmost by their technique. . . . Precise, lucid design, a painful care in execution down to the last detail, an exactness one is tempted to call mechanical. A technique adequate to modern precision–machine manufacture, whose touch has something of the cleanliness and mirror-finish elegance of a honed ball-bearing, but also something of the actuality of a photogram.[31]

Dix rejected the mechanical age yet turned himself into a piece of precision machinery. Emerging unscathed from the technology of war, he depicted mechanized *War Cripples* and behind them his own profile on the wall, with superimposed crosshairs to show that he, too, had been under fire, but that he had overcome technology as a craftsman. And through art he also attempted to subdue those cruel, fascinating forces of nature from which he had escaped. In his paintings, he brought the inexorable cycle to a halt and at the same time triumphed over the artists' greatest technical competitor, the camera. 'That portrait painting has been superseded by photography, is one of the most modernistic, arrogant and also naïve misconceptions there is,' Dix stated in 1955.

> Photography can only record a moment, and that only superficially, but it cannot delineate specific, individual form, something that depends on the imaginative power and intuition of the painter. A hundred photographs of a person would only result in a hundred different momentary aspects, but never capture the phenomenon as a whole.[32]

Here, the 'skull' definitely asserts its supremacy over the

41. Otto Dix. *Sleeping Woman*, 1914. Black crayon, Private collection

42. Otto Dix. *Dancer*, 1914. Black crayon, 32 × 23.9 cm. Private collection.

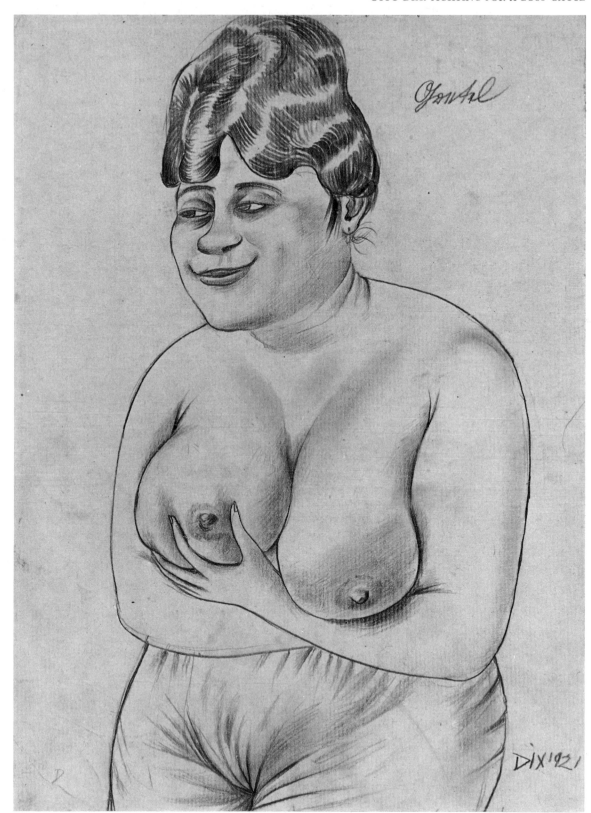

43. Otto Dix. *Gretel*, 1921. Drawing, pencil, 44 × 31.8 cm. Private collection.

momentary character of natural phenomena and over its mind-lessness, the indifference of nature to the individual. And the painter asserts his superiority over the mechanical instrument.

Thus by reviving an old technique, which involved great renunciation and effort, Dix took his lone stand against the mechanical principle that dominated the age, exemplified in the passage from Westheim quoted above, at the same time gaining perspective on the inexorable cycle of birth and death. He captured moments from the flux of time, fixing them in a form that was entirely his own. Yet though his paintings still expressed the force which he felt moved the universe, this force had been tamed. He had abandoned his earlier impasto technique 'since it depended much too much on accident, while a more controlled painting style presupposes a conception of the image, an idea'. Here, again, the thinking 'skull' defends itself against fortuitousness, attempting to grasp the essence of insentient nature. 'Once you've begun, you have to go on, and mistakes are very hard to correct. And establishing the image at an early point precludes spontaneity.' Dix curbed even his own natural vitality and temperament, saying that the drawing 'had to be very strong from the start'. And asked about the durability of his paintings, he replied proudly, and with a sigh of relief, 'Yes, that's the great thing. They last much better than any wet-in-wet painting ever would—forever, really.'[33]

With the aid of an idea, a mental conception expressed in clear, solid form established from the start and dependent solely on individual skill, not on any apparatus, artists took their stand as unique, thinking individuals against the modern world and the flux of time. This stand crucially shaped the New Objectivity, which was primarily a German style. From tentative beginnings immediately after the war, it emerged full blown when inflation ebbed and the currency was stabilized, in 1924 and 1925. While the mark remained almost worthless, no artist could invest the incredible time and effort that painting in this style demanded. An entire generation pursued the same goals as Dix—to quell primal forces and to triumph over the machine. The recourse of many artists of the New Objectivity to iconography and techniques of the Renaissance can probably be explained partly from their feeling that the Great War marked the beginning of a new era in human history, and partly from their desire to reinstate artistic individuality with the aid of traditional approaches. Their precise technique conformed to the industrial age and kept nature in check while establishing the individual as master of both. Yet when their paintings are compared to the works of the Renaissance, it becomes obvious that most of these artists were on the retreat. Frequently they resorted to traditional types of composition, anxiously expecting that tradition would compensate for their lack of original ideas. Not all artists of the New Objectivity succeeded in using the style to shed critical light on their own age.

Dix differed from most of his contemporaries not only in technical brilliance but in imaginative power. His reliance on tradition went beyond imitation of forms and methods. He realized that pictorial conceptions had to be developed for an age in which art could no longer rely on general agreement, religious cult, or social status. Dix's mastery of inventing new types of composition by ironically twisting and updating old ones has already been illustrated in *Skull*, a contemporary version of the *memento mori* theme, and *Girl before a Mirror*, a reworking of the *Vanitas* motif.

Many contemporary observers already suspected that Dix's biting criticism of post-war society may have veiled profound disappointment:

44. Otto Dix. *Nude*, 1921. Drawing, pencil, 63.6 × 42 cm. Private collection.

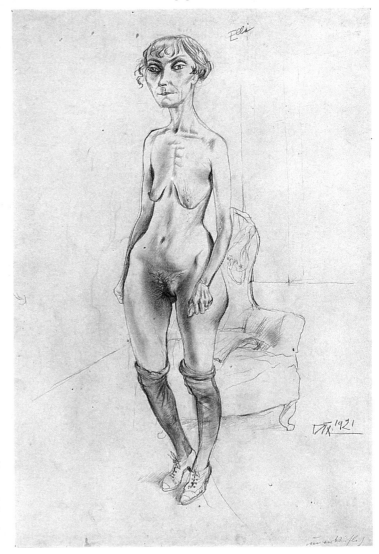

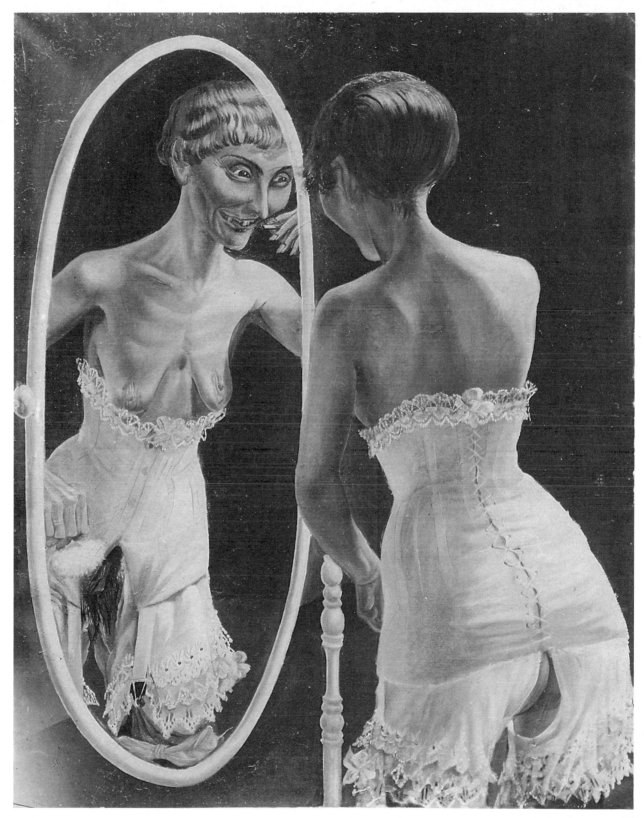

45. Otto Dix. *Girl
before a Mirror*, 1921.
Oil on canvas.
Destroyed.

Possibly his obstinacy is only inverted love, the resentment of a man who imagines his surroundings in terms so completely different from his daily experience. This may explain why his over-sharp portraits, seen with a policeman's eye, so often resemble wanted posters, even to the way they mercilessly state and publicize the facts.[34]

The intention behind Dix's painting, Paul Westheim thought, was to convince people and improve social conditions in the only way that was still possible, by confronting them with 'facts, stark, brutal facts'.[35]

The people whose faces appear on wanted posters have failed to conform to the rules of society. Yet since Dix believed that society had forfeited its right to set up rules, his portraits naturally became arraignments of its members. In this sense he was critical of society as a whole, but without having an alternative model. What disturbed him most was the fact that society could not deal with the contradictions of human nature; he, too, had difficulty enough in being reconciled to them. Therefore he attacked the hypocrisy of people whose psychological problems were very much the same as his own. He condemned himself to being an outsider, since no one enjoys bitter jokes at his own expense. When after the Second World War he was asked about his inconsistent attitude to the First World War, he immediately shifted the blame to middle-class complacency in general:

So now you want me to explain this whole paradox to those people out there. . . sitting in front of their radios. Well, it'll really give them the shivers. . . . What kind of a fellow is this, some kind of animal . . . saying all this straight out . . . it's not done. You have to observe the conventions. You're supposed to be moderate, reasonable, middle-class average in everything you say, right?[36]

Dix was always fascinated by people who disregarded conventions. He portrayed people whose faces, like gaps in the veneer of civilization, revealed primeval depths beneath. Some of them were conscious rebels; others were rebels unawares, who needed the artist's help to realize their non-conformity. In any event, Dix showed them that they were not what they pretended to be. The self-satisfied visages that Grosz never tired of belabouring did not tempt Dix, however. He was not interested in throwing the small change of agitation to the masses. Seeking no political or social panaceas, he mounted no political accusations. What he sought was something eternal and unchanging—human nature. If Westheim was right in saying that Dix was out to change society by confronting it with naked, brutal facts, then his attempt was doomed from the start. The fact that amoral, cruel nature stared from the

faces of his portraits certainly did not change them. If an artist is fundamentally convinced of the brute violence and deep inherent contradictions of nature, his depictions of these things, no matter how critical, will only serve to confirm them.

A good example is the well-known portrait he painted of Alfred Flechtheim in 1926 (Colour Plate 8). Flechtheim, with Cassirer, was one of the most influential and important art dealers in Berlin at that time. While Cassirer held to established styles, Flechtheim represented the French vanguard.

To define Cassirer artistically, a long list of names, periods, countries, would be necessary, while for Flechtheim one suffices: Paris of the twentieth century. . . . If Cassirer was the most powerful of German art dealers, Flechtheim, from the Rhine, was doubtless the most amusing. If people entered Cassirer's gallery as they would a museum, to devoutly worship fine art, they sauntered over to Flechtheim knowing that their visit would be mainly an enjoyable diversion with a little art thrown in for good measure.[37]

In Dix's portrait, Flechtheim seems to be waiting for just such a casual customer to drop in. He stands before an ink-blue wall, ensconced behind a small, round table on which he has spread his bait—two Picasso drawings of nudes. His flank is protected by a Braque oil. Encased spider-like in his jacket, he reaches out slender arms to secure his possessions. As he measures his prospective client, his mouth mobile, and lower lip ironically protruding, Flechtheim seems ready for anything that may come. His right hand rests firmly but not too possessively on the drawing of a naked couple, partially concealing it; his left holds a Braque still-life. If his erotic bait works, the customer can probably be made to swallow the painting, too.

This portrait is certainly an attack on Flechtheim, whom Dix described as 'avaricious and decadent',[38] but it was just as certainly intended as an attack on the lasciviousness and stupidity of buyers whose interest in art is anything but aesthetic. Moreover, Dix had a very personal bone to pick with Flechtheim. His own dealer, Nierendorf, who disliked Flechtheim, had informed Dix that he 'has been cussing again, calling you a "fart painter" and telling everybody your pictures stink. He's still enthusing about his Frenchmen and always giving you as their German antithesis.'[39] Behind the figure Dix has put a still-life by Juan Gris, signing it with his own name as if to say that he could do as well any day. This irony infuses the entire composition, which is constructed in an almost Cubist manner. The contours of the figure and its attributes correspond to those in the still-life on the wall. The table with

46. Otto Dix. *Self-portrait as a Prisoner of War*, 1947. Oil on canvas, 60 × 54cm. Galerie der Stadt Stuttgart.

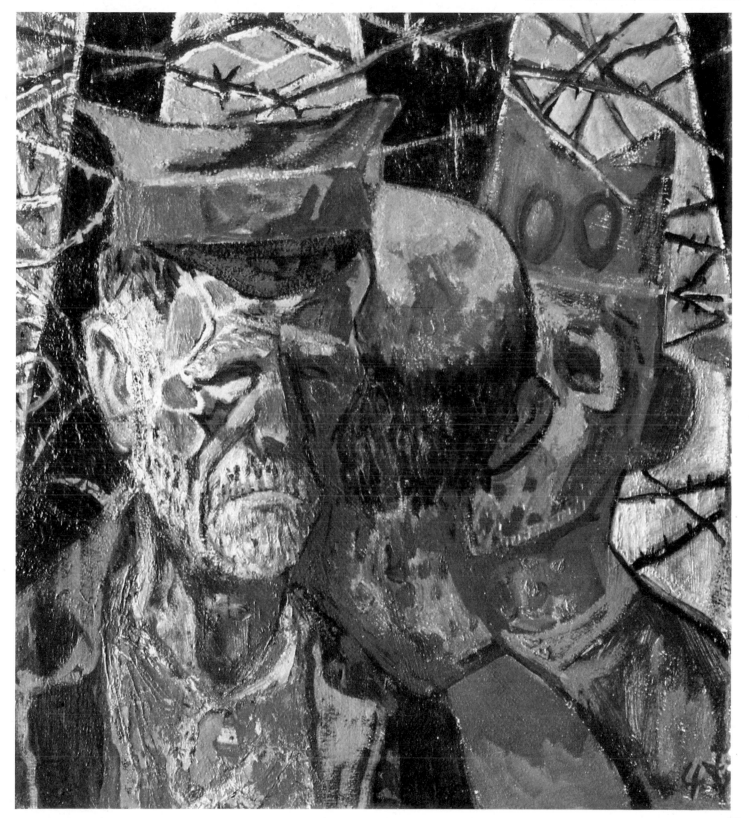

its striking grain and the drawings overlapping and curving away from one another recall certain of the still-lifes of Braque and Picasso. The perspective has been consciously distorted. Dix's verism, instead of imitating reality, like Cubism combines diverse fragments of reality. As Carl Einstein wrote in 1923,

> There is a tremendous tension between the poles of contemporary art. Constructivists and non-objective painters establish a dictatorship of form; others like Grosz, Dix and Schlichter smash reality by poignant objectivity, unmask the period and compel it to self-irony. Their painting is a cool death-sentence, their observation an aggressive weapon.[40]

It remains unclear as to who commissioned Flechtheim's portrait or whether it was commissioned at all. It is unlikely that the model himself ordered it.

Dix maintained his style and with it his critical stance longer than many other artists of his generation. He aimed at the centre of the target, the primal impulse of nature, which he simultaneously hated and worshipped. His confession that his own temper frightened him fits perfectly with his admission that his technique prevented spontaneity, the free expression of his own nature. His personality was just as unfathomable to him as the elemental violence of war. Basically, he blamed society for the split he felt within himself. As long as he felt strong enough to take up the challenge of nature, he remained true to his precise style. The lonely years of inner emigration— after being ousted from his professorship at Dresden in 1933, Dix lived in isolation at Lake Constance—and the war years and internment, apparently broke his will. His *Self-portrait as a Prisoner of War* (1947; Löffler 1947/2; Plate 46) not only shows a humbled, frightened man but is painted in his old *alla prima* style.

This inner change had already been predicted during the 1930s. In the large *War Triptych* of 1929–32 (Colour Plate 10), Dix could still depict the natural cycle of death and rebirth. To the left, soldiers go into battle like Jesus went to Golgotha. In the centre, mechanical death reigns, leaving destruction and grotesquely mangled corpses in its wake, witnessed by a man in a gas mask entering the trench. To the right, illuminated by a flare, Dix himself carries a wounded comrade out of the line of fire. In the predella at the bottom of the picture lie men sleeping the sleep of death, like Christ in His grave; when they awake, the murderous cycle will begin again.

Here war is depicted as a Passion which each man must live through alone. The mangled body cast up in the centre of the image recalls Christ crucified and the remnants of his uniform Christ's loincloth in paintings by Grünewald.[41] Yet for all the parallels, one decisive aspect of the Christian Passion is missing here, the Salvation. The Resurrection of Christ transcended

the cycle of death and rebirth, while Dix's 'resurrection', depicted on the right-hand panel, only inexorably continues it. And the artist's own face, marked by exhaustion and anger, reveals that he no longer believes in the positive message of this eternal return. He wants to interrupt the process, bring it to a halt. Dix intended his triptych to be installed 'in a bunker built in the midst of a big city's sound and fury'[42] as if in a chapel, but certainly not in order to put people into the mood for the next war.

In *Flanders* (Colour Plate 9), painted in 1934–6, even greater emphasis has been placed on the motifs of sacrifice and salvation. By this time Dix had already gone into the inner emigration caused by his expulsion from his teaching post. The hope that those who saw his paintings would or could do anything to prevent the coming war, had certainly diminished, as can be seen from the composition of *Flanders*. It was influenced by Henry Barbusse's war novel *Under Fire*, which the artist had read. Torrential rains have transformed this battlefield into a primeval landscape. Sun and moon both shine; water mixes with earth and both merge with the sky at the horizon; human beings can hardly be distinguished from inorganic matter. The life cycle, spurred by division and separation, has been arrested in a state like that which must have preceded Creation. The image is dominated by the horizontal. The group of three figures in the foreground not only recalls St Sebastian, a drawing of whom Dix had made as early as 1913,[43] but again evokes the motif of Golgotha and transcendence of the eternal cycle. This image, in other words, not only anticipates the Second World War, as many observers have noted, but expresses the hope that the victims of the First World War might prevent it. Through sacrifice, a new order might emerge from chaos, a primeval state like that which preceded the creation of the universe. At least in terms of motif, Dix abandoned the old stance of opposition and accusation by which he had hoped to change men and conditions by ruthlessly recording the facts. In his vision of *Flanders* accusation is replaced by an almost mystic hope, since at the time it was painted he had been deprived of every opportunity to influence public opinion. The idea that the vicious cycle might be broken by sacrifice appealed to him more and more. And in 1943, when many millions of human beings had again been sacrificed in vain, he painted his first *Resurrection of Christ*, followed by a second in 1948 (Plates 47 and 48). In place of the front-line soldiers of 1914–18 now appeared the Son of God.

During the hopeless war and post-war years Dix laid down his weapons one by one, took off his armour, and submitted to the grace of God and what he called 'the inner immediacy of life'. His style changed accordingly. His frank, objective, and sometimes cruel record of a great and awesome nature was

over. Yet he remained fascinated by natural forms and appearances, so much so that he never crossed the border to abstraction. His self-perception remained linked to perception of the world outside, his subjectivity continued to test itself against fact.

Recognizing nature's awesome force, he had attempted to transcend it; when he did not succeed, he succumbed to resignation. After 1945 his art, like that of many of his German contemporaries, lost its force.

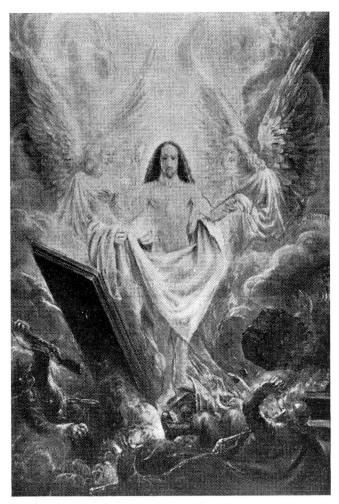

47. Otto Dix. *Resurrection*, 1943. Oil and tempera on canvas. Destroyed.

48. Otto Dix. *Resurrection*, 1948. Oil on wood, 100 × 81 cm. Internatsschule Gaienhofen.

3. GEORGE GROSZ: THE IRATE DANDY
Art as a Weapon in the Class Struggle

No artist mounted a harsher attack on the establishment of Weimar during the early 1920s than George Grosz. Yet no other so roundly condemned his own satire a few years later. Grosz called his earlier drawings 'pseudo-art', adding that an artist who made fun of people's mundane comedies and tragedies was 'like a violinist scratching on a too-small violin'.[1]

In May 1933, having escaped just in time from the Gestapo, he heard of the Nazis' burning books, amongst which were his own, and wrote from the security of New York to his old friend Walter Mehring, 'in principle, I agree with their book-burning'.[2] Grosz believed that the cynicism of Weimar artists and writers had contributed to the rise of the Nazis. With a sideswipe at dictatorial systems and full of disparagement about his earlier work, he went on,

> modern nations can get along on an army songbook and code of conduct and a few classics—look at Russia! The only sad thing is that now all that 'right-wing' Hugenberg kitsch is being produced instead of the pinko variety. Oh well. I don't hold it against them for burning my witch-hunting books as a symbol; after all, a couple of drawings in them are unburnable and will live on.[3]

The drawings he considered 'unburnable' he described in a letter to the publisher, friend and brother-in-arms, Wieland Herzfelde. They

> deal with military brutality. My other and best ones, of the ugly human face. . . . This face—though in 1914 I still had idealistic illusions about it—is the same everywhere, of course. That's why I'm not such a hundred percent believer in Russia. I know very well that people are crushed, pushed around and suppressed everywhere. The OGPU is the same all over the world . . . if . . . the German Communist Party had won, the world would be resounding with even more hateful propaganda; only the emphasis on racial hatred would have shifted to a class hatred that is just as ugly and bloodthirsty.[4]

To Herzfelde's suggestion that they start a satirical magazine along the old lines and attack the Nazis in it, Grosz replied that the 'ugly human face' was basically all that interested him, and that besides Hitler's, there were plenty of 'faces in the other camp, the victorious proletariat, that were just as disgusting as the Prussians''. Both sides were

always dreaming of a better day-after-tomorrow—and in the meantime avalanches of misery and lies (well-intended or not). No, we can't go on believing in all this. No more scientifically planned paradises of equal distribution. Let's sow doubt—just plain doubt—not 'proletarian' optimism. That's one reason I'm against a satirical magazine.[5]

Grosz wrote these words exactly ten years after the publication of one of his harshest, most malicious books, *Abrechnung folgt* (Reckoning Follows), which must still be counted among his best. He had definitely come to terms with his former life.

The 'idealistic illusions' of which he had spoken in his letter to Herzfelde differed in important respects from those of many of his contemporaries in 1914. 'For me,' he said in retrospect, the war 'was not the "liberation" which so many others hoped it would be.'[6] Tempted to see the war in this light also, as it released suppressed natural impulses and brought relief from the drudgery of daily life or hated surroundings, he insisted that 'the war's influence on me was totally negative'.[7]

> Of course, there was a kind of mass enthusiasm at the start. But this intoxication soon evaporated, leaving a huge vacuum. . . . And then after a few years when everything bogged down, when we were defeated, when everything went to pieces, all that remained, at least for me and most of my friends, were disgust and horror.[8]

Grosz's idealism did not consist in his having hoped that war would reassess all values. What he later described as his 'idealistic illusions' amounted to believing that Prussia was the only country to have produced barking drill-sergeants, unscrupulous army doctors, arrogant lieutenants and cynical generals.

Grosz appears to have suffered terribly under the first-named ranks, at least. It is true that he volunteered, on 11 November 1914, but not because he looked forward to the 'tremendous event' of war, like Dix, or wanted to escape an 'oversophisticated culture' like Jünger. He would soon have been conscripted anyway, and thought that volunteering would give him a chance to choose his division. Grosz joined the Second Kaiser Franz Regiment of Grenadier Guards, stationed in Berlin. He never saw battle, being transferred on 5 January 1915 to the First Reserve Battalion where, six days later, he was declared unfit for service after an operation for a sinus infection. Overjoyed, he wrote to a friend, 'I'm a civilian again,' adding ironically,

49. George Grosz. *Mouse in a Trap*, 1943. Graphite on white wove paper, 23.4 × 15.3 cm. Busch-Reisinger Museum, Cambridge, Massachusetts.

If it weren't sinning against the sacred patriotic commandments of the moment, I would allow myself to be glad; as it is, however, I must be content with feeling a profound disappointment at not being able to assist in this grand enterprise. They say it was instinctive rebellion against every kind of compulsion (the diagnosis of a doctor friend of mine) that caused my sinus infection, but I maintain it was because I did too much hard thinking on duty.[9]

Grosz continued to rebel instinctively against force even when it came from his friends in the Communist Party. There is no better way to describe his attitude to authority than as a virulent infection caused by too much thinking on, or rather about, military duty. He never gave up the dreams of individual liberty so colourfully embodied by the adventurers, rebels, robbers and mysterious murderers he found so fascinating.

Born in 1893 in Berlin, this innkeeper's son was attracted by the myths of popular art from an early age. He went to fairs and marksmen's meetings to wonder at the spine-chilling paintings of horrors and disasters, read entire series of penny dreadfuls and sordid murder stories, devoured the novels of Karl May,[10] and, at the age of nine, wrote Cooper's *Last Mohican* out by hand. 'The romance of an unexplored world full of terrific dangers and bloodstained adventurers',[11] gargantuan feasts and, later, erotic pleasures of a kind to be had anywhere except the sleepy Pomeranian village where he grew up, filled the boy's mind. When Grosz returned a teacher's box on the ear, he was expelled from school. He enrolled in the Dresden Academy of Art, where from 1908 to 1911 he received a solid training in drawing. In 1912, when he moved to Berlin to continue his studies, he felt his real life had at last begun.

The big city provided subjects for his work and, so far as his money allowed, participation in the life he had dreamed of. Berlin was modern and alive, full of bars and nightclubs,

55

vaudeville shows, circus, masquerade balls—bohemian life in every variety. Grosz, who already in Dresden had been known as something of a dandy, dressed so well that Karl Hubbuch, one of his fellow students at the Academy, recalled,

> Actually, the only remarkable thing about Grosz at that time was his self-assurance (not arrogance). His modern clothes in the American style—padded shoulders, extremely tapered trousers, gold-rimmed glasses, and a watch on a leather thong in his outside breast pocket.[12]

This American style in dress and behaviour with which Grosz demonstrably set himself apart from old-fashioned and reactionary Germany went hand in hand with his preference for the *demi-monde*. Rejecting the mores and manners of well-to-do, middle-class society, he arranged his public appearances to shock. One day in 1912, he walked into the Café des Westens with his face powdered white and lips tinted red, sat down at a table, and put his 'thin black stick topped with an ivory skull between his knees'.[13]

> He generally sat in the first row on the terrace, mustering the passers-by and the other customers with impertinent scorn. . . . Apparently he was somebody from a circus or vaudeville show—a clown looking for work? A tightrope dancer? Or some hole-in-corner artistes' agent?[14]

The more he rejected normal life, emphasized his extravagance and his artistic exclusiveness, the greater grew his hatred of philistines. Almost everyone was a philistine, as far as Grosz was concerned. He became a misanthropic loner who felt himself surrounded by stupid, ugly, brutal people who revelled in their own banality. It is not hard to imagine how Grosz must have reacted to the tone of his drill-sergeant, how much this dandy must have suffered under the smell of the barracks, poorly cut uniforms, and the rude joviality of his fellow privates when he entered the army in 1914. In the letter already cited, written after his demobilization, Grosz describes his experience with malicious irony:

> My dear Robert, who in the world has ever been more German in deportment and dress than I, who have always defended our German ways against foreign nonsense . . . it's so wonderful, so divine to be living in Germany at this hour; verily, the entire world hates us, how wonderful, and contemplating all these superb, well-fed men in their handsome uniforms—oh, how I love these uniforms. . . . Illustrious Prussia, great and glorious united Germany with your grand army! You alone are called to dribble the seed of culture into all these barbarian nations against whom we are compelled to fight.[15]

After his temporary discharge, Grosz felt the possibility of

being called up again hanging over his head like the sword of Damocles. His hatred of the system that had this power over him seethed. 'It's true, I'm against war, that is, I'm against every system that cages *ME*.'[16] And this capitalized, underlined 'me' not only hated the military but everyone who supported it, followed its orders, bowed to its authority.

> Every day my hatred of the Germans gets new, highly inflammable fuel from the incredibly ugly, unaesthetic (that's right!), badly, oh how badly-dressed look of the most German of them all. Here it is for you in black and white: 'I feel no relationship to this human stew. . . .' Being German always means being tasteless, stupid, ugly, fat, unathletic—means not being able to climb a ladder when you're 40, wearing impossible clothes. Being German means being a reactionary of the worst sort; it means that maybe one man in a hundred ever washes his whole body. They only believe what you're capable of believing when you're bloated with beer and sauerkraut . . . to digest which they go on 'victory' marches. . . . You really begin to wonder how it can be possible that . . . millions of people exist so mindlessly, so unable to see what is really happening, people who have had the wool pulled over their stupid eyes ever since their school-days, whose minds have been stuffed with the attributes of ignorant reaction, such as God, Fatherland, militarism.[17]

These passages from Grosz's letters already contain the entire human bestiary to which he would later apply the knife edge of his caricature. Yet his ugly Germans remained to be politically defined, since the German Communist Party, the KPD, was not yet there to supply the categories needed to turn them to the ends of agitation. Already quite apparent from Grosz's words, however, is the extent to which the masses revolted him, how insulted and cornered he felt by their very existence. This 'most superior of individualists' would hear nothing of 'theories of collectivism, majority rule, and socialism'.[18] Nor could he ever find it within himself to depict The People or The Masses in positive terms, much to the dismay of his Communist friends. There are only different degrees of disgust in his drawings. His range was limited, marked at the one end by hatred of those in power or possessed of authority, and at the other by ridicule of those who followed and obeyed them.

In January 1917, possibly a short time after he wrote the letter just quoted at length, Grosz was conscripted, only to be sent to the infirmary the following day. From there he was transferred to a sanatorium, on 15 February 1917. A month later he wrote in despair to a friend:

> My nerves broke down, this time before I could even get near the front and see rotting corpses and barbed wire—first

of all they defused me, interned me, for a special investigation of what they still think is my fitness for service. . . . You work on, polish, build yourself up for years—and suddenly it's all over, you can't adapt and adjust any more to the way the particular powers that be want you—never will be able to. . . . Nerves, down to the tiniest fibre, nausea, revolt—pathological, maybe—anyway, a total breakdown, even in the face of omnipotent regulations.[19]

The sanatorium was probably the scene of the grotesque event that finally and literally brought Grosz down. Having been pronounced by his doctors as perfectly healthy, he was then ordered by a medical student to get out of bed. Grosz attacked the latter, and was jumped on by the other men in the sickroom. The fight 'burned an indelible scar in my brain—the way those normal everyday fellows beat me up, and the fun they had doing it. Not that they hated me personally. . . . Afterwards they probably played cards, drank beer, smoked, and told dirty jokes as if nothing had happened.'[20]

Grosz was finally discharged as unfit for service in May 1917. The bitter comedy that had begun on Carnival Day, 11 November 1914, was officially over.

But it was not over in the mind of the sensitive young man. While still in the infirmary Grosz had begun giving vent to his injured pride in drawings: 'In notebooks and on stationery I sketched everything I disliked about my surroundings—the brutal faces of my companions, malicious invalids, arrogant officers, sex-starved nurses, etc.'[21] One of the first products of his smouldering resentment was the well-known drawing, *Passed—The Faith Healers*, 1917 (Plate 50). While two officers in the foreground talk of other things, an army doctor pronounces a skeleton fit for war service. The verdict, duly noted by a secretary hunched over his record, brings a flat-footed medical student with the obligatory file under his arm to attention. This fellow looks rather sickly, and Grosz, who did not hesitate to hit below the belt, has equipped him much less formidably than the beefy guard to the right. The skeleton is probably a self-portrait, since it is wearing the gold-rimmed glasses already mentioned and since, of course, Grosz felt that he had been given the same treatment. The fact that he himself was not skin and bones and was soon sent to hospital might not prove that the Prussian army could be humane, but it certainly shows Grosz's tendency to grotesquely exaggerate situations that raised his ire.

In 1917 Grosz concentrated all his anger, hatred and disgust into a large canvas, *Funeral Procession (Homage to Oskar Panizza)* (Plate 51). He described the painting as a 'picture of hell', a 'Gin Lane of grotesque deadmen and madmen', a 'swarm of possessed human beasts', expressing his conviction that 'this era is sailing downhill into destruction'.[21] A crowd of savagely

50. George Grosz. *Passed – The Faith Healers*, 1916–17. Drawing, 50.8 × 36.5cm. Museum of Modern Art, New York.

grimacing figures rushes down the frighteningly inclined street, their infernal procession headed by Alcoholism, Pestilence and Syphilis. A dwarfish, moon-faced preacher waves a crucifix in a vain attempt to pacify the crowd. Officers swing their sabres, the buildings seem on the verge of toppling in the general conflagration. In the midst of this descent into hell rides Death triumphant, straddling a coffin.

Like his drawings at this date, the painting contains no express political message, nor has Grosz put the blame on any particular sector of society as he later would. This is an image of apocalypse pure and simple, predicting the end of an era which the artist hated to the depths of his being. One is reminded of his descriptions of people as 'death-dealing little ants', or 'possessed human animals' who longed for self-destruction. Grosz himself seems to have derived not a little pleasure from his doomsday mood. Reading his letters of the time with their self-satisfied descriptions of drinking bouts, orgies, a detailed case of gonorrhoea, and one wild sensation after another, no other conclusion is possible. Werner Hofmann asked whether this painting did not reveal a certain enjoyment of the perverse and abnormal—the answer would appear to be yes.[22]

Crucial to an understanding of Grosz's work is the recognition of his highly ambivalent attitude towards lust, crime, violence—

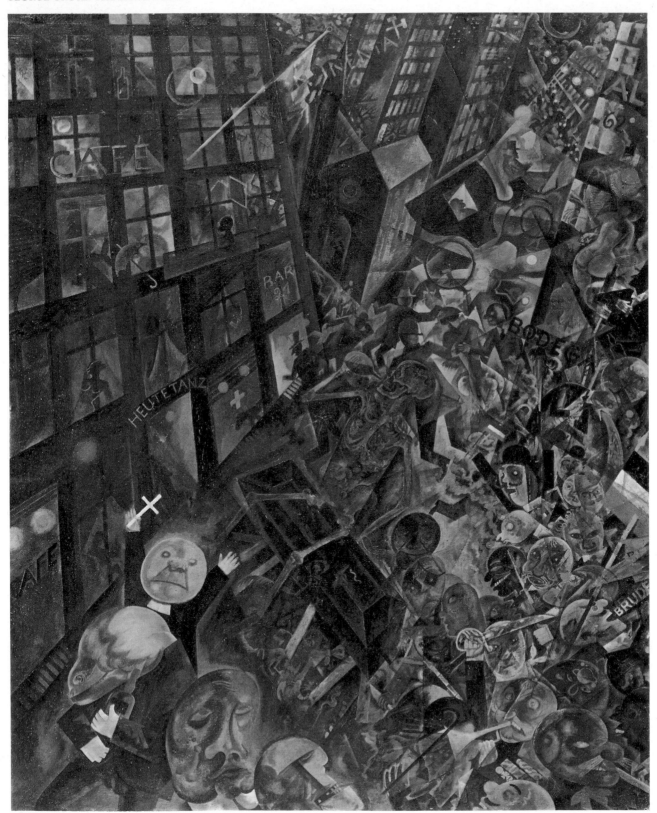

51. George
Grosz. *Funeral
Procession (Homage
to Oskar Panizza)*,
1917–18.
Oil on canvas,
140 × 110cm.
Staatsgalerie
Stuttgart.

in short, towards all the more extreme expressions of human vitality. He often portrayed himself in the role of adventurer, Indian brave, clown or criminal; he dreamed of being the he-man, outlaw or ladykiller he so brilliantly imitated both in real life and in his art. Continually defending his own right to enjoy an outlaw's liberty, he refused it to others. Sex was a good thing for him, but in the rich and powerful it was a vice. The champagne he ordered at Kempinski's showed him to be a man of taste—he looked down on beer-drinkers—but the same champagne on a profiteer's or general's table proved them traitors to the working class. The prostitutes he slept with were exciting creatures whom the touch of a bourgeois transformed into sluts.

Grosz, in other words, feared and hated in others those instincts which kept him alive and gave him pleasure. In this he differed fundamentally from Otto Dix, to whom the vital principle seemed good and sacred until the war had revealed its moral indifference. This made him a sceptic and a cynic, yet one who remained fascinated by human vitality in all its forms. Grosz, by contrast, judged life from a self-centred, aesthetic point of view, accepting human nature only in certain of its manifestations. Dix saw it everywhere, pulsating through the veins of everyone with the same force. Whether it produced affectation or greed, stupidity or lechery, these were all expressions of life itself, and life cannot be judged aesthetically. With Grosz, the aesthetic judgement preceded the political. If he had not thought first in aesthetic and individual terms, the outbreak of brute force he experienced in the sanatorium would not have engraved itself so 'indelibly' on his brain. Grosz did not like physical violence, particularly when he was the target. Dix, the former machine-gunner (Plate 38), probably took brutality more in his stride. He had seen enough of it in the trenches. His nerves were shaken neither by the sight of 'barbed wire and rotting corpses' nor by that of the ranks of men he himself had mown down (Plate 29).

The difference between the two men becomes particularly clear when their depictions of sex murders are compared (Plates 36 and 52). With Dix, the cycle of procreation and death, symbolized by the two dogs, goes on. Grosz's *Jack the Ripper* (1918) slinks away from the scene of his crime, and the gang in *When it was all over, they played cards* (1917; Plate 52) sits in brute complacency in the same room with the dismembered corpse. In a drawing of 1916, *Sex Murder on Ackerstrasse* (Plate 53), the culprit washes his hands of the deed, continuing not the cycle of procreation and death but the banality of everyday life, a grey, eventless and sordid life for which the crime is a mere compensation. Beneath the mask of the normal, Grosz sees cruelty of a kind anyone is capable of, even the unassuming law-abiding fellow next door. Dix had experienced all of this at the front—it was for the sake of this experience

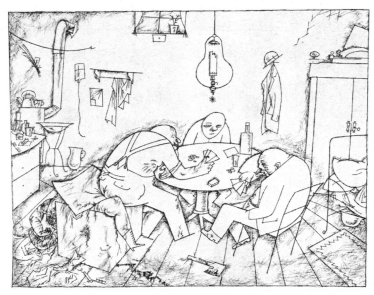

52. George Grosz. *When it was all over, they played cards*, 1917. Pen and ink, 26.3 × 33.3 cm. George Grosz Estate, Princeton, New Jersey.

53. George Grosz. *Sex Murder on Ackerstrasse*, 1916. Pen and ink, 36.3 × 28.3 cm. George Grosz Estate, Princeton, New Jersey.

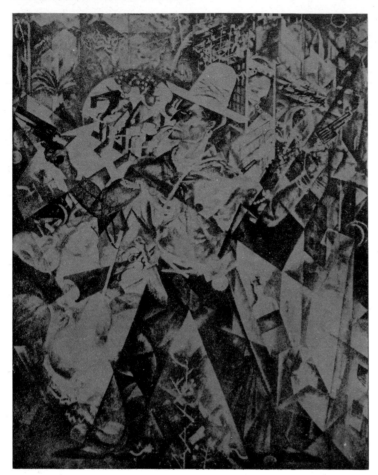

54. George Grosz. *The Adventurer*, 1916. Whereabouts unknown.

he had volunteered. He immersed himself in the wholesale slaughter, to kill or be killed, while Grosz, concerned for his individuality and elegance, felt no desire either to be made into a number or go on the rampage. That is why he feared the lack of restraint in others, and why he developed a fine sense for what goes on beneath the complacent surface of daily life. Yet fine as his sense may have been, Grosz never depicted himself as a murderer, which Dix unmistakably did both in his self-portrait as machine-gunner and in his *Sex Murderer* of 1920 (Plate 37). Grosz could kill only from behind a mask, or let others do it for him.

A favourite victim was the source of all men's troubles and of all men's lives, woman the temptress.[24] Grosz signed his *Sex Murder on Ackerstrasse* 'Dr William King Thomas', one of his assumed personalities. Behind this coolly diagnosing physician lurks a notorious criminal of the day, Thomas William King, who blew up a ship in Bremen in order to collect the insurance money.[25] The murder is committed, as the inscription indicates, by a certain 'Jack the Killer', a figure based on Jack the Ripper

from the penny novels Grosz had read since boyhood. Here, clearly, is a tangle of allusions, pseudonyms, and characters out of novels behind which hides the author himself, George Grosz. And it may not be too far-fetched to trace back the motif of a washing of hands after sacrifice to Pontius Pilate and his declaration of innocence: the woman in Plate 52 was murdered and dismembered by a group of three men, making it impossible to put the blame on any one of them. Grosz appears to recoil from the hot breath of violence he himself evokes, even to the titles and compositions of these images.

In other words, instead of translating them into action, he projected his fantasies onto paper and canvas, abreacting, getting them out of his system. He took no part in acts of violence, hiding his need to do so behind clever pseudonyms, even in his pictures. Grosz let his murdering be done by others, and these others filled him with a mixture of horror and covert admiration. For they gave free rein to what the artist very

55. George Grosz. *Cheers Noske! The proletariat has been disarmed.* Drawing for *Die Pleite*, 1919.

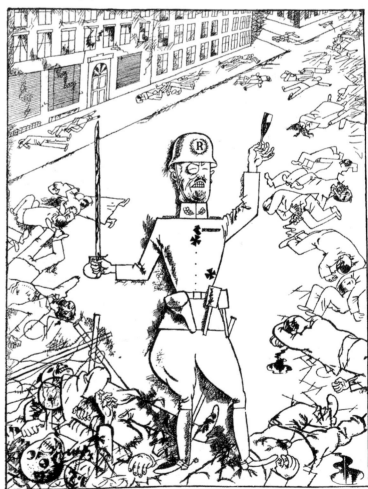

much feared. Their brutality, or unleashed vigour, naturally did not make them attractive figures with whom the dandy and aesthete Grosz could identify without hesitation. When in 1917 he wrote, 'From an aesthetic point of view, though, I rejoice at every German who dies a hero's death on the field of honour (how lovely)'[26]—the Germans, it should be remembered were ugly—the question arises as to whether Grosz secretly sympathized with those who butchered workingmen in his later drawings. Were the Berlin proletariats of 1919 any more handsome Germans than those who fought for God, Kaiser and Fatherland in 1917? Grosz may have covertly sympathized with the hard-bitten officers to whom, he imagined, cutting down a couple of proles was all in a day's work. An unadmitted sympathy, certainly, compounded of hatred and admiration.

It is revealing to compare Grosz's lost painting of 1916, *The Adventurer* (Plate 54), with his famous drawing *Cheers Noske!*

56. George Grosz. *Cheers Noske!* Second version. Drawing for *Face of the Ruling Class*, 1921.

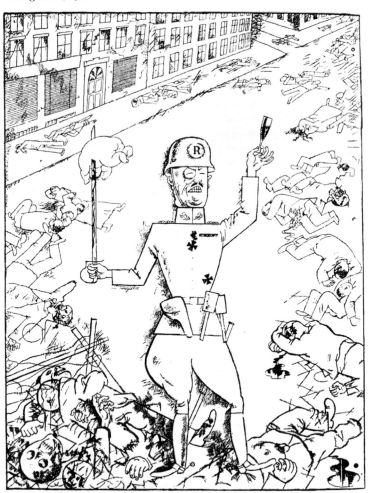

The proletariat has been disarmed of 1919 (Plate 55). The first is doubtless a self-portrait, or more precisely, a portrait of the artist in one of the many roles he delighted in playing. The man has Grosz's profile, and like him smokes a pipe, whose bowl, a miniature carved skull, recalls the painter's walking-stick. Booted and spurred, the Adventurer stands solidly in the middle of the road and at the centre of the image, around him a tumultuous storm of fragments both natural and man-made. This background is the America of his dreams, a country where a real man could remake the universe. All the principal lines of the composition pass through the figure, and meet at his heart. He is the focus of the chaos which he both discovers and creates. Yet he is not a war god, nor the Mars into whom Dix projected himself, needing to live through his own inner chaos. Grosz's Adventurer is an adventurer of the imagination, a fantasy tough guy in a mad world, like his *Gold-digger* (Plate 57) which also bears traits of an ideal self. Texas Jack in the big city, making the dudes in the background run like rabbits. All erect masculinity, he brandishes his guns, carries a whip over his arm, and a knife and whiskey bottle in his belt. Willi Wolfradt wrote of this grimly grimacing *Adventurer* in 1920, 'an inevitable product of nature and avenging god of this soulless thieving civilization',[27] a somewhat more negative view of the image than Grosz's own.

The second figure was conceived three years later, for the cover of the third issue of the Communist journal, *Die Pleite* (April 1919). This time it is an army lieutenant who holds the centre of the street and the image. The façades recede precipitately behind him as in the *Adventurer*. But this figure does not dominate the image quite so self-assuredly as his predecessor, being neither as muscular nor quite so firmly planted on his spindly legs, to which bulging riding pants lend a spurious solidity. Yet he too gesticulates threateningly and dominatingly, and instead of the cowboy's whiskey bottle, he raises a glass of champagne in a toast. Finally, the scene is quite different, not a vision of the New World but a slice of the Old, a working-class quarter of Berlin with flaking walls and shuttered shops. Here too chaos reigns; dead and wounded litter the street, horribly massacred. The Spartacist revolt had been crushed. The commanding officer of the government troops brandishes a sabre on which, in the second edition of the print (Plate 56), Grosz impaled a baby which bore a macabre resemblance to a roast sucking pig. Champagne and roast sucking pig, a gluttony not the taste of the gourmet Grosz, nor does Grosz like this particular lord of the street and the city. It is for this reason that he portrays him as short, puny, bandy-legged, gives him bent spurs and, in place of his ideal cowboy's massive boots, those of a ridiculous dandy. His bared teeth mark him just as much a wild animal as the other, but his is an impotent one—an army pistol pointing downwards replaces the erect penis of Grosz's

57. George Grosz. *The Gold-digger*, 1916. Pen and ink, 41 × 29.5cm. Private collection, New York.

58. George Grosz in his Berlin studio, 1917. Photograph. George Grosz Estate, Princeton, New Jersey.

tough guy of 1916.

But though this latter-day Adventurer may be stupid and incapable, he is a victor nonetheless. There is a striking similarity in human type, weapons, and other attributes, as well as the figure's placement in the centre of the image and the street, and the obvious general parallels of this composition to the earlier one. Only the evaluation is diametrically opposed. Here Grosz both physically and mentally disparages the stereotype of the Prussian officer. It is difficult to imagine that all the officers of the Reichswehr were really such cretins and that none matched up to the Adventurer. But it is also clear as to why Grosz himself could not conceive of the possibility. His Adventurer was a product of his imagination, a piece of wishful thinking, one of his self-images, roles. The Prussian officer, by contrast, had a number of very real confrères who posed a very real threat to George Grosz.

It is possible that the figure of the lieutenant actually represents a denigrated, caricatured 'brother' of the painter's ideal self indicating that Grosz possibly identified less with the victims than with their persecutors. There is no doubt that he hoped for a more just society after the war, and he certainly must have suffered when those who shared this hope with him were suppressed. Yet it is equally certain that he never really sympathized with the proletariat, that he scorned 'the masses' and was something of a social climber. It was success he worshipped in his daydreams, the figure of the winner he himself always wanted to be. And now that the winner was on the wrong side, the only thing he could do was to vent his wrath on his own inmost ideal. It is easy to imagine how deeply injured the artist must have been by the victor's cool, nonchalant gesture, Grosz, the man who in 1915 had told a friend about

phantom figures in which I can make certain dreams, ideas, tendencies, etc. come true. It's like tearing three other

62

people out of my inner imaginative life, and I even believe in these imaginative pseudonyms. Gradually three clearly out-lined types have taken shape. 1. Grosz; 2. Count Ehrenfried, the nonchalant aristocrat with well-pared fingernails, con-cerned only with cultivating himself, in short—the superior individual; 3. Dr William King Thomas, the physician . . .[28]

These 'phantom figures' have been introduced already, a cold-blooded mass murderer, and also a man characterized by an aloofness from accepted morality, the pressures of normal life, and the promptings of human fellowship which Grosz himself would have liked. All of which also characterize the Reichswehr officer. At the risk of overstatement, one might say that the Reichswehr stole Grosz's show. Since he could be an aristocrat and mass murderer only in fantasy and in his studio (see Plate 58), he basically ended up on the wrong side, a perpetual underdog when his tastes and instincts told him he should have been just the opposite. It was too much for him, and he therefore destroyed the lieutenant in his caricature, and in countless other caricatures the entire class to which he was not allowed to belong. In this drawing George Grosz, satirist of humble origin, drags Dr Thomas, Count Ehrenfried and the lieutenant of the Reichswehr, through the mud. And so that there is no doubt that the man's reputation will be forever ruined, Grosz's officer skewers an innocent baby on his sabre. Massacring ugly Germans was within Grosz's competence also, but the job of murdering infants belonged to the army!

Yet Grosz destroyed still another ideal with this satirical figure, an ideal with which he was never able to identify. This was the classic tradition of the human image, in particular the figure of Athena Lemnia by Phidias, a contemplative goddess of war. The Dresden collections contain a reconstruction of this statue in bronze (Plate 59). It would be difficult to deny that Grosz knew it—as a student of the Dresden Academy, he had been forced to draw from antique plaster casts for years, something which he had violently disliked. In the drawing, the severely frontal pose of the officer, which almost makes him tip out of the picture, closely resembles that of the Athena, an embodiment of classical culture and education—for cultivated burghers, but not for Grosz. His caricature ridicules the tradition which they claimed for their own, shows what Weimar reactionaries made of classic poses and the inheritance of Greece and Rome. Grosz may not have consciously intended this parallel, but the fact that the features of Dr King Thomas, Count Ehrenfried and even his Adventurer all emerged from his pen here surely says much about his self-image.

Ernst Kallai was the first to point out the close resemblances between Grosz the satirist and his victims. 'He probably has to empathize to a certain extent with what he opposes,' wrote Kallai in 1927, when the artist was at the height of his fame.

This internalized struggle with his adversary places him far above the vulgar caricaturists and naïve illustrators of humorous weeklies in whatever camp. It lends that deadly point to his hatred. But it also tempts him into not merely making short, clean work of his enemy but dispatching him slowly and cruelly, tearing him apart limb by limb . . .

The lieutenant is an example of such cruel executions.

59. *Athena*, Roman copy after an original by Myron. Staatliche Kunstsamm-lungen, Dresden.

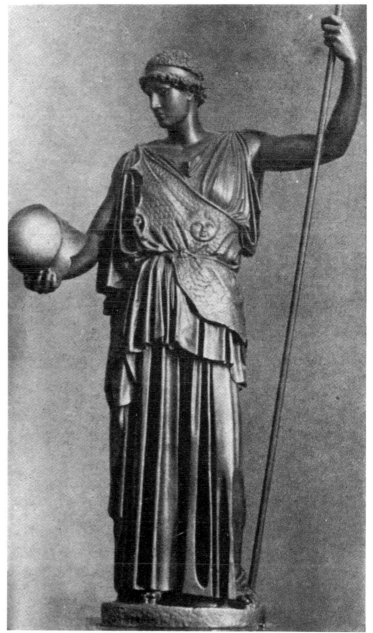

Thus if caricature expands in the hands of this artist to the proportions of a satirical world-view, it is because of his deep involvement with his opponent. . . . He is literally a man divided against himself.[29]

As has been shown, Grosz, gave names to some of these conflicting selves. The problems that resulted from his identity conflict plunged him into depression and alcoholism. He searched in vain for a way to remain detached from society and yet reap its praise. Grosz's army officer illustrates his attempt to resolve the dilemma. The Adventurer metamorphosed into a brainless militarist because he entered reality, and on the wrong side of the political line. And in uniform, which to Grosz, the superior individual, was an intolerable state of affairs. Moreover, by this time, Grosz himself had metamorphosed from moralizing loner and aesthete into a comrade and political satirist with an aesthetic bent. His Communist-oriented friends, led by Wieland Herzfelde, had brought him into the Marxist camp. The ideology of the KPD, which Grosz joined together with Herzfelde and Piscator in the winter of 1918, helped him put his ideas in order, gain control of his confused emotional life, and find a purpose for his protest, a purpose shared by others. He was no longer alone with his hatred. At last he could feel that his dislikes were not merely personal idiosyncracies but historical and social problems. His opponents had suddenly become the objective waste-products of history, ripe for the famous junkpile. The world was nicely divided into two camps—culprits and victims. This must indeed have been a relief for the young artist. In his art, at least, the battle-lines were now clearly drawn, though in his mind and heart they still tortuously intermingled.

Nor was he able to keep them separate in his life. Richard Huelsenbeck recalls that in 1919 to 1920,

> Grosz and I sat night after night at Kempinski's over wine and good food (or what money would get you back then), and Grosz told me about his expectations. I remember perfectly his once bringing up Beardsley, the English artist, saying what a fabulous snob he was, and how his servant used to bring him his paints and pencils. This was the ideal of a man who at that time was flirting with the proletariat and was prepared to take the political consequences.[30]

One begins to understand why Grosz felt attracted to a system that, at least intellectually, and abstractly, resolved his identity conflict. In the long run, he was harmed by the fact that the system was not of his own devising. As a satirist he became famous; as a Communist he earned good money; but both ruined him as an artist. Because of its greater complexity, his Adventurer is more interesting than his champagne-drinking lieutenant. Grosz made a name for himself, and as he became a

more proficient caricaturist, he grew weaker as an artist.

Some light should be shed on his process of 'becoming aware', as he called it. Referring to himself and his friends, he announced publicly that, 'We saw the final crazy products of the prevalent social order and laughed out loud. What we did not yet see was that there was method in this madness . . . insight came with the imminent revolution.'

In 1924, describing the conclusions he had drawn from this insight, he wrote,

> I do not hate people indiscriminately any more, I hate their bad institutions and the people in power who defend these institutions. And if I have a hope, it is that these institutions and the class of people that protects them will disappear. This hope furthers my work.[31]

By the time Grosz wrote these words he may well have come to doubt their truth. The year before, he had spent several months in the Soviet Union, which did not increase his hopes that the world would soon change for the better. At any rate, on his return he ceased paying his KPD membership dues. Marxism certainly provided him at first with a kind of intellectual corset that concentrated his hatred, giving it a target as well as ending his personal isolation. How mechanically he must have adhered to this ideology may be gathered from the desire he often expressed, 'To be able to think and work with the precision of a machine—what a noble motto.' This was written in the summer of 1918, before he joined the Communist Party. He continues: 'but even nobler—to be intolerant upwards and not downwards',[32] illustrating in words his approach in his satirical drawings. And Grosz had found himself a new pseudonym: 'Latest name: Dr Maschin Georg Ventil, derived from boiler explosion.'[33] Because it was nobler to explode upwards, in a direction determined by the party apparatus, George Grosz exploded upwards for the next few years. Even in retrospect, when he had long overcome this politically biased 'precision' thinking, he still saw it in almost mechanical terms. Fresh out of Russia, he compared Lenin, whom he had heard give a speech in the Kremlin, with an old apothecary who always prescribes the same three patent medicines for every ill.[34] In 1935, on a visit to New York, the composer Hans Eisler argued along the same old blinkered historic-dialectical lines. Grosz in turn wrote an unpleasant letter to Brecht, who was naturally also implicated:

> And if anything remains unexplained, historical dialectics always rush in to save the day. Marvellous! . . . I've always wondered why Marxists even bother to travel at all—they've got their own special television-type gadget known as dialectic—the world looks the same everywhere for a good Marxist, namely flat as a plate. It's that simple.[35]

Yet it was just this mechanical categorization of social phenomena that Grosz himself attempted after the war. He not only blamed all evil on capitalists and militarists but designed his imagery accordingly. Having seen works by de Chirico and Carrà at the Goltz gallery in Munich, in the spring of 1920, he began a series of mechanistic compositions. To Grosz, this new style was more 'realistic' and 'objective'. As he put it in 1921,

> I am trying to give an absolutely realistic picture of the world again. My desire is to be generally understandable— without the profundity demanded nowadays. . . . In the attempt to develop a simple, lucid style you automatically come close to Carrà. . . . People are no longer individual, they are collective, almost mechanical concepts. Individual fates no longer matter. . . . The straightforwardness and clarity of engineering drawings are a better guide than uncontrollable gush about the cabbals and metaphysics and saintly ecstasies.[36]

If this was intended as a rebuff to Max Beckmann, Grosz was indeed the mouse that had not yet realized it was caught in a trap, raging against the giant who had just begun to stir. He wanted to escape from nature to the modern saviours of mankind, the warmth of the collective and the strength of the machine. His enthusiasm was shortlived. His craftsmanship rebelled against technology, and his individualism and sharp eye rebelled against conformity. Both gradually vanquished his theories. First doubts about his new doctrine had come with the visit to the Soviet Union. The functionaries he had met seemed colourless, devoid of a private life, he later recorded:

> Many of them seemed like animated, red-covered pamphlets, and they were even proud of the fact. And naturally, since this was supposed to be the mass era, they tried to suppress what little individuality they had, and would actually have been glad to have grey cardboard discs for faces with red numbers on them instead of names.[37]

Just two years before, in 1920, Grosz had portrayed die-hard German patriots in exactly the same terms. One of his two *Republican Automatons* (1920; Colour Plate 11), salutes by clockwork, his hollow head serving merely to amplify the obligatory patriotic cheer. The other, whose dress and bearing characterize him as middle-class, apparently has an internal mechanism which makes him wave his little flag, the black-red-gold tricolour of the young republic. And he, too, is a cripple, a number, indicating that he represents ideas Grosz considered historically outmoded. While these figures are clearly negative, Grosz's *Diabolo Player* (1920; Plate 60) gives what appears to be a more positive picture of the mechanized, collectivized modern world he so longed for at the time. For

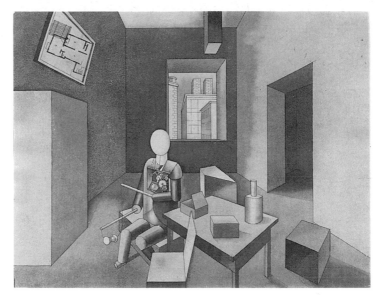

60. George Grosz. *Diabolo Player*, 1920. Watercolour on cardboard, 42.5 × 56cm. Private collection.

vital organs the figure has gears which move its arms up and down, in a pastime just as mechanical as the geometric room it takes place in and the severe city outside. Yet it was just this engineered simplicity, this functionally perfected world that embodied the future for Grosz, a future upon which America, for one, had already entered. In his autobiography he recalled,

> What came from America was 'Americanism', a much-quoted and much-discussed term for an advanced industrial civilization. New forms of automation . . . the whole modern manufacturing process, in which labour is divided into separate, precisely calculated parts, the systems of Taylor, Ford and others—all of this came from America.

Excited by this fascinating New World,

> we all suddenly started playing Diabolo. With a string stretched between two sticks you held in your hands, you tossed an hourglass-shaped top up in the air and dextrously caught it on the string when it came back down again. Humming all the while the latest tune, 'Since my old man caught the latest craze of Dee-Eye-Eh-Bee-Olo'.[38]

Diabolo Player was apparently meant to express a mood just opposite to that of *Republican Automatons*, down to the tune it is possible to imagine him humming—no rousing march, no huzzas, just the innocuous hit of the day. It may be naïve, entertaining, even a little mechanical, but certainly a relief from the omnipresent drone of the period's politicians.

Grosz was not satisfied with this solution for long, however. The mechanical approach denied his temperament and talent,

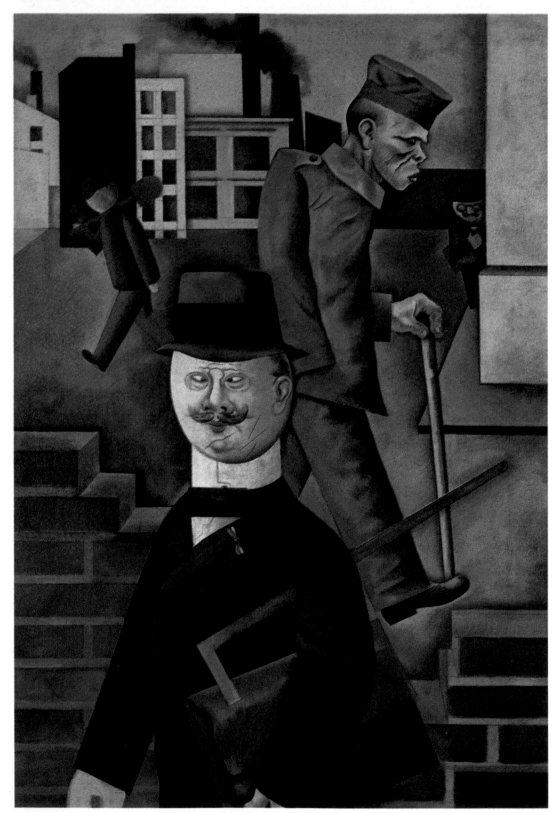

Col.Pl.12. George Grosz. *Dreary Day*, 1921. Oil on canvas, 115 × 80cm. Staatliche Museen Preußischer Kulturbesitz, Nationalgalerie Berlin.

Col.Pl.13. George Grosz, *The Pillars of Society*, 1926. Oil on canvas, 200 × 108cm. Stattliche Museen Preußischer Kulturbesitz, Nationalgalerie Berlin.

61. George Grosz. *We meet to pray to the just Lord*, 1921. Drawing. Whereabouts unknown.

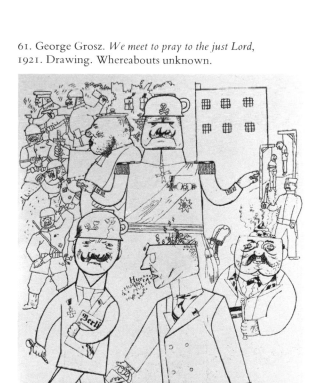

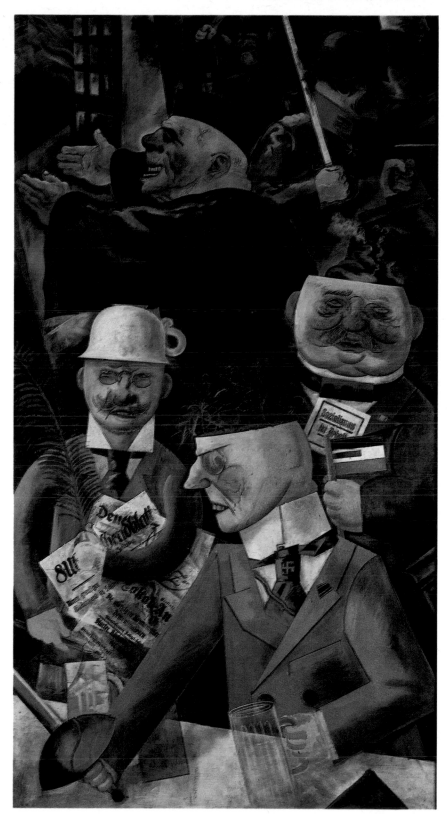

and a rubber stamp in place of a signature ran counter to his self-assessment as a 'superior individual'. A year later he had already recast his mechanical dolls as social types and replaced their anonymous masks with caricatured faces. His canvas *Dreary Day* (1921; Colour Plate 12), was exhibited at the 1925 *Neue Sachlichkeit* show in Mannheim under the title 'Council Official for Disabled Veterans' Welfare'. While this title describes the relationship between the public servant in the foreground and the disabled man behind the wall, *Dreary Day* alludes more to the state of society in general. The person responsible for altering the title is unknown.

The official, in dark suit and hat, is an old fraternity man who proudly displays his duelling scars. The imperial colours, black, white and red, which still shine on his lapel, and the moustache like that worn by the exiled Kaiser suggest that his nationalism is of the reactionary variety. Judging by his squint, he cannot see past the end of his nose. The stick under his arm resembles an L-square of the type masons use, perhaps indicating that he is one of those who are building new walls between the classes. The old walls had, after all, been torn down in 1918, even if three years later, in 1921, everything seemed to have reverted. One can almost hear Grosz saying, 'at this moment I hate the institutions and the people in power who defend them'. His public servant, whose job it is to aid war veterans, seems oblivious to the one behind him and the entire dreary scene in the background, a petty black-marketeer slinking around the corner, a faceless worker hurrying to work, the depressing façades. He sees nothing because as the black crêpe on his sleeve shows, he is in mourning, for the old Empire, his beloved Kaiser, the old order with its well-built walls which so effectively kept people in their places.

Grosz depicted this type of man in countless drawings which over the past years have become so well-known that they need not be discussed here. He drew them with a sharp pen, giving them angular movements, fat bellies, horrible masklike faces, and frequently letting them gesticulate like marionettes in a vacuum. They had predetermined roles to play in a scenario written by 'the system' which Grosz carried in his brain as an instrument for analysing reality. As long as he trusted it, it gave his style sureness and concision.

If Dix employed the precise technique of the old masters to defend himself against the cruel cycle of life and the modern world, Grosz resorted to an intellectual, almost mechanical technique. Fed with the input of current events, this intellectual mechanism automatically produced the right culprit, nicely packaged and labelled. Cause and effect jibed, the right answers provided themselves without the trouble of individual thought. When Grosz realized that this mechanical approach no longer did justice to what he saw happening around him, its hold on him began to relax. His view of life broadened but his art lost

focus, the impulse behind it diminished. Grosz's drawings record his gradual abandonment of the 'precision' style he had prescribed for himself. Towards the mid-1920s his stroke grew broader and his compositions began rather awkwardly to emphasize painterly values, though his subjects remained initially unchanged. In his large paintings, such as *Pillars of Society* (1926), he merely repeated combinations of human types that had brought him success in 1920 and 1921.

In March 1926, Grosz met Heinrich Vogeler, another artist, in Berlin. The latter, who was then living in Moscow, informed Grosz that most painters there were working in 'a kind of synthetic realism'. That same evening, Grosz was heard to say that he 'would like to paint modern historical pictures', referring to the great William Hogarth as his ideal.[39] The *Pillars of Society* is just such an historical picture in a 'synthetic realist' style (Colour Plate 13). It was probably intended as the right-hand panel of a triptych whose centre section bears the title *Eclipse of the Sun* (Heckscher Museum, Huntingdon, New York), and whose left-hand panel was never executed. While *Eclipse of the Sun* portrays the political headquarters of capitalist society, the *Pillars* represent its executive, the members of which, not without reason, look and act like marionettes. This body had already met in a drawing entitled *We meet to pray to the Just Lord* (Plate 61) in Grosz's book, *Face of the Ruling Class* (1921). At the lower right in both drawing and painting is a gentleman in a grey, double-breasted suit, stiff collar, monocled and duelling-scarred. Obviously a chauvinist, in the drawing he yells, 'Hurrah, hurrah,' a favourite commentary on political events missing from the painting. By compensation he is given other, no less indicative attributes. His open skull issues forth law paragraphs, to which in the painting is added a ghostly lancer parading the Kaiser's colours. Grosz represents the man as a desk-bound pedant who imagines himself still riding the cavalry attacks of the Great War. The swastika stickpin in his tie signifies a trend that in 1921, the year the drawing was made, had not yet become threatening. A ribbon across his chest, his scarred cheek, sword and inevitable beer glass, characterize him as an 'old boy' of a duelling fraternity, his monocle as a short-sighted conservative. Ears to hear he lacks entirely. The figure's pose, attributes and position in the picture are only slightly different from the 1921 drawing.

To his left is an embodiment of the bourgeois press whose features bear a certain similarity to those of Alfred Hugenberg, the Weimar newspaper tycoon. He, too, had not yet risen to his prominent position in 1921; in the painting, Grosz increased the resemblance to Hugenberg and added his typical *pince-nez*. The journalist's pencil-dagger in the drawing has reverted to a mere pencil here, but the man grips it like a knife. While in 1921 a single newspaper sufficed, probably the *Berliner Zeitung* whose title is just legible, the painting shows several sheets.

68

62. George Grosz.
*Self-portrait as
Admonisher*, 1926.
Oil on canvas,
90 × 70 cm. Galerie
Nierendorf, West
Berlin.

Col. Pl. 14. Max Beckmann. *Scene from the Destruction of Messina*, 1909. Oil on canvas, 253 × 262 cm. Saint Louis Art Museum, Bequest of Morton D. May.

Two of these, the *Deutsche Zeitung* and *Berliner Lokal-Anzeiger*, belonged to the Hugenberg corporation, which advocated a radical, nationalist line; two others were in the liberal camp. The *Acht-Uhr-Abendblatt* was published by Mosse, the *B.Z. am Mittag* by Ullstein. Grosz's 'realism' does not distinguish these important political differences, tossing them all into the same

70

Col. Pl. 15. Max Beckmann. *Resurrection*, 1916–18. Oil on canvas, 345 × 497 cm. Staatsgalerie Stuttgart.

synthetic pot—a chamber-pot upended on the head of the 'bourgeois' press and decorated with a shadowy iron cross to symbolize latent militarism. The palm frond in the figure's left hand probably stands for hypocrisy, since one of his newspapers drips blood. The headline on the top paper indirectly advocates violence: *Police Say Tomorrow's Communist Demonstration to be Adequately Gunned* (not Guarded: *Polizeischuß* instead of *–schutz*). In the drawing, the bloodstain stands without commentary, and the iron cross decorates the journalist's lapel. Otherwise the differences are minimal.

To the press's right, in both drawing and painting, is a fat fellow whom Grosz has given a pile of excrement for brains. He waves an old imperial flag and, in the painting, wears a cardboard sign around his neck stating 'Socialism is Labour', a slogan with which the SPD countered Communist strike appeals. That Grosz meant this figure to personify what he considered an incapable, traitorous SPD government becomes perfectly clear in *Pillars of Society*, where the man's right elbow rests heavily on the pediment over the entrance to the Reichstag building.

In the drawing, an embodiment of the General Staff blesses the actions of these marionettes; he is replaced in the painting by a clergyman. Since Grosz's planned triptych showed the General Staff, in the person of President Hindenburg, in the central panel, he is missing from *Pillars of Society*. The pastor who takes Hindenburg's place appears in a similar pose in the drawing, though his features are different. To the right, finally, is a company of Reichswehr burning and pillaging, apparently enjoying what would now be called anti-insurgency. These character-types, too, had already been worked out in the early drawing. Grosz had ceased to invent, merely expanding to a

larger, more effective scale imagery he had developed years before. He heightened, compressed, and sharpened it, but without inner necessity. The triptych remained in his studio, unfinished.

Grosz's enthusiastic and artistically original commitment to the working-class and revolutionary cause was over, and not only because he realized his 'mission' had failed but because he yearned to escape from the trap of a mechanical ideology. He wanted to be a free artist at long last, not a caricaturist of class conflict. He began to paint landscapes and portraits which lacked the scornful irony of his earlier years (*Max Hermann Neisse*, 1925, Kunsthalle Mannheim; *Eduard Plietzsch*, 1928, Wallraf-Richartz-Museum, Cologne). If grotesque traits entered these portraits as well, they were probably the sitter's rather than the artist's.

The constriction Grosz now felt by the role of satirist and its basic superfluity can be gleaned from his letters of 1927. He had heaped ridicule on the bureaucrats of the republic, its arrogant officials and overfed philistines with their self-satisfied faces. And now he found the same characters among his own comrades in the KPD. They were unable to take criticism, he remarks bitterly, 'and those overstuffed blitherers are the worst. Oh these Marxist authorities, how touchy they are. . . . But one eternal truth remains sacred and inviolable throughout epochs of world history: Thou shalt not laugh at a functionary.'[40] He calls his comrades 'jargon-mongerers' (*Phrasöre*) and when he asks them to remember an old friend who has fallen on hard times, by visiting him in hospital, receives answers such as:

'I disapprove of sympathy, Comrade. Being a communist I'm an adherent of a scientific philosophy which has proved that philanthropy is counter-revolutionary—only the unified international proletariat can exercise solidarity with the suppressed enslaved colonial peoples—that's how they always talk at their congress and New Dawn parties.[41]

It is clear why his attacks on the Right gradually lost their acidity and precision.

By the time of the *Self-portrait as Admonisher* (1926; Plate 62), the last act had begun. If history had not shown that it was the Right that finally plunged Germany and Europe into the war, one might wonder just whom Grosz was warning people against. He leaves the question open. The painting is weak; all that remains of the artist's fighting spirit is a schoolmasterly gesture. Resignation has robbed his line of tension and his colour of force. He was never to regain them. His guiding idea, his mission, had proved mistaken; Communist ideology had turned into a trap out of which he was unable to escape. A short time later, he summed his experience up in a letter: 'I always used to think there were infernal tyrants up there on top who enslaved us poor mortals—well, shit, this mindless crowd doesn't want it any other way.'[42] Whom, therefore, was Grosz warning people against, possibly their own stupidity, brutality, themselves. If so, his message will always be important.

The conditions finally rendered his role of irate, protesting dandy obsolete. A dandy who shapes his self-image on an aristocratic model needs aristocrats to measure himself against. Dr Thomas and Count Ehrenfried needs a lieutenant of the Reichswehr as hated *alter ego*. In times dominated by petty bourgeois or proletarian mass parties, he will find an adequate counterpart as rarely as in a country where normality reigns. Being intolerant downwards was not noble enough for George Grosz. But what happened when there was no 'upwards' to exercise a dandy's insolence on? In the United States, where Grosz emigrated at the last moment, he was not able to find it. His role was dead though he himself lived on. He had been lured into the trap of his own longing for a world without contradictions, and its mechanism crushed him.

4. MAX BECKMANN: THE TRAGIC KING
Art as a Search for Meaning – Transcendental Objectivity

On New Year's Eve, 1908, the thermometer read three below zero. Max Beckmann, twenty-four years old, spent a few hours heating his old stove. At about four in the afternoon his flat was warm, and he decided to go for a walk with friends in Berlin-Hermsdorf. He noted in his diary: 'Beautiful snowy mood, with a lot of cigarette smoking and burnt almond eating'.[1] Afterwards he and Gustav Landauer 'sounded off . . . seriously about poetry and theatre . . . including profitable things about my art'. It was the same Gustav Landauer who eleven years later, in May 1919, following the liquidation of the Munich soviet, fell victim to the White Terror.[2]

Later that evening in 1908, Beckmann and his friends sat in his flat over beer and punch. Beckmann picked up a newspaper, the evening edition of the *Berliner Lokal-Anzeiger* No. 664, and read of the earthquake in Messina. Three days previously, 84,000 people, about two-thirds of the population of the town, had lost their lives in the disaster. One passage in the report particularly caught the artist's attention and fired his imagination:

> Suddenly new screams and brute roars—a gang of ragged, half-naked, maddened men had broken into the ruins of the customs building. You could read crime in their eyes, they were out to rob and kill. The few remaining customs guards were powerless against the mob. . . .[3]

That same evening Beckmann noted in his diary:

> and the description by the doctor and particularly the place where half-naked escaped convicts attack other people and their property in the terrible confusion gave me an idea for a new picture.[4]

While his wife Minna cared for little Peter, who had been born that year, Beckmann sketched his first version of *Scene from the Destruction of Messina* (Colour Plate 14). His last diary entry for New Year's Eve read:

> We agreed a while ago that the year 1908 had brought us much intrinsic good, and the baby boy. . . . If only every year could be like this, making us so much happier and me, in my painting, so much richer, then we will have reason to be satisfied with life. Happy New Year.[5]

In a diary entry Beckmann describes, in short, concise phrases separated by full stops, the events of a normal domestic life. He heats his stove, goes for a walk, has a discussion about art; his wife cares for their child. Into this well-regulated life and orderly syntax breaks the report of the Messina earthquake, and Beckmann's thoughts suddenly run wild. Punctuation is forgotten, image chases image, the artist's imagination has been set free. Yet his daily life apparently runs its orderly course as before. Life and art, reality and imagination seem to have little in common, unless the restriction of the one allows the burgeoning of the other. Painting and the life of the mind seem to bring a new quality into the confines of everyday life.

Just over a month later, Beckmann was already working on a huge canvas, 255 by 262 cm. and noted in his diary that he would like to paint it at one go. Yet difficulties cropped up, and the painting made only slow progress. He wanted the composition to evoke space, look natural, and have no violent juxtapositions, if he could manage it. Beckmann's aims were balance, a careful distribution of masses, and a continual development of the groupings from foreground to background. Nor were the colours to be exaggerated. In short the painting was to be

> As lifelike as possible, yet not overly so. The lividness of a threatening storm and yet all of pulsating, carnal life. A new, even richer variation of violet, red and pale yellow-gold. A rustling richness, like spreading out a lot of heavy silk, and savage, cruel, glorious life.[6]

In the right foreground lie men wounded in the violent mêlée. To the left, a man in a dark suit shoves a woman before him; the figure is intersected by the edge of the canvas. A barrel rolls through shimmering pools of water at the man's feet, and behind it a woman is being raped. In the middle distance one of the escaped convicts attacks a man in uniform; still further back, people run frightened and confused through the ruins of their city. Destruction has unleashed the dark, primal forces in all their cruel, superb beauty. The composition is based on a circular movement, from struggle and death to the right, to abduction and rape to the left. Figures symbolic of struggle and procreation share the middle distance and the centre of the composition, a symbolism emphasized by the rolling barrel, in which Nietzsche's wheel of life might be seen, already familiar from Dix's *Self-portrait as Mars* (Colour Plate 6) and other drawings.

Though he chose to paint this 'savage, cruel, glorious life', human vitality breaking the bonds of custom and morality, such outbreaks of violence in daily life troubled Beckmann

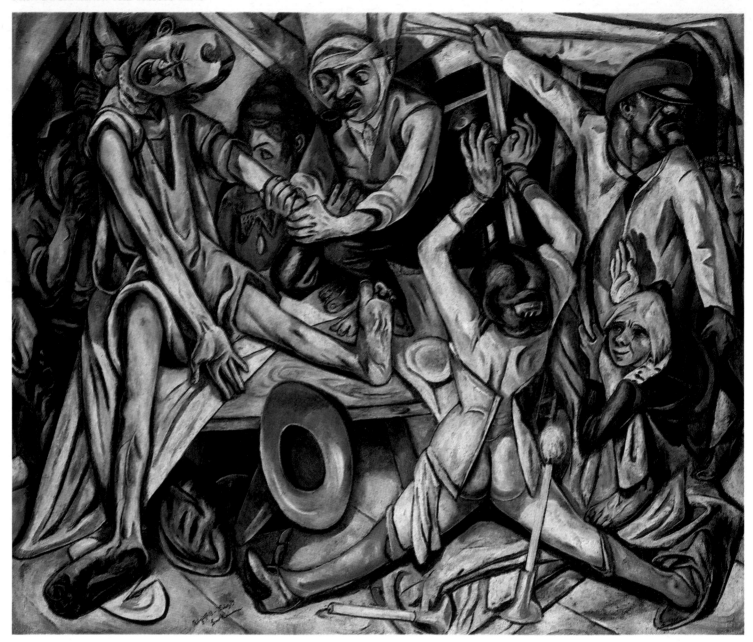

deeply. This may be seen from an entry he made in his diary two days later, on 30 January 1909. That morning he had worked on the 'rape group' in his painting, the scene in which one of the half-naked convicts has pushed a woman to the ground and is attempting to force himself between her legs. Later that day Beckmann went to the Secession, was repelled by the superficiality of the gathering, and on the way home that evening, witnessed an 'unpleasant scene'.

A police officer was trying to lead away a man who resisted being led and in the process shoved him brutally to the ground, since the man continued to struggle. I yelled at the policeman since everything in me boiled up at this mean and brutal assault on another human being and I managed to make him release the man who though still cursing and lamenting at least could go his way.[7]

The next morning he finished the rape scene, noting in his diary, 'I think it turned out well.'[8]

This example is doubly revealing. It shows, first, that Beckmann made use in his paintings of impressions and experiences from everyday life. Inspired by a newspaper report, he began

Col. Pl.16. Max Beckmann. *Night*, 1918–19. Oil on canvas, 133 × 154cm. Kunstsammlung Nordrhein Westfalen, Düsseldorf.

Col. Pl.17. Max Beckmann. *Self-Portrait as a Clown*, 1921. Oil on canvas, 100 × 59cm. Von der Heydt-Museum, Wuppertal.

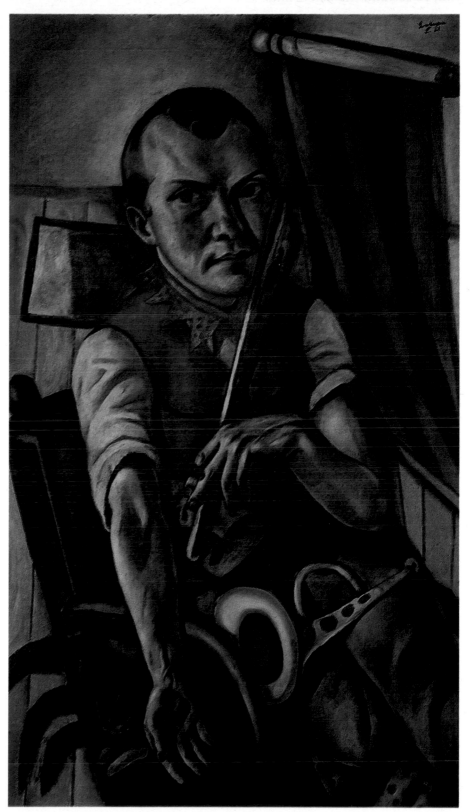

a composition into which the fight he witnessed between a policeman and a passer-by immediately entered. Yet, and this is the second thing the example reveals, Beckmann enthusiastically painted real events that frightened and disgusted him. His imagination, it seems, followed devious paths. Dangers from which he protected his home and family flowed across huge canvases, acted out by figures larger than life. Though domestic peace was of the greatest value to him, he broke with it completely in his art. Beckmann may have seen nothing but vile commercialism and egoistic competition in the society around him and longed for some vital transformation, yet at the first sign of actual violence he recoiled, hurt and angry.

With this contradiction in mind, we immediately prick up our ears at a conversation Beckmann had three weeks later with his brother-in-law, Martin Tube. They had talked at dinner about the world situation at large, and the artist noted in his diary:

> Martin thinks there will be a war. Russia France England against Germany. We agreed that it really would not be so bad for our present quite demoralized society if the instincts and drives were all to be focused again by a single interest.[9]

Six years later Martin Tube was dead, killed on the Eastern Front in the winter of 1914.

Without reflecting on the consequences of this kind of thought, the two men looked forward to an outbreak, an explosion of human instincts. Yet there was to be a purpose, an interest to focus them. Apparently they considered this outbreak inevitable, even desirable, since it would blast away what Freud called 'the accumulated deposits of culture' and perhaps even reinstate the vitality in human relations that commercialism had obscured. It was better, of course, that the outbreak follow some higher purpose than that half-naked savages should 'attack people and their property', as Beckmann had put it nine days before, writing in his diary on New Year's Eve, with his family gathered around him in the comfortable room. It is possible to conclude that he did not really long for the internecine conflict depicted in his *Battle* of 1907 or *Deluge* of 1908. Instinctually, he hoped for a change, for a transformation of ossified middle-class life; intellectually, however, he knew that it must take an orderly course. Beckmann, apparently believing in the principle of selection, saw life as a conflict out of which a better, more vital humanity would emerge, a new social order out of chaos. He would not have accepted the notion so readily had he not had some conception of this new order. We might expect to find features of it in his compositions.

A review of Beckmann's compositions of the time shows how basically traditional their forms were. They clearly defined the standpoint of artists and spectator; the artist always remained in control of the events that unfolded on the canvas. This he did by applying values and categories like those that governed his own life and conduct. He surveyed his pictorial world in terms of individual experience, seeing it as a spatially and temporally unified whole and giving meaning to this whole through selection and composition. Nevertheless, foreground and background in these paintings often seem to diverge, which would suggest that Beckmann sensed a difference between the people he portrayed and the structure of the objective world, and was not able to reconcile this difference pictorially. It would be over-hasty to see this as anticipating the break that occurred in his painting in about 1917, however. Beckmann himself, at any rate, seems to have expected conflict and war to produce just the opposite effect, an integration of human beings with nature, a vital confluence of mind and world which he felt was impossible in the bourgeois society of the day.

Beckmann, in his famous exchange with Franz Marc, threw light on his reasons for choosing certain forms of composition. Marc had said that personal experience of time and space was less important in painting than empathy, by which he hoped to plumb the essence of natural appearances. Beckmann replied that he considered a painting an 'individual, organic, universal whole'.[10] He insisted, in other words, on retaining his role as creator of a personal world, which was to be populated with figures imbued with the expressive power of myth. By seeking a mythic dimension in history, he hoped to disclose the profound forces at work within it. In his reply to Marc he criticized Gauguin, who although he had a similar goal had taken the wrong path. According to Beckmann, Gauguin had relied on old styles which had developed out of a common religion and a popular consciousness of myth. He was against Gauguin 'because he was incapable of creating, out of our own period with all its obscurities and disruptions, human types that might be to us moderns what gods and heroes were to men of the past'.[11] What Beckmann announced here was no more and no less than his intention to create a mythology for the twentieth century. These words reveal his almost Olympian self-confidence, which made him feel capable of recording history in the making regardless of the horrors and catastrophes it might hold in store.

Evidence for this assumption may be found in his war letters, where he frequently compared his experiences to motifs he had painted or wished to paint. Thus he reported from East Prussia, probably on or about 16 September 1914, 'Another fellow who also died last night I dissected. He resembled my model for the Lamentation, had an imposing, livid profile.'[12] And a few months later, writing from a field hospital in Flanders, 'I've seen some wonderful things. In the semi-darkness of the emplacement, half-dressed men streaming with blood to whom white bandages were just being applied. An embodiment of grandeur and pain. New ideas for the Scourging of Christ.'[13]

In the Son of Man Beckmann saw Nietzsche's Dionysian hero, who willingly took pain and suffering upon Himself to show mankind new paths to life. How greatly this belief and its translation into art helped Beckmann to deal with his terrible experiences, may be gathered from a well-known passage in one of his letters:

> and my will to live is stronger now than it ever was, regardless of the terrible things I've been through and the fact that I've died a few deaths myself by now. But the more often you die, the more intensely you live. I've been drawing, and that keeps a man from death and danger.[14]

His art helped him to digest the horrors he witnessed and to integrate them meaningfully into the philosophy whose basic tenets have already been outlined in the first chapter.

Yet where did Beckmann find this incredible self-confidence which initially allowed him to see war, conflict and disaster with such a dispassionate eye? If Ernst Güse is correct, Beckmann painted his early pictures in a Nietzschean spirit.[15] Some of the basic features of his philosophy have already been discussed in connection with Otto Dix. Beckmann read Nietzsche at the early age of thirteen, and striking parallels exist between his thinking and the philosopher's. Beckmann's *Scene from the Destruction of Messina* might illustrate the destruction of the 'great city' foretold in *Zarathustra*, a symbol of modern civilization making way for the 'great noon'.[16] In the *Sinking of the 'Titanic'* (Colour Plate 1), Beckmann shows the survivors in the foreground fighting for a place in the lifeboat while the great ship floats unharmed on the horizon. It is not the failure of technology, tremblingly recorded in many other, contemporary images which is the subject, but the struggle for survival. Güse interprets the *Titanic* and the iceberg next to it as symbols of petrifaction and animosity to life, and the calamity itself as the moment 'in which a situation adverse to life is overcome'.[17] Struggle is the element from which a new and vital humanity will emerge, the incipient gods and heroes of the modern age.

In painting his images of catastrophe, Beckmann seems to have remained outside and above the action, directing it and bringing order into its chaos. No evidence has yet turned up that he depicted himself in any of the figures in these paintings. Chaos and struggle, he believed, served to select the fittest, the best, the 'exceptional man', and Beckmann indeed appears to have identified only with those who had emerged superior out of history. His *Christ carrying the Cross* (1911; Plate 63) seems to be just such a figure of identification; the artist, interpreting the Imitation of Christ in his own way, understands himself as a hero whose sacrifice will set an example for others and lead to a renewal of the world.[18] The figure of Christ has also been seen in connection with Hercules, who corresponds to the Dionysian, tragic man Nietzsche celebrated in his late writ-

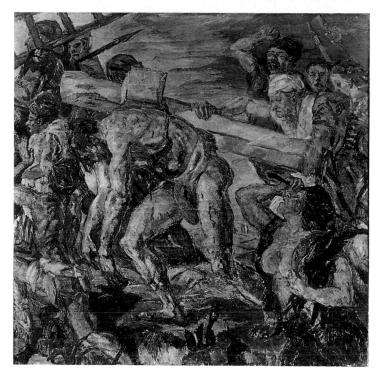

63. Max Beckmann. *Christ carrying the Cross*, 1911. Oil on canvas, 175 × 174.5 cm. Private collection.

ings.[19] For Beckmann, in other words, it was not a matter of interpreting and accepting Christian doctrine, a belief in life after death and divine mercy, but of taking the historical figure of Christ, His life, acts and sacrifices as his model. An isolated, suffering artist might well make a contribution of his own to a renewal by emulating Christ's Passion and sacrifice. Hence it is quite probable that Beckmann again depicted himself in the role of Christ in his *Self-portrait with Raised Hand* of 1908 (Plate 64), a role to which we shall return because it demonstrably continued into the 1920s.[20] This self-portrait, in which Beckmann vacillates between his usual attribute of a cigarette and the brush symbolic of his mission, probably goes back to the tradition of the Imitation of Christ established by Dürer with his celebrated self-portrait of 1500 (Plate 65).

Beckmann painted another canvas before the war, which strikingly illustrates the change that was to occur in the artist's view of himself and the world when it is compared with a later version of the same subject. This is *Resurrection*, a huge (395 by 250 cm.) canvas of 1909 (Plate 66). Beckmann combines two contrasting motifs in this painting: people gathered in a drawing-room witnessing the resurrection of the dead. The artist himself stands to the far left, facing the spectator, surrounded by his family and friends who look on, some astonished, some sceptically, at the grandiose spectacle of two columns of men and women rising ecstatically towards the

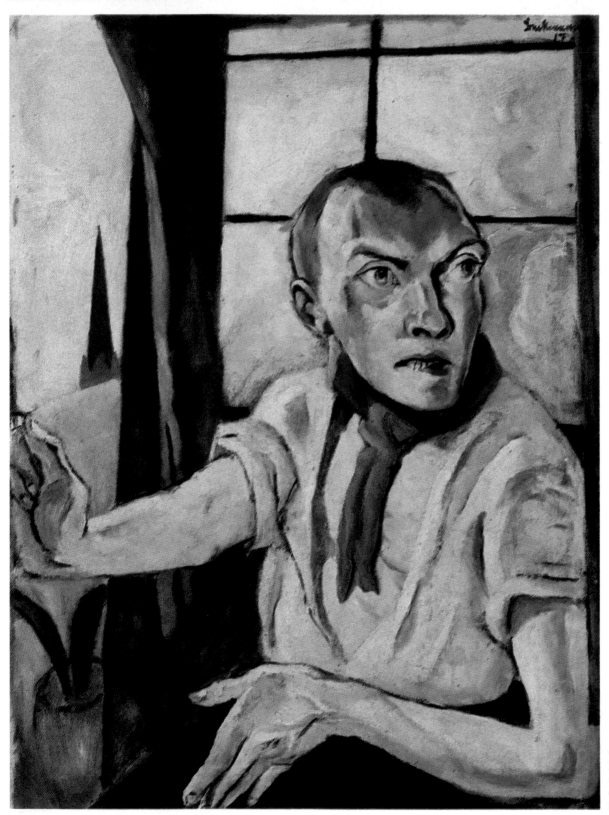

Col. Pl. 18. Max Beckmann. *Self-portrait with Red Scarf*, 1917. Oil on canvas, 80 × 60 cm. Staatsgalerie Stuttgart.

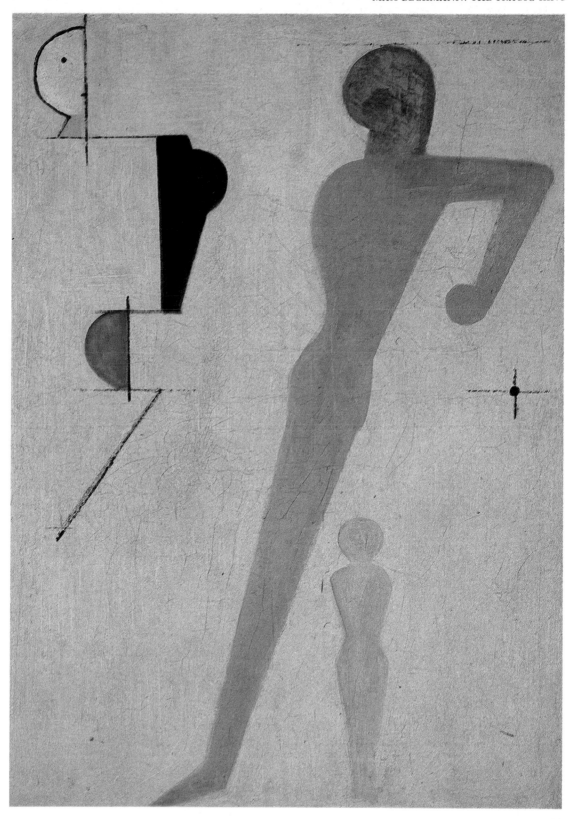

Col. Pl. 19. Oskar Schlemmer.
Composition on Pink, 1916. Oil
on canvas, 130 × 92 cm.
Westfälisches Landesmuseum
Münster, lent by the Schlemmer
family.

64. Max Beckmann. *Self-portrait with Raised Hand*, 1908. Oil on canvas, 55.5 × 45.5 cm. Private collection.

Much speculation has been aroused by the figure of Frau Tube, his mother-in-law, who stands just to the right and behind him in the painting. Frau Tube, the widow of a theologian, was probably one of the painter's most important confidantes. A commentator has said that her unshakeable faith allowed her to accept the scene as a matter of course, that she stood there as if waiting for her name to be called.[23] But what is not clear is who is there to call it. And it seems strange that this deeply pious Protestant woman of an older generation who can expect her faith to be rewarded on Judgement Day should calmly contemplate the rising bodies of those who, traditionally, as sinners, should be descending into hell. Beckmann, at any rate, appears to be profoundly convinced of the validity of his new version of the orthodox theme, judging by the hand he has raised to his heart in a gesture of confession.

Güse's theory is therefore appealing:

65. Albrecht Dürer. *Self-portrait*, 1500. Oil on limewood, 67 × 49 cm. Bayerische Staatsgemäldesammlungen, Alte Pinakothek, Munich.

light. This is a resurrection without judgement, without a St Michael weighing virtues or Christ enthroned on high, without the hallelujah of angels and the hiss of demons. All these sinners have been saved, they all strive together towards the brilliant vortex which replaces both Christ and paradise. Güse supposes this light to represent Zarathustra, who compared himself to the sun and lighted the paths of those who were destined to become superhuman.[21] Whether Beckmann's conception derives from Nietzsche or from modern Protestant theology, which at that time was also divesting Christian doctrine of mystical elements, is not really at issue here.[22] Beckmann simply equates redemption with a resurrection of the flesh, which merges with light, the most diaphanous and highest form of matter. But the raised dead are more beautiful, freer, more vital and alive than the figures below, earthbound by their conventional poses and formal clothes. With this image Beckmann provides an alternative to his contemporaries' mundane existence.

80

66. Max Beckmann. *Resurrection*, 1909.
Oil on canvas, 395 × 250 cm. Staatsgalerie
Stuttgart.

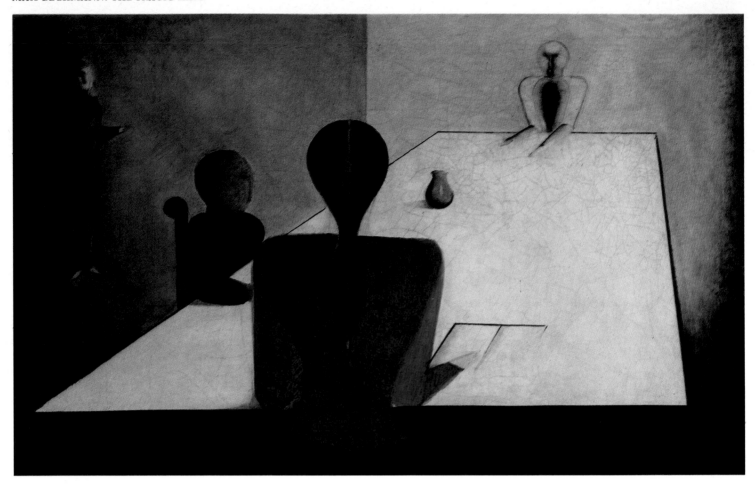

Beckmann's orientation to Nietzsche must have been received with scepticism if not opposition in the Tube family. In attempting to characterize Beckmann's portrayal of his mother-in-law against this background, we find that she follows his vision of resurrection with interest but also with a certain detachment. Beckmann depicts himself . . . as an initiate who is not surprised by these incredible events. He assumes for the first time the role of 'director and stagehand', acquainting his friends and relations with his imaginative world. The picture appears to provide a sequel to discussions he had had with his family.[24]

If this is correct, the painting must have been an affront, particularly towards the profound Protestant faith of Beckmann's family, against which he set his own personal view of the world. Perhaps this also explains why he altered the sketch, which showed the risen dead in a single group, in favour of a demonstrable division, whose purpose, of course, was precisely to deny traditional notions of Christian justice and judgement.

If this interpretation is sound, it also explains a further dilemma which becomes apparent when we compare his letters from the front to drawings made at the same time. Beckmann volunteered in autumn 1914, for ambulance service on the Eastern Front. As noted above, what he saw there initially reminded him of his own paintings—*The Destruction of Messina*, for instance: 'Yesterday—N. was incredible. As if after a tremendous earthquake, the church tower cut in half, the buildings on the marketplace sliced off cleanly down the middle. . . .'[25] The tantalizing power of war comes out in such passages as this:

> The incredibly grand noise of battle out there. . . . It's like the gates of eternity bursting open when a great salvo like this sounds across the fields. Everything evokes space, distance, infinity. I wish I could paint that sound. Oh, this expanse and uncannily beautiful depth! Masses of men, 'soldiers', continually streamed towards the centre of this melody, towards the decision over their lives.[26]

The elemental forces released in war would decide men's lives,

Col. Pl. 20. Oskar Schlemmer. *Supper Party*, 1923. Oil on canvas, 64 × 101 cm. Private collection, Darmstadt.

Col. Pl. 21. Oskar Schlemmer. *Five Figures – Roman Things*, 1925. Oil on canvas, 97 × 62 cm. Öffentliche Kunstsammlung, Kunstmuseum Basel.

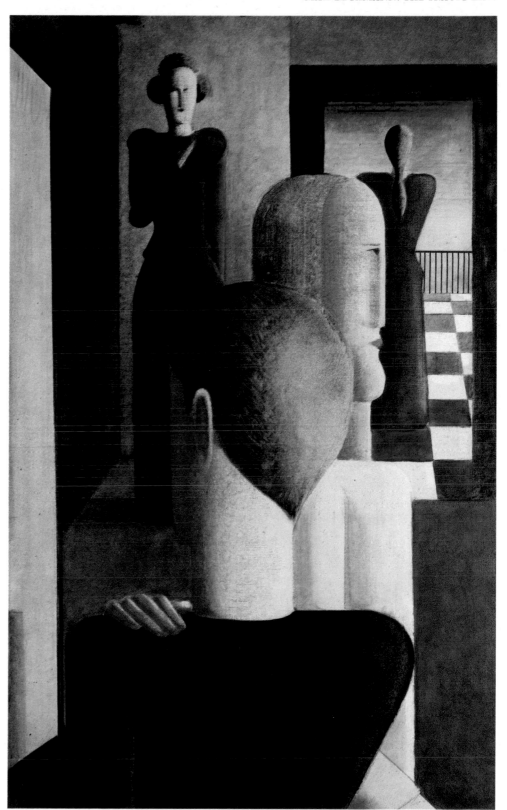

lend them significance, fulfilment. Beckmann describes the space of the battlefield in perspective terms—expanse and depth—thus endowing it with meaning, which in turn emanates from a meaningful centre point: death. Death, as judgement in this world, determines whether men's lives will have been lived meaningfully or not, and for Beckmann in a certain sense it replaces metaphysics. At this point, the artist still accepted conflict and war as powers that lend significance to life because he considered the readiness of men to face up to them a decision to accept what life brings. A few months later, he would realize the error in this view.

In about April 1915, describing in a letter the bombardment of British positions by his own artillery, Beckmann wrote that the attack was meant as 'some sort of retribution, because the enemy captured something from us, a hill. But actually it's meant to draw the final line under the lives of a few hundred men which are short enough as it is.' He could not have said more clearly that the deaths were useless. A meaningful fate had been replaced by the mechanism of war, and Beckmann's conception of space changed accordingly. In the same letter he describes the horizon illuminated by exploding shells, and 'above it the cold stars and empty, indifferent, insane space and the moon gnawed by shadows. And everywhere the howl of guns.'[27] 'Uncannily beautiful depth' has been reduced to 'empty, insane space', indifferent to human destiny. Battle destruction and death could no longer be considered forces of the great cycle that gave men's lives meaning, for indeed this cycle itself had been mechanized, emptied of significance. Beckmann's style and composition were to be influenced by this perception.

Throughout 1915, however, these apocalyptic impressions continued to be a source of fascination, manifesting themselves more in his letters than in the drawings. He was still apparently unable to admit to his wife or family how deeply his beliefs had been shaken. Had he not quite demonstrably represented his 'modern' apotheosis of struggle and war in those huge paintings of the pre-war period? As late as April 1915 he could still write home that 'For me the war is a miracle, if a rather unpleasant one. My art finds plenty to feed on here.'[28] Yet a glance at his drawings of the time is enough to show that this 'miracle' must have had a bitter aftertaste.

One of the most moving documents of his inner change is probably the drawing *Théâtre du Monde—Grand Spectacle de la Vie*, dated 21 December 1914 (Plate 67). Just two years previously he would have reserved this title for a truly gigantic spectacle like the *Sinking of the 'Titanic'*, or the 'savage, cruel, glorious life' he celebrated in his painting of Messina. Now, almost exactly six years after his diary entry, his brother-in-law already dead, the grand spectacle of life is a human ruin, a *Man with Crutch in a Wheelchair*, as the drawing has since been entitled. With trembling hand Beckmann has drawn a man

84

67. Max Beckmann. *Théâtre du Monde – Grand Spectacle de la Vie. Man with Crutch in a Wheelchair*, 1914. Pen and ink, 15.7 × 12.8cm. Staatsgalerie Stuttgart, Graphische Sammlung.

with a disfigured face, frightened eyes, hands and feet like the claws of an animal, wild hair and a body wracked and exhausted —a strong contrast to the Baroque vitality of his pre-war figures. The drawing reminds us that Beckmann often worked to the point of physical exhaustion in the field hospital, and also that he was under extreme mental pressure. As Stephan von Wiese wrote, 'Beckmann's fluent calligraphy has split into separate, strangely awkward ciphers—strokes that obviously reveal a state of extreme mental shock. The same disorganization has communicated itself to the style of the drawing.'[29]

Though in his drawings he now began to depict suffering, pain and death with ever greater intensity, Beckmann's letters remained slightly hesitant, as when he wrote, 'It is really interesting to see that much-maligned peacetime life advancing with inexorable logic to a paradisal state.'[30]

His increasing disenchantment with the war made his approach very different from Dix's. This is clear when we compare Dix's etching *Feeding-time in the Trench* (Plate 33), with a very

similar scene described by Beckmann in a letter: 'Anecdotal as it may sound—one man, sitting on a grave next to his dugout, was frying himself some potatoes. It really turned the existence of life into a paradoxical joke.' Up to this point, Dix would have agreed. He had illustrated just this farcical paradox of the survival instinct, which in the very act of asserting itself re-entered the absurd, cruel cycle. At any rate, a scene of this kind did not raise a metaphysical question for Dix, at least not directly. It did for Beckmann, however, who went on to reflect,

> But on the other hand you can't be sure that it isn't always [a paradox], when you consider the ring of fire burning all around us right now. But actually you don't even have to do that. When my mother died the world looked no different to me either. The mystery of the corpse wherever you turn.[31]

Here the question of fleshly existence leads directly to that of transcendence. This is in turn followed by the psychological trauma of bereavement. What remains is dead matter, a corpse. When Beckmann speaks of a 'mystery', we may conclude that he suspects that the outer shell of death conceals something else. He was to spend many years attempting to find out what this something else was. Yet since he was no longer able to look upon death as a temporal judgement and the corpse its meaningful testimony, his previous beliefs could no longer furnish him with the answer. The corpse, therefore, became a mystery to him.

The events of war, however, forced him to provide answers. On 4 May 1915 his life was in immediate danger for the first time, when a German artillery position he was stationed near came under fire. He wrote to his wife, 'I frankly admit that I've been through some considerable concern for my precious life.'[32] Six days later he did the *Self-portrait, drawing* (Plate 68), which he inscribed with place and date: 'Varwik, 10.5.15'. The tortured irony of the letter is made conspicuous by its absence here. The painter is more frank and honest with himself than with his family. He peers intently into a mirror, his drawing hand poised over the paper, the other seeming to indicate the place where he has left off in contemplation. The portrait shows

> not only a draughtsman creating form; it also includes attributes that define the situation more precisely. Above all, it shows the draughtsman *at war*, unmistakably indicated by the pouch (for his paybook) and dogtag around his neck, both of which were compulsory for identification purposes in case of death. These suggest that Beckmann made the drawing in the awareness that his life was in imminent danger. . . .[33]

The next night, Beckmann wrote home, 'The war's not a bad thing as far as I'm concerned. What I've done up to now was all training, and I'm still learning and expanding my mind.'[34]

68. Max Beckmann. *Self-portrait, drawing*, 1915. Pen and black ink, 31.4 × 24.1 cm. Staatsgalerie Stuttgart, Graphische Sammlung.

Reading this, one wonders what the man in the self-portrait really thought, what questions he asked of himself. Ernst Jünger, a combat soldier, wrote later of a similar experience:

> In times we are accustomed to call extraordinary, the fortuity of threat appears in a much clearer light. In war, with projectiles flying past you at high speed, you certainly feel that no degree of intelligence, virtue or valour is strong enough to deflect them even by a hair. As the threat increases, doubt in the efficacy of your values mounts. Where the mind sees everything called in question, it tends to a catastrophic view of things.[35]

Two weeks later, Beckmann recounted how a group of soldiers, giving a send-off to a captain from the field hospital, broke out into the national anthem. The discrepancy between the noble song and the actual condition of these tormented men appeared to him in a flash:

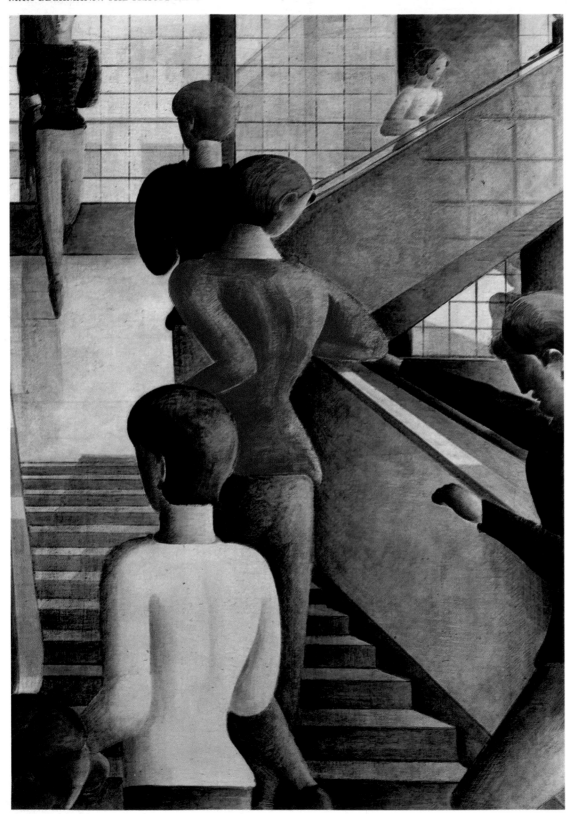

Col. Pl. 22. Oskar Schlemmer.
Stairs at the Bauhaus, 1932.
Oil on canvas, 116 × 113 cm.
Museum of Modern Art,
New York.

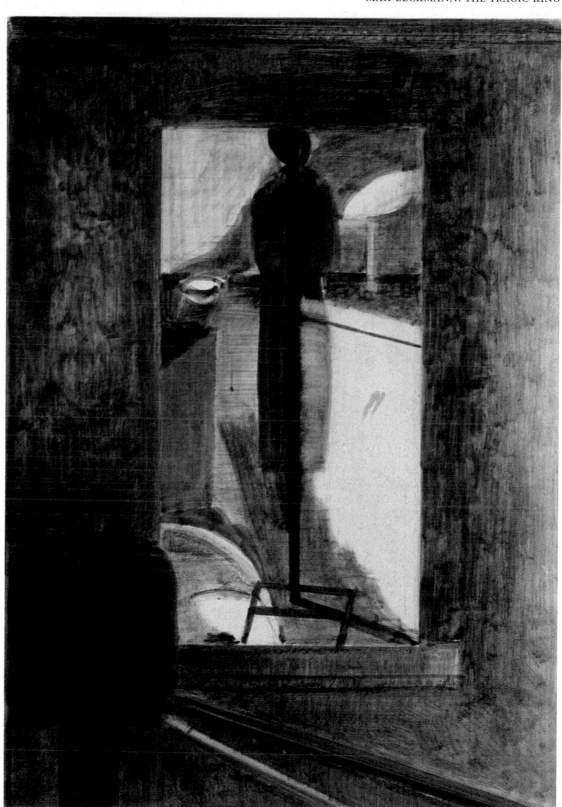

Col. Pl. 23. Oskar Schlemmer.
*Window-Painting, Women
standing in a Room*, 1942.
Oil and pencil on cardboard,
32.6 × 22.8 cm. Öffentliche
Kunstsammlung, Kunstmuseum
Basel, lent by Mrs Tut
Schlemmer.

Oh, this infinite space, whose foreground you continually have to fill up with junk so you don't see its awful depth too clearly. What would we poor mortals do if we didn't continually equip ourselves with ideas about God and country, love and art, in an attempt to hide that sinister black hole. This endless desolation in eternity. This loneliness.[36]

No better answer can be given to the question of what was going through the artist's mind while he did his self-portrait. He was at the end of his tether, but not yet ready to admit it. He no longer saw light on the horizon, unless the ring of fire he described can be thus thought of. His view of things was indeed catastrophic. Existence had lost its focus; no longer able to see a meaning in life, the space around him expanded to a formless vacuum. Anyone caught in the machinery of war, which mocks all human values, will find the problem of existence insoluble. Beckmann provided an example of the futility of seeking after a rationale in the description of the artillery bombardment of British emplacements, in the letter quoted above. Revenge seemed to him no human reason at all for this killing; the question was decided by other, ineffable powers. In the summer of 1915, he suffered a nervous and physical breakdown and was sent to Strasbourg to recuperate. In 1917 he was finally discharged from the army without having been back to the front lines. What actually happened during those last months is unknown. No documents exist, and the artist never talked about his experience.

As Beckmann's letters suggest, the question of transcendence, of an existence beyond this life, was central to the artist. He wanted to know what lay beyond the horizon and could find no answer. In the *Resurrection* of 1909, he could still give one; yet now he felt forced to say that, in his eyes, the universe was nothing but an empty black hole. After devoting the next two years of his life to this task, Beckmann left the second version of *Resurrection* unfinished (Colour Plate 15). With the abandoned painting before him, he began to work on others.

Unlike the first *Resurrection* of 1909, the second version is a horizontal format, making every development upwards or heavenwards, impossible. The horizon is high, and the figures are not allowed to rise above it. Instead of striving vigorously upwards as before, they wander, tormented and aimless, through a devastated plain. There is no resurrection of the flesh to a new, living glory here, no transformation of matter into light. A dark, apocalyptic planet hovers in the sky over the inferno of a war-torn earth to which the risen dead stumble back unredeemed. The plain is illuminated by merciless light from some uncertain source which casts shadows in all directions. Nothing but chaos and despair meets the eye. The vigorous figures of the pre-war period have given way to shades from some medieval Inferno or Dance of Death. Their tense sinews,

elongated limbs, and painfully twisted postures show that instead of being involved in the sublime struggle for existence—Beckmann's pre-war theme—they are entangled in inner conflicts and contradictions. The human body has become a tormenting burden in a world devoid of metaphysical orientation.

In the centre of the image, figures creep like larvae from their graves, still wrapped in bandages and shrouds. The body of an old woman floats like a portent over this world without hope, as if a prisoner not of death but of her own mortal shell. For if the shrouded figure to the upper left indeed represents death, it is death robbed of its transmuting power—the figure slinks away, out of the picture.[37] The 'mystery of the corpse' is solved: total nothingness. Next to the old woman's corpse a man has raised himself to his feet; his body twisted grotesquely, he rubs his eyes or holds his hands over them—for what is there to see? To his left, nothing but gestures of resistance and horror—a man covering his eyes in shock, a woman lying on the ground, apparently bewailing her fate and that of her infant—for what reason has she brought life into this world? To the right, a bandaged male figure takes ungainly strides into a group of crouching and reclining people, his head thrown back and his eyes gazing into the vacuum above. Next to him is another woman in grief, her head pressed to her shoulder and her gaze directed into nothingness. On the right-hand side of the image, the artist appears to draw the conclusion from the horror and despair of the left: that a complete lack of orientation will lead to madness.

And, from a fissure in the earth in the right foreground, the artist himself looks out on the scene. Around him are gathered his family and the friends in Frankfurt who had given him shelter. His face half concealed by his wife's, he casts a sidelong glance at the grisly spectacle. Neither he nor his friends appear to be involved in it yet; they still wear their worldly clothes; what they witness presages their own future, their life after death. The dark cave in which they stand offers no path of escape or return; some day they too will make their appearance on this scene like the bandaged corpses. Among the figures in this group Beckmann has set the inscription *Zur Sache* (Get to the point), which might be interpreted to mean that people must realize the illusoriness of a future existence and that the meaning of life can be found only here and now.

Opposite this group, on the far left, is a picture within the picture. It shows friends of the family and perhaps Frau Tube, Beckmann's mother-in-law, praying. As in his vision of 1909, the artist has included his friends and family in the scene, but here their participation is indirect, passive. Gathered to the left, the older generation, seems farther removed from this new and apocalyptic vision than the artist and his close relations and friends, who are more familiar with Beckmann's philosophy

than those who still adhere to archaic ideas. Frau Tube's despairing prayer in the face of a world without God seems to predict unconsciously the lamentation of the resurrected woman to the upper right. No prayer can change things now. Beckmann's son Peter, who is depicted standing in front of his mother, peering out of the fissure, later wrote of the unfinished painting that 'It perhaps represents the downfall of all the pictures he painted before, those works that sufficed up to the First World War but which now had been robbed of their truth, their heaven, and their colour.'[38] The fact that the canvas was left unfinished may confirm the supposition that neither the artist's approach to form, his subject-matter, nor the reaction of the older generation to his vision, were in any way adequate to the changed situation.

It also seems indicative that the artist has not depicted himself here with anything like the self-assurance he had in 1909. It is as though he were ashamed or afraid of the vision he reveals; the pride and nonchalance of a few years before are gone. His optimism, his belief in life, the cornerstone of his pre-war philosophy, has crumbled to reveal absolute hopelessness and despair. War showed Beckmann that life could not be an absolute value, in and of itself—it was too cruel, brutal and terrible for that. Faced with the horrifying consequences of this vitalistic belief, he must have felt fear and shame without being able to avoid the bitter truth. The experience of war did not make him religious; it forced him to drink the bitter cup to the dregs.

He was apparently also quite willing to draw personal conclusions from this experience. After his release from the army in 1917 he went to Frankfurt and not back to Berlin. His wife and son had left Berlin—Frau Beckmann had accepted a singing engagement at the Elberfeld opera—but this circumstance in itself is not sufficient to explain his separation from them. He chose not to join his family, and moved to Frankfurt, perhaps in an attempt to gain distance not only from the pre-war world but from all his personal ties to it. The separation of Jesus from His family offers itself as a comparison, and, as remains to be shown, not only in a metaphorical sense. Christ went alone into the wilderness (a motif Beckmann etched in 1911) to prepare Himself for His sacrifice. Christ died on the Cross, and Beckmann, in the painting *Night*, was to depict himself crucified, to symbolize the death of his earlier self. However, this is to anticipate.

In the *Confessions*, written in August 1918, shortly before the end of the war, Beckmann comes across as a man with the self-confidence of the founder of a religion, a missionary ready to devote his life to the cause:

We must participate to the full in the adversities to come. We must abandon our hearts and nerves to the horrifying cry of pain of poor, misled humanity. Now is the time to draw as close as we can to them. This is the only way to at least partially motivate our really quite superfluous existence. By showing people an image of their destiny, something you can only do if you love them.[39]

Beckmann had sacrificed his 'self' and was now ready to accept life in all its absurdity, both recoiling from it and finding a way to overcome it. It was this willingness to suffer with others that allowed him to create images symbolic of human fate; to find a new and personally genuine approach to the fundamental questions of existence for which philosophy and theology could no longer provide answers. God and metaphysics were dead, as his *Resurrection* showed. Beckmann embarked on a search for knowledge that would some day enable him 'to make buildings with my paintings. To build a tower from which human beings can scream all their anger and despair, all their poor hopes, joys, and fierce longings. A new church.'[40] In the 1919 lithograph sequence *Hell*, two images, in print 3, *Martyrdom* (Plate 69) and print 6, *Night*, are examples of such depictions of human destiny. In the first, Beckmann shows the martyrdom of Rosa Luxemburg, and behind the scene rises the tower of a church. Christian Lenz has convincingly argued that although Beckmann did not sympathize with the political aims of the Spartacus group, he saw the murder of its leaders as indicative and symbolic.[41] The death of Rosa Luxemburg on a stage as in a Passion play demonstrates the distance he felt from the event. By contrast, the fateful happenings in *Night*, in which he was directly involved, strike us with the full force of reality.

Theology could no longer give an answer to Beckmann's questions. Yet one of the most influential Protestant theologians of the post-war period, with whose ideas the artist was probably unfamiliar, held a very similar position, both derived, presumably from certain shared assumptions. Karl Barth's essay 'Der Christ in der Gesellschaft' (Christians in Society), written in 1919, contains surprising parallels to Beckmann's *Confessions*. Barth begins by criticizing people who withdraw from society for the sake of their own peace of mind: 'One cannot turn away from life, from society,' he writes. 'Life surrounds us on all sides; it poses questions to us; it faces us with decisions. We have to stand up to it.'[42] Beckmann writes of being as close as possible to people, which to him means remaining in the city, and that 'Absenting oneself completely in order to get one's share of that famous personal purity and communion with God seems to me bloodless and also wanting in human charity. We should first do what there is to be done, and our work is painting.'[43] While Beckmann speaks of the necessity to serve one's fellow men, Barth writes that souls must stand 'the trial that is of this world, take the burden upon themselves. An awakening of the soul can be nothing else but "bearing, out of

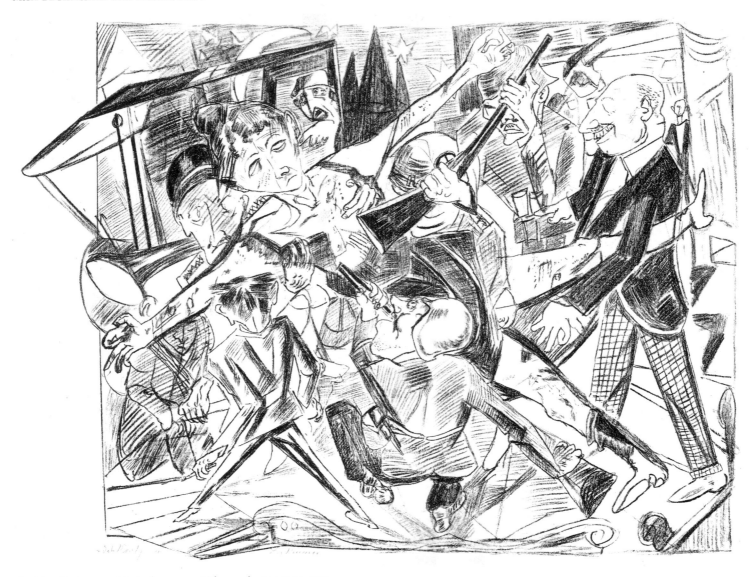

69. Max Beckmann. *Martyrdom*, 1919. Lithograph, 54.7 × 75.2 cm.

pity, the afflictions of all one's contemporaries''.'[44] But this awakening, says Barth, cannot happen unless people put their precious values to the test of reason.

> We can . . . no longer avoid first submitting all temporal values to a fundamental denial, testing them for their connection with what may be universally valid. Every living being must be willing to let itself be measured against life itself.[45]

Men must regain that 'great objectivity with which Paul meets the prophets, and Plato',[46] writes Barth, adding a warning against confusing religious and sexual emotions. Beckmann, in his turn, hopes that

> Out of thoughtless imitation of appearances, and feeble, archaistic degeneration into empty decoration, and out of a false and sentimentally morbid mysticism, we will hopefully arrive at a transcendental objectivity that might emerge from a deeper love of nature and mankind,[47]

as examples of which he cites elsewhere the four 'great painters of a masculine mysticism: Mäleßkirchner, Grünewald, Brueghel and van Gogh'.[48] Thus Beckmann, too, demanded that his gospel, the 'images of destiny' he wished to paint, be tested against life, and his ideals were 'masculine' mystics. With transcendental objectivity, he envisaged a style of painting based solely on appearances, on nature, which could nevertheless pull aside the veil to reveal what lay beneath.

Yet since Beckmann could no longer rely on the Redeemer,

a belief in whom he had lost even before the war, he had to search for the meaning of life in life itself—and in his own existence. Painting was the medium used in his search, and the perceptions it provided were arduously gained: 'Pious! God . . . I'll be both when I've finished my work and can die at last. A painted or drawn hand, a grinning or a weeping face—these are my confessions of faith; if I've sensed anything about life, it's right there.'[49]

If the theologian Barth saw 'Christ within ourselves' as a symbol of promise in the dark night of cataclysm and revolution[50] and the Cross as a sign of redemption through which a new immediacy of faith and life could be achieved, Beckmann, though he indeed assumed the role of 'Christ within himself' and took up his cross, did so without hope of being delivered from this world. He not only had to stand up to its trials and conflicts but also to find the purpose of this struggle within himself. In other words, he had to bear the cross in this world and for this world, since there was no other life beyond it. Yet since the sole source of his purpose, life itself, simultaneously prevented him from achieving comprehension of it, the pressure on him became enormous. His own vitality, in which he had to search for the meaning of existence, stood in his way. 'The stronger and more intense my desire becomes to express the unutterable things in life,' he wrote,

the deeper and more painful my distress grows with regard to human existence, the tighter I close my lips, the colder my resolution becomes to grab this horrible, twitching monster of vitality and cage it, throw it down, strangle it with sharp, crystal-clear lines and planes.[51]

And when Barth concludes,

Understanding means taking the entire situation upon oneself in the fear of God and to step into the motion of time in the fear of God. . . . The negation that flows from God and means God is positive, while every position not built on God is negative. For to understand the meaning of our epoch in God, to enter into anxiety through God and into critical opposition to life, at the same time means giving our epoch its meaning in God,[52]

then one can substitute Beckmann for God in this passage. He himself often did just this in his writings, as here:

A new law is lacking—a New Faith that we ourselves are God and bear the responsibility over life and death; . . . Every minute is wasted which does not understand that mankind itself can be God, can have the responsibility and the decision over life and death.[53]

The decision over life and death could no longer be left up to external agency, to fate however defined. It had become incumbent on Beckmann, the artist in the role of God, to create a new and meaningful world for himself and others —in the course of which he was not to be spared the fate of the Son of God, the Word incarnate. This, perhaps, is why he was able to say, 'My religion is pride before God, defiance of God. Defiance because He created us such that we cannot love ourselves,' and 'In my paintings I blame God for everything He did wrong.'[54] It was not only wrong that God allowed so much cruelty and injustice in the world; even worse was that Max Beckmann, the artist, was made to bear the terrible burden of finding enough meaning in it to prevent his despairing completely. The universe had come to seem a sinister cave before the entrance of which men piled junk of all descriptions to keep themselves from despairing of life. Beckmann now set himself the task of transforming this flotsam into building blocks for a new church. He intended to 'express the unutterable things in life', but before he could do that, he had to experience them. His going into the wilderness and separation from his family prepared him for the Passion which he had to suffer—as painter, not redeemer. For he continued to believe in his mission 'to paint an individual, organic, universal whole', even though he had realized that it was no longer organic and meaningful but cruel and brutal.

If this interpretation is correct, it allows a new reading of the major painting of this period, Night (Colour Plate 16). It would make this painting, on which Beckmann worked from August 1918 to March 1919, the climax of a self-imposed Calvary, a sequel to the statement of the artist's duty and destiny which Beckmann made in the Christ carrying the Cross of 1911 (Plate 63). Yet now he related this image of suffering to himself alone. Night became his personal, artistic and philosophic Golgatha from which, as from Christ's sacrifice and death, the path to a new life would emerge. For the sake of mankind, the artist felt he had to take up his cross and walk his road.

One consequence of Beckmann's denial of the vitality he had exalted in before the war was a new type of figure, which has already been mentioned in connection with his second Resurrection. Another result was a new structuring of space. In Night, the figures are cramped into a tiny room whose angles and walls interlock in a complex maze. The laws of aerial and linear perspective, cause and effect, no longer apply, and the figures no longer 'develop out of their own centre of force and, secure within themselves, enter a larger context of action in space'.[55] Although the woman in the foreground, for example, is tied by the hands to a window that opens from the back wall of the room, her body does not lie across the intervening table. Parts of the rear wall project into the front plane of the image and vice versa. Everything nevertheless remains solidly anchored in the picture plane. It is a disquieting experience to attempt to unravel the complex tangle of this com-

position. The figures, with whom we necessarily identify since they embody our experience of space, sit, stand and lie in painfully distorted positions within this structure, as if they were physically tied to completely disparate and mutually contradictory elements of reality. This new type of composition itself expresses much about Beckmann's new understanding of human existence. How different it is from his conception of 1909, where he confidently accepted a world filled with conflict and violence yet wished to avoid 'doing violence' to his composition. Now, violence has come in from the street, broken into a room to destroy a family. This family is none other than the one gathered around the painter as he read of the events in Messina—his own.

Night is generally described as portraying an attic room into which three marauders have forced their way. They have bound the woman, partially undressed her, and apparently raped her. One of them strangles her husband while another twists his arm from its socket. The third man is about to kidnap the child. In the background an elderly woman stares past the strangler.

Many attempts have been made to relate this motif to earlier paintings and to explain it in terms of them—Nightmare of 1900, for instance, which shows three giants standing around the bed of a boy awakening in fright.[56] Beckmann treated a similar theme in the 1914 etching Night, yet in a much more brutal manner: a man has been killed, apparently after being lured into the murderer's trap by a prostitute. Stephan von Wiese also emphasizes this motif of woman's betrayal, citing by comparison a Hogarth engraving in Beckmann's possession.[57] The theme of physical violence in an underworld milieu was certainly the aspect of such subjects which most interested Beckmann before the war. Later, as can be seen from his preliminary drawings to Night, the motif of the victim began to take on greater significance.[58] Both sexes, tortured man and violated woman, regardless of the inner tension that may exist between them, have in this painting become victims. There is really no indication of planned, selfish treachery here, for even the woman in the background, whom many observers have seen as the intruders' accomplice, receives neither pay nor praise from them. Her frightened eyes are averted from the scene.

But back to the theme of the victim. The tortured man is very probably a veiled self-portrait. Certain features, particularly the lock of hair falling across his forehead and his outstretched right arm, recall Beckmann's Self-portrait as a Clown of 1921 (Colour Plate 17). There are also striking parallels to the Self-portrait with Red Scarf, 1917 (Colour Plate 18), whose scarf definitely resembles the red cloth twisted into a noose in Night. But the most obvious similarity between this painting and the 1921 self-portrait is the victim's right arm, which is in exactly

the same position as the artist's. The open palm in the self-portrait even shows traces of a wound. The reference to Christ's arm, dangling lifeless after He was taken from the Cross, is unmistakable. Beckmann would have seen this motif in any number of Depositions or Lamentations. His familiarity with it is shown not only by the Lamentation he painted in 1908, in which a Herculean Christ lies across Mary's lap, but also by the passage cited above from a letter of September 1914, where he noted the similarity of a dead soldier to the model he used in 1908 for the martyred Christ. In his etching The Morgue of 1915 (Plate 70) we find two correspondences to the Christian iconography of this theme. The corpse in the centre recalls the dead Christ in the painting by Andrea Mantegna; and the group of three figures at the right is a modern version of a group traditionally present in Depositions, with orderlies replacing Mary and John. In April 1915, Beckmann had visited the Musée Royal des Beaux-Arts in occupied Brussels, and in a letter to his wife reported that he had seen 'wonderful Rogger van der Wydens [sic] . . . whom I like best of all the Belgian primitives'.[59] One of the finest works by van der Weyden (or his school) in the museum is a Lamentation (Plate 71), which may well have provided the model for Beckmann's Morgue. Still more obvious are parallels with an etching of 1918, the Deposition from the Cross (Plate 72), in which the dead Christ has an almost identical pose. It has been said that the decisive influence on Night, also done in 1918, was the artist's confrontation with a primitive German Pietà (Plate 73) which he saw at the Liebighaus in Frankfurt and which moved him to say that he wanted 'to create . . . a work just as strong out of the spirit of our times'.[60]

Yet echoes of Christ crucified are not limited to the pose and treatment of the male figure in Night. His garment, too, be it a nightgown or a conventional shirt, diverges in too many details from these everyday articles of clothing not to suggest the garment worn by Christ. In the 1917 painting Christ and the Woman taken in Adultery (Plate 74), Jesus not only evinces Beckmann's features but wears a smock similar to that of the artist in his Self-portrait with Red Scarf of the same year. As these comparisons show, Christ and Beckmann, in attitude, gesture, dress and fate, are frequently interchangeable protagonists of a timeless drama. The mutal correspondences not only show how closely related the roles of Christ and the artist are, but also that Night, for all its allegorical character, must be interpreted in real terms. Beyond that, the painting depicts a nightmare and, as we shall see, was Beckmann's means of dealing with the horrifying visions that plagued him.

The artist brought not only himself but his family into this image. At the time it was painted, his wife and son were preparing to go to Graz in Austria, where Frau Beckmann-Tube had accepted an opera engagement. Their separation was real

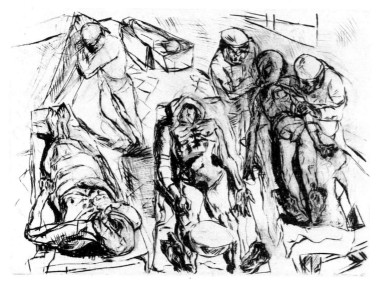

70. Max Beckmann. *The Morgue*, 1915. Etching, 25.9 × 35.9cm.

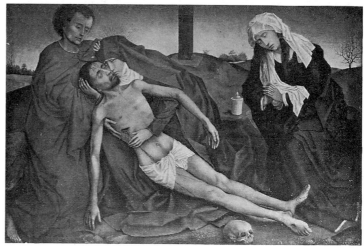

71. Roger van der Weyden. *Lamentation of Christ*, 1450. Musée des Beaux Arts, Brussels.

72. Max Beckmann. *Deposition from the Cross*, 1918. Etching 30.5 × 25.8cm.

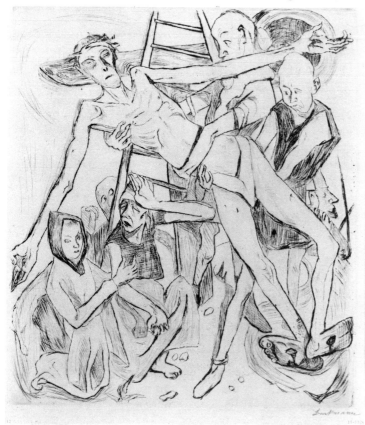

73. *Pietà*, 1450. Limewood, Stadtische Galerie Liebighaus, Frankfurt am Main.

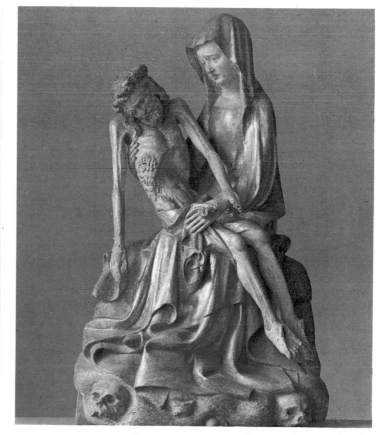

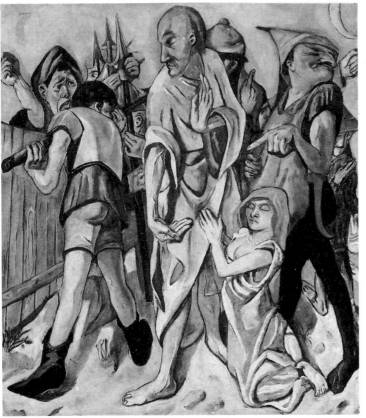

74. Max Beckmann. *Christ and the Woman taken in Adultery*, 1917. Oil on canvas, 150 × 128 cm. City Art Museum, Saint Louis, Missouri.

and painful, and it was brought about in part by external necessity and in part by personal decision. The child in the painting, at least, is easily identifiable as Beckmann's son Peter whose features we see in print 10 of *Hell*, entitled 'The Family' (Plate 75). He has the same upturned nose, the same wide, grim smile with a wrinkle in the left corner, and the same broad lower lip. The boy being abducted here is none other than Peter in pyjamas or nightgown. A tear in his eye and hand raised in farewell, he grips his kidnapper's jacket without struggling to release himself. The female figure seen from the back can only be assumed to represent Frau Beckmann. Yet this vagueness in turn suggests the complex ambiguity of the image, which represents the artist's family but not only them. This might be any family of the period, a husband, wife and child symbolic of families since time began. The difficulties involved in deciphering the spatial framework of this image are compounded by those of identifying the figures, separating levels of significance and reality, and interpreting the symbolism.

The merger of symbolic and real references in the tortured man's garment can be seen throughout the image. The situation might be explained by assuming that husband and wife, having put their child to bed, were about to sit down to dinner when

the thugs broke into their room. The men's clothing appears to characterize them as representatives of the opposing political camps of the time, between whose battle-lines many families were caught. The man in tie and vest would appear to belong to one of the bourgeois or petty bourgeois parties, while the kidnapper is characterized as a radical working man. In the lithograph of the same title done after this painting, Beckmann gave this man an earring, which increased his resemblance to a sailor. Yet why are all the figures barefoot? Realistic as they are, they also certainly evoke figures in a dream, embodiments of tormenting memories and anxious visions.

As far as the memories are concerned, they can be traced with surprising exactness to events in the artist's life. Stephan von Wiese has pointed out that this entire scene of martyrdom goes back to the 1914 drawing *During an Operation* (Plate 76), which certainly also belongs in the tradition of the Lamentation motif. As von Wiese notes,

> the striking thing about the projection of the hospital motif into the painting is the way in which a depiction of humane assistance merges without transition into an image of torture. Yet it was precisely this situation in the field hospital . . . that Beckmann experienced, to the point of nervous breakdown, as pure and meaningless mutual torture.[61]

That is the crucial point here. If Beckmann tortured others with the best intention of helping them, it is not surprising that the experience returned to torment him. In the summer of 1915, he wrote to his wife, 'Night-watch again yesterday . . . two stomach wounds and a severe brain contusion with delirium. Wrestled all night with the unconscious man. The room dimly lit, by night-lights and sheet lightning, and reeking of decay. . . .'[62] Both the patient on the table in the 1914 drawing and the man with whom Beckmann wrestled had suffered head wounds. The torturer in *Night*, twisting his victim's arm with a vacant and probably half-unconscious stare, also wears a bandage on his head. This uncanny figure may well have stepped barefoot from one of the dreams which Beckmann described, writing from Strasbourg in September 1915: 'Every day is a battle for me. A battle with myself and with the bad dreams that buzz around my head like mosquitoes. Singing *We'll be back again, we'll be back again*. Work always helps me to get over my various attacks of persecution mania.'[63] Elsewhere, he recounted that he had been visited during the night by dead men from the morgue in Flanders above which he had been quartered. His *Self-portrait with Red Scarf* may well have been painted under just such a haunting impression. In *Night*, his nightmares and the figures that appeared in them have evidently caught up with him—or he has decided to bring them out in the open. Memories and dreams have materialized, slipped into the garb of forces that outside, on

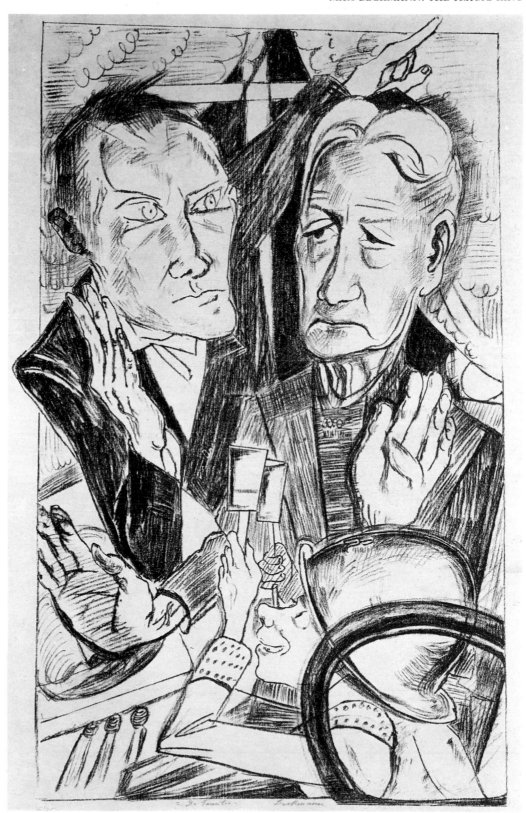

75. Max Beckmann. *The Family*, 1919.
Lithograph, 75.5 × 45.8 cm.

76. Max Beckmann. *During an Operation*, 1914. Pen, ink and brush, 26.1 × 21.1 cm. Private collection.

the streets of a republic torn by civil war, continued their killing. And paradoxical as it may sound, this enabled Beckmann to see them as embodying a higher meaning. By translating figures from dreams into contemporary social types, he transformed a personal nightmare into a general image expressive of human destiny. He returned these figures to a universal order. If there had been no Roman torturers and executioners, what would have become of a humanity crying out for salvation? If there were no bad dreams and brain-damaged soldiers, how was the artist to find his mission? The universal order underlying this martyrdom was cruel and merciless, preventing anyone from escaping its dungeons. Yet his work gave the artist the chance to ban his demons, bring the evil machinery of life to canvas, and hence to free himself, at least temporarily, from the terrible pressure witnessed by the figures in his pictures. By painting Beckmann endured his passion and also liberated himself from suffering. The artist shows us his right hand, his painting hand. But this hand is also that of the strangled man, and that of Christ taken from the Cross, whose

96

suffering is over and who will rise from the dead three days later. In *Night*, this hand is opened towards the woman in the foreground.

Before turning to this female figure, let us consider the gramophone and dog in the left corner of the image, directly beneath the torture scene. The instrument has fallen to the floor and its gaping horn is empty. The little dog from the record label that cocks his ear to the reassuring sound of his master's voice, has been transported into a world where there is no master, no Lord's voice to be heard, and he howls in misery.[64] This relates him to the howling cat which Beckmann placed in the foreground of his *Resurrection* of 1916–18 (Colour Plate 15), which can probably be interpreted as a symbol of dumb creatures caged by their own vitality, for which there was no salvation even when God was still in the world. And now that human beings have realized that God is dead, they have come to share the fate of insentient creatures.

The right hand and left foot of the tortured man point to the bound woman, who dangles, her legs painfully spread, above the floor. The motif of a young woman crouching and spreading her thighs derives from Beckmann's *Large Death Scene* of 1906 (Plate 77). As he was working on *Night*, the artist told Reinhard Piper, 'I know only one thing—that I am going to pursue the idea I was born with and that maybe is already embryonically present in *Drama* and *Death Scene* with all the power at my disposal, until I can do no more.'[65] The motif just

77. Max Beckmann. *Large Death Scene*, 1906. Oil on canvas, 131 × 141 cm. Bayerische Staatsgemäldesammlungen, Neue Pinakothek, Munich.

Magna Mater or Gaea, who gives life and receives it back into herself.[66] Human life emerges from the womb, which symbolizes nature or the earth, and must return to it. Yet in *Night*, the woman's twisted fingers and spread legs also reveal her helplessness and pain. The way in which she is bound recalls depictions of the scourging of Christ and the martyrdom of St Sebastian (Plate 78), who was forced to expose his body to the arrows of his tormentors. In a world where the protection and mutual love of the family have been destroyed, the exposure of woman's nakedness becomes a source of her power to torment man. She herself is also a victim of this power, a victim of the attraction she exerts on those who see her — a victim of the functions which nature performs through her and demands of her. No one in the painting takes conscious notice of her; she is exposed primarily to us, the spectators. And since she is the only figure who wears at least one shoe, she probably belongs more to reality than any of the others. We are the ones who abuse this woman; and who are tempted by her into this hell.

78. Martin Schongauer. *St Sebastian*, 1450. Etching.

mentioned has figured since prehistoric times as a symbol of fertility, the fecundity of nature, and the omnipotence of life. In *Death Scene*, it probably signifies a young woman's defiance of death, and Beckmann very likely introduced this conjunction to refer to the link between death and Eros. The allusion is even clearer in *Night*. Before the woman's spread legs are two candles symbolizing life and death. The burning one points to the right and to the child, and the one to the left, snuffed out, points back to the man, whose tormented hand not only lies over his genitals but points to the red orifice of the gramophone. To his torment is added an ensnarement in sexuality, from which death temporarily liberates him. Temporarily because, like Christ, he will repose when his suffering is over in his mother's lap. The woman's thighs encompass two zones — that of the man's death and that of the child's life. Both pass through her body; life and death, past and future meet here. Fischer has confirmed that Beckmann was aware of the ambiguity of the

79. Max Beckmann. *Nude Dancer*, 1922. Lithograph, 47.5 × 37.2cm.

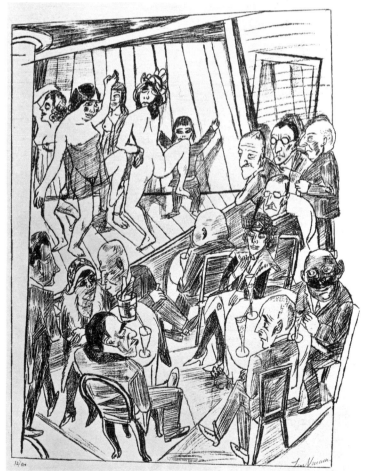

In his lithograph *Nude Dancer*, print 4 of the 1922 portfolio *Trip to Berlin* (Plate 79), Beckmann shows a woman in a similar pose before an eagerly staring audience. Here the artist has begun to fight the very thing he exalted before the war: 'Icy wrath fills my soul. Is one never to escape this everlasting horrible vegetative physical nature . . . our only chance . . . is infinite disdain of all the lascivious snares that lure us back again and again to the rack of life.'[67] Yet even in *Night*, the eternal cycle goes mercilessly on. In the *Lamentation* from the school of Roger van der Weyden (Plate 71) which Beckmann saw in 1915, the body of Christ lies on His mother's garment. In many similar depictions this garment is a white cloth, which is also found in depictions of Christ's birth. The cloth is both sheet and burial shroud, and a mother's wrap, which she spreads carefully beneath the body of her Son. In *Night*, this same cloth is spread out between the woman's legs; on it stand the two candles; and it is wrapped around her right shoeless foot. Painfully fettered to the present, the woman spans past and future, death and life. The sinister man who has lifted the child under his arm steps onto the cloth, striding directly towards the centre of the woman's body, though his face is turned away to the right, out of the picture, and he feels his way with his hand along the back wall. Christian Lenz has discovered the source of the head for this figure: the fresco, *The Triumph of Death*, by Francesco Traini, in the Campo Santo in Pisa (Plate 80).

Beckmann had a large photograph of the fresco in his studio as he worked on *Night*.[68] The head is that of a blind beggar who, together with other unfortunates, supplicates death to release him from his suffering. Yet he does so in vain: Death, in the guise of a gigantic woman (Plate 81) swings its scythe towards the prosperous young people seated on the green field of life, talking, singing, and courting.[69] Since the cripple is blind, he can see neither Death nor the good and evil spirits battling over the souls of the dead who, like newborn babies, emerge from their mouths. It was only logical that Beckmann, who believed neither in a Last Judgement (*Resurrection I*, Plate 66) nor in any conceivable life after death (*Resurrection II*, Colour Plate 15) should have brought into this image what the blindman may sense is happening beyond the walls but

80. Francesco Traini, *Triumph of Death* (detail), 1355. Camposanto, Pisa.

81. Francesco Traini *Triumph of Death* (detail).

which he cannot see. And just as logically, Beckmann let this blindman—who can see neither this world nor one beyond—perform the acts which the good and evil spirits performed in the medieval fresco. His blind cripple is a post-war radical working man who unconsciously passes judgement in this world as Traini's demons passed judgement in the next. Yet the executioner does not quite know where to turn. For the spirits in Traini's fresco, there was still a clear difference between heaven and hell, while the radical working man, though he appears to sense where the future lies, cannot find it. He feels his way blindly around the closed room and, finding no exit, strides with the child under his arm towards the mother, who will probably have to receive her child from him once more. The blind, vital life embodied by this figure can find no escape, no future, and hence takes the child back to its source. To this child, the mother's womb will become paradise and hell in one. The merciless cycle can begin anew.

The life force itself, then, is divine judgement come into the world, containing within itself both damnation and bliss—but never freedom. That Beckmann saw woman as the focus of the life force is indicated not only by her central position in the image. She is certainly also symbolized by the circular red horn of the gramophone, to which the sufferer's hand points, just as the rolling barrel in the *Destruction of Messina* was associated with the violated woman. In an etching entitled *Tightrope Dancers* of 1921 (Plate 82) Beckmann depicted two performers on the tightrope wire, a hooded man approaching gingerly from the right towards a woman who spreads her legs wide in a dance step. Over her shoulder she rotates a parasol, and behind her turns a ferris wheel. Dedicating this print to his wife, Beckmann spoke of it as 'a self-portrait of us two'.[70]

Whatever interpretation is given to the right-hand section of *Night*, it certainly shows a reversion to the un-freedom of unconscious, blind life. Evidence that Beckmann saw blind destructiveness and meaningless violence in the battles then raging between revolutionary and conservative forces, and that he rejected them for that very reason, is to be found in print 9 of the sequence *Hell* (1919), in which he also included, as print 6, a lithograph of *Night*. The ninth print, entitled *The Last Stand* (Plate 83), shows a group of motley characters firing blindly in every direction at some invisible enemy. After the war, Beckmann came to look upon violence as absurd, however justified, as can be seen from the emphasis on the victimization of Rosa Luxemburg in *Martyrium*, also included in *Hell*. Violence was a typical expression of that 'horrible monster of vitality' he was determined to cage and strangle 'with sharp, crystal-clear lines and planes' (see note 51).

And now his own son, Peter, brought this violence home. Print 10 of *Hell*, entitled *Family* (Plate 75), shows him in a steel helmet, proudly displaying to his father and grandmother two

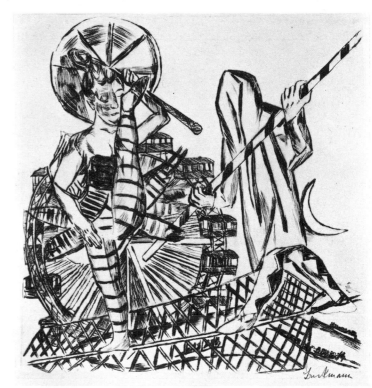

82. Max Beckmann. *Tightrope Dancers*, 1921. Etching, 26.2 × 25.2 cm.

hand-grenades he has found—a little Mars in the midst of civil war, famine and need.[71] While his pious grandmother attempts to interpose, the father points upwards angrily as if intimating that his son is only unconsciously carrying out the universal plan. Peter, ten years old at the time, also appears in an etching of 1920, *Peter with Pointed Cap* (Plate 84), and again in the role of naïve hero. A paper hat on his head, he points with a malicious smile to the spear in his left hand, certainly dreaming of being a big, strong, aggressive man like those in his father's pre-war paintings. In the 1918 etching *Children Playing* (Plate 85), the war continues on a playground, whose shape again suggests the vicious circle, to which now only the smallest children have no access though one of them already jumps in singing and whistling. And, finally, in the painting *Women's Bath* (Plate 86), a boy cries and complains in his mother's close embrace, which he obviously wishes to escape. He too wears a paper helmet-like hat, which has been folded from the newspaper *Vorwärts*. The general idea expressed in the title probably appealed more to Beckmann than the fact that the paper was the official organ of the government party, the SPD. The conclusion may be drawn that the boy—like all boys, though he may be called Peter for convenience sake—still loves guns and fighting despite the disaster of war and the revolutionary street

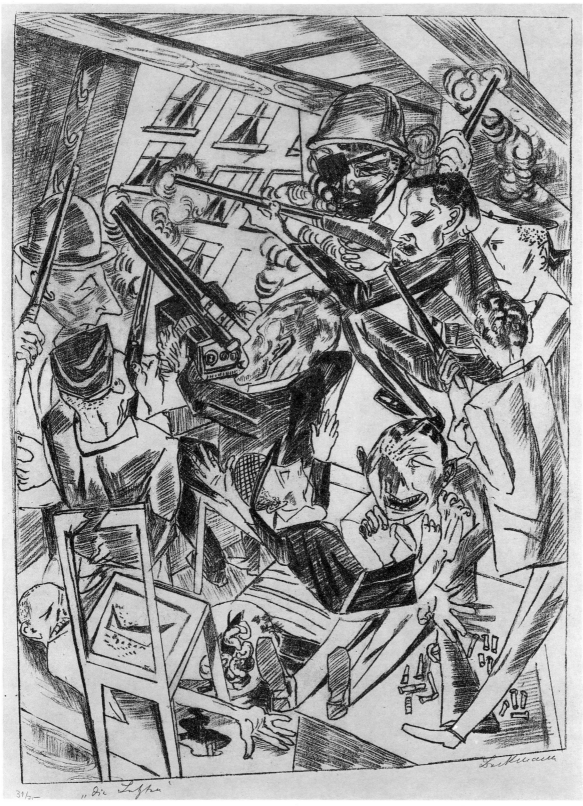

83. Max Beckmann. *The Last Stand*, 1919. Lithograph, 66.7 × 47.4 cm.

slaughters that followed. It is not surprising when he is surrounded by shouts of '*Forward!*' and strong, sinister men who so resemble his boyish fantasies of robbers. In *Night*, these fantasies of strength and independence materialize in the figure of the blind working man. This may be the reason why the boy wears red underneath his nightgown, a colour that recurs to signify vitality and pain in the woman's stockings, the gramophone's horn, and the man's chest and throat.

The boy in *Night*, then, is a half-voluntary and half-involuntary victim of the force that takes him back to the very place he wished to escape by choosing vitality and life. The boy's grimace, probably a result of very mixed feelings, expresses a conflict of which he is not yet conscious but which lies at the root of his existence. He holds tight to the sinister man, and waves goodbye—yet he is already on the way back. His freedom was as short as life itself, his future is in the past. He has realized as little as the rebel carrying him that there is only one solution to the problem of life—a willingness to accept its contradictions and to endure them. The woman, a symbol of fertility and suffering, must live through this tormenting conflict just as much as the man and the other figures, who are tormentors and victims in one.

The woman who appears in the background of the image, though also dressed in red, would seem to be an exception. She looks to the right with a terrified, unmoving gaze, to where the torturer performs his grisly work. Ensconced in the farthest corner of the garret, she witnesses these happenings without so much as batting an eyelid or raising a finger to stop them. This has led to the supposition that she has betrayed the others to the intruders; the evidence of the image, however, is not actually

84. Max Beckmann. *Peter with a Pointed Cap*, 1920. Etching.

85. Max Beckmann. *Children Playing*, 1918. Etching, 25.8 × 30.3 cm.

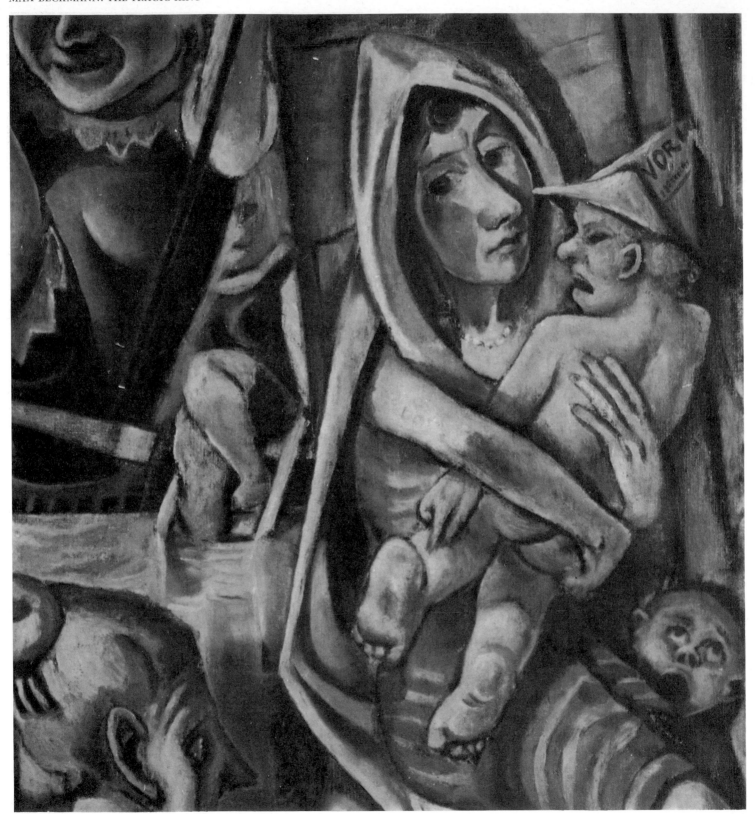

strong enough to convict her. The main clue to her significance was provided by Beckmann himself when he remarked that he wanted to complete what he had begun in *Large Death Scene* and *Drama* (Plate 87). Three crosses appear in the latter painting, and behind them a broad plain populated by naked, ecstatic figures who seem to be celebrating their hero's sacrifice rather than mourning his death.[72] He has, after all, abandoned himself entirely to life, even accepting suffering and death, like the Dionysian Christ in *Christ carrying the Cross* and like Rosa Luxemburg in *Martyrdom*. In keeping with this mood of acceptance, a powerful man attempts to tear an old woman away from the cross she has wrapped her arms around. Instead of identifying the mystical ecstasy with the sacrifice which has already run its course, she must face life as Christ did. Christ gave mankind an ideal to follow in daily life, not a guarantee that life would be free of care and suffering. His maxim was an abandonment to life, not a mystical unity with His crucified body, examples of which abound in Christian iconography in the shape of Mary Magdalene in erotic transport.

In a foreword to a catalogue of 1917, Beckmann referred to painters of 'masculine mysticism', whom he named again in his *Confessions* (see note 48). His woman in red in *Night*, we might conclude, was probably intended to represent a feminine mysticism which, with a mixture of religious and erotic sentiment, clings to a passion that took place in the distant past. This woman is therefore incapable of seeing the suffering taking place before her eyes. Her attitude also enables her, as the only figure in *Night*, to appear in formal dress. She refuses to face the horror and cruelty which are also part of human nature and timidly avoids what Beckmann demanded and achieved in his art: 'Truth to one's inner visions.'[73] This brings her close to the uncharitable, holier-than-thou believers in Beckmann's *Ideologues* of 1919 (Plate 88), who like her are betrayers of life. Simplifying life's complexities with their ideological panaceas, wrangling over terms and principles, they are blind to what is happening around them. Behind the old-fashioned, devout figure in the foreground sits Beckmann himself, thoughtful and uneasy.

Ten years before Beckmann painted *Night*, he spoke with fascination of 'savage, cruel, glorious life' and enthusiastically began work on the *Scene from the Destruction of Messina*. A comparison of the principal motifs in the two images points up the change which Beckmann's philosophy underwent in the interim. The main motifs of the earlier canvas are combat, abduction and suffering. To the lower right is a wounded or dead man and next to him a fettered woman—two figures who, in altered form, became the principal motif in *Night*. The

86. Max Beckmann. *Women's Bath* (detail), 1919. Staatliche Museen Preußischer Kulturbesitz, Nationalgalerie Berlin.

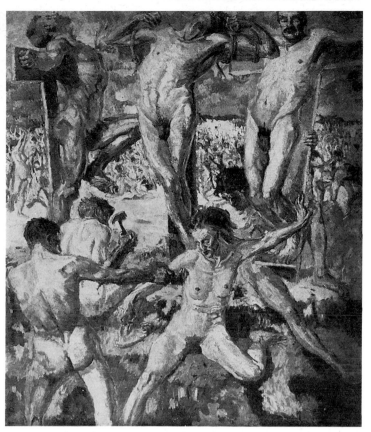

87. Max Beckmann. *Drama*, 1906. Oil on canvas, 229 × 200cm. Destroyed, 1943.

kidnapper in the Messina painting now enters from the right, still embodying life's savagery and cruelty; but its glory has departed, leaving it blind, self-enmeshed and sinister. Grosz and Dix could have learned much from this painting, particularly in 1919. Beckmann's victims of 1909, battered, defeated and anonymous, in 1919 became himself and his family, the family in whose reassuring presence he had read of the Messina earthquake and begun his first sketches for the painting. Now Minkchen, the artist's wife, no longer dandles the baby—the child has been gripped by a dark force; the brutality of the Messina convicts, once borne by others, must now be borne by the painter himself and his beloved. Beckmann's heroes of before the war have metamorphosed into ghosts that emerge from his own mind, or into powers inherent in life itself that have arisen to destroy him and his family—all families. Hence *Night* is more than an image of death overtaking a family, it is one of the death of the family as an institution. Perpetrators and victims are both victims of a role written by life.

Beckmann chose to remain in the bourgeois camp during the years of threat since opposition to it, contrary to his pre-war belief, offered no alternative. In *Night*, the artist symbolically

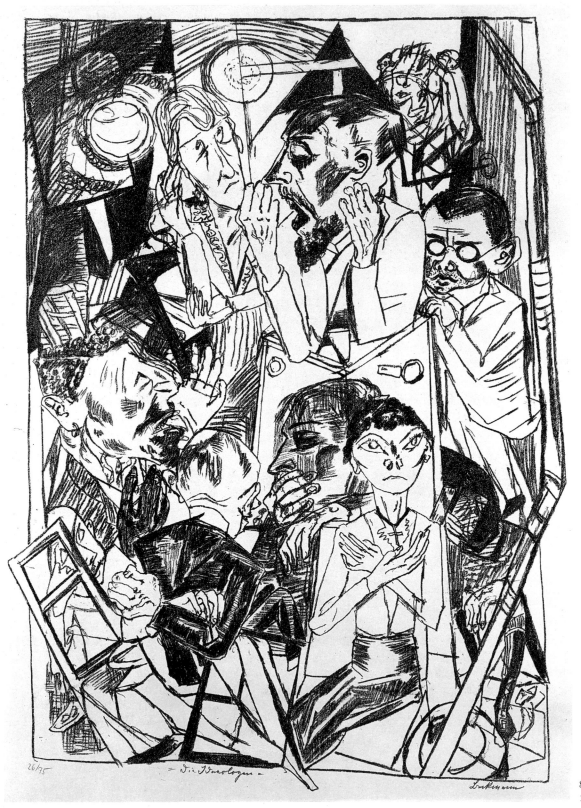

88. Max Beckmann. *The Ideologues*, 1919. Lithograph, 71.4 × 50.5 cm.

abandoned himself to his unfeeling opponents. In so doing, he found humanity and subordinated himself to the laws of nature. Grosz, by contrast, struck out savagely at narrow-minded, self-satisfied philistines, and Dix fought nature, the 'skull'—and both artists lost. Beckmann's insight into the hopelessness of this alternative is revealed in *Ebbi*, a comedy he wrote six years after painting *Night*. The play describes the vain attempt of a middle-class man to escape from his narrow life into the underworld of gangsters, prostitutes and pimps.

A great deal of speculation surrounds Beckmann's much-quoted statement that 'The war did not change my ideas about life at all, it actually confirmed them.'[74] If the interpretation of *Night* is correct, it also provides a key to this last statement. Beckmann saw life in terms of struggle before the war, and he continued to do so after it. What had changed was the fact that he had stopped searching for an intrinsic meaning in the struggle, and was attempting to celebrate and exalt life by lending it sublime form in art. Now it was a matter of bearing life, struggling through its adversities in the hope that a new meaning might emerge from them. When in 1915 he wrote home that 'We just have to assume that life isn't everything,' he had already begun to change. And although he added, 'How, why and wherefore, all that is none of our business,' he could not remain satisfied for long with this outright denial that the question of meaning could be asked at all. His 'transcendental objectivity' would help him to put the question differently and gradually lead to an answer. And when, still during the war, he summed up his philosophy by stating, 'You have to be ready for anything that comes and yet still keep your head about water,'[75] he set himself a task to which he remained dedicated to the end.

Before 1914, the Beckmann who painted the 'glorious' life unleashed at Messina and the Beckmann who saved the man from a police truncheon in the 'unpleasant scene' described in his diary, were two different men. In *Night* he forced them, with suicidal determination, to merge. Life and art are not two different things; it is impossible to glorify in the former what is abhorrent in the latter, but what should be depicted in art is what is gleaned from life by living it. Tragically, the act of living can be an obstacle to understanding. Beckmann battled with his own vitality in order to see life whole, and this vitality and the visible world always remained the moulding source of his knowledge. Since it is impossible simply to equate the two realms, life neither being art nor art being life, he was necessarily led to the central theme of his life's work: the universal theatre of myth.

The Golgotha of Beckmann's *Night* was followed, gradually and step by step, by a symbolic rebirth into which self-recognition and a consolidation of his personal life obviously entered.[76] By the time of the *Self-portrait as a Clown* (Colour Plate 17), he had partially regained his feeling of personal worth and self-assurance. Seated on the stage of the world like a king on his throne, this man is well aware of the role allotted to him. His sceptre is that of a carnival clown, the symbol of his mission a toy horn. His painting hand, the hand of the Passion, is opened to the spectator as if to invite emulation. He has suffered life's adversities and risen above them, to regain his human dignity. Now he can turn to his task with confidence, even if it only means playing a comic role in the universal drama.

Beckmann was aware of the role he had to play unlike, for example, George Grosz, who was already caught in the trap when Beckmann submitted to his symbolic self-sacrifice. Nor, unlike Dix, did Beckmann fight nature in order to make it seem contemptible, but in order to spiritually transcend it. Dix never attained this magnanimity. And Beckmann submitted to nature in order to derive a new meaning from it, which in turn prevented him from taking the path to an abstraction that disregarded nature. Without wishing to anticipate the judgement of time, it is probably no exaggeration to say that Beckmann is the greatest German painter of the twentieth century. He surpasses all the rest not only in the force and variety of his imagery but also in the sheer length of his productivity on the highest level. Neither the dismissal from his teaching post in 1933, nor the difficult years of his exile in Amsterdam were able to break his will. His creative power was in fact increased by external obstacles, despite the fact that they undermined his health. From the start, his approach was broader, more profound, and more complex than that of most of his contemporaries, and he was honest to the point of self-immolation. This honesty saved him from the snares of artistic and intellectual fashion, from the one-sidedness that proved disastrous to so many contemporary artists even before they were ostracized or murdered by the National Socialists. Despite his detachment from the political and moral issues of the day, Beckmann's paintings relate more about the period and the forces at work within it than, say, the embittered worm's-eye-views of Grosz, and his *Night* contains more insight into the terrors of the vital principle than Dix's *War* sequence, at the head of which the latter artist placed himself as victor (Plate 38). Dix morally condemned nature, which, forcing him to place his hopes in a higher principle to overcome it, eventually brought him to a redeeming God whom Beckmann had already struck from his philosophy before the First World War. And while Dix's allegiance brought his task to an end, Beckmann's rejection enabled him to begin. Nature, for Beckmann, was something no man could presume to pass moral judgement on, as little as on his fellow men.

5. OSKAR SCHLEMMER: ADAM TRANSFORMED INTO PROMETHEUS BY GEOMETRY
Transcendental Anatomy

Oskar Schlemmer was born in Stuttgart in 1888 into a middle-class family; his father, who worked in various occupations, wrote comedies in his spare time which even saw a few performances. While he is said to have been somewhat devil-may-care, Schlemmer's mother was apparently strict, Protestant, dutiful, and infused with profound, moral earnestness.

Schlemmer was four years younger than Max Beckmann and as many years older than George Grosz and Otto Dix. By the outbreak of the First World War he had achieved a more than regional reputation, though it could not match that of Beckmann. His immunity to the current philosophy of vitalism primarily distinguished him from the other three artists. Schlemmer never exalted the dynamic force of life, its joys and dangers, or its cruel beauty. He painted no heroes, no images of conflict and catastrophe, no full-blooded females or gold-hungry desperadoes. His reaction to bourgeois, imperial Germany with its materialism and superficial pleasures was not vitalism but asceticism. And consequently the war and the onset of the machine age affected him differently from other artists of his generation.

While the war led Beckmann to see life as a cruel, perpetual drama ordained to be endured, Dix to scorn life and Grosz to blame its perversions on capitalism, it faced Schlemmer with problems of a different order entirely. Having mistrusted the vital principle from the start, he had never glorified the instinctual side of human nature. His aim was to heal the rift between intellect and instinct, mind and matter, by creating images of almost mathematical harmony.

Early entries in his diary show how deeply ingrained in his character this desire must have been. On 4 September 1910, while in Berlin, Schlemmer wrote:

> I dreamed I was walking at night along the brightly-lit Joachimstaler Strasse—involuntarily shouting 'I need a friend to talk to and to love.' People on both sides of the street grinned at me derisively. The echo of my words bounced off the buildings, reverberated from street to street.[1]

At first sight, this would appear to be a perfect example of Expressionist sentiment—the artist abandoned, shouting his pain to a heedless universe. Characteristically, Schlemmer however only dreamed his Expressionist outcry. He was a reserved man who disliked emotional scenes and this may

explain his asceticism, and need to intellectually master nature, including his own. In March 1913 he noted:

> I'm in a wonderful mood, harmonious and peaceful as at certain earlier times, and I attribute it to my temperate life. I often have to prevent myself from simply embracing people, and have visionary ecstasies of a kind you usually only have when you're running a fever.

After justifying the necessity of self-control by quoting Flaubert, Schlemmer concluded, 'Isn't asceticism a higher form of epicurism and fasting a more refined form of feasting (*Schlemmerei*) . . .?'[2]

To define the term *Schlemmerei* as a refined, spiritualized enjoyment of life's pleasures by abstaining from them, is to fly in the face of its accepted meaning. Schlemmer, whose name literally means gourmand or glutton, apparently felt the need to purge himself of that part of his heritage to which his name alludes. The same need also shaped his preferences and ideals. 'What I love most,' he wrote, 'are plain, austere things; not flowery, scented, silky, Wagnerian things but Bach, Handel.'[3]

When he entered the Stuttgart Academy of Art in 1906, he was painting in the *plein air* tradition. By the time he entrusted the above thoughts to his diary seven years later, he had turned to Cubism. He believed that the most promising path for a contemporary artist was to translate natural forms into abstract ones by filtering them through his mind, yet without divesting them completely of natural appearance. It certainly suited his temperament. Abstraction enabled him to recreate nature on canvas while remaining in complete control of the process. Instead of the Expressionists' mystique of nature he could pursue a mystique of symbolic form and colour which, although it also aimed at transcendence, could bypass the tumultuous emotions and images which arise in immediate confrontation with nature. Technique and style would remain subject to intellectual control. Schlemmer once defined his approach by implication when criticizing the very different technique of his friend, Willi Baumeister. In his diary of April 1913, he wrote of Baumeister's canvases,

89. Oskar Schlemmer. *Homo, Wire-Figure*, 1930–1. 248×210cm. Staatsgalerie Stuttgart.

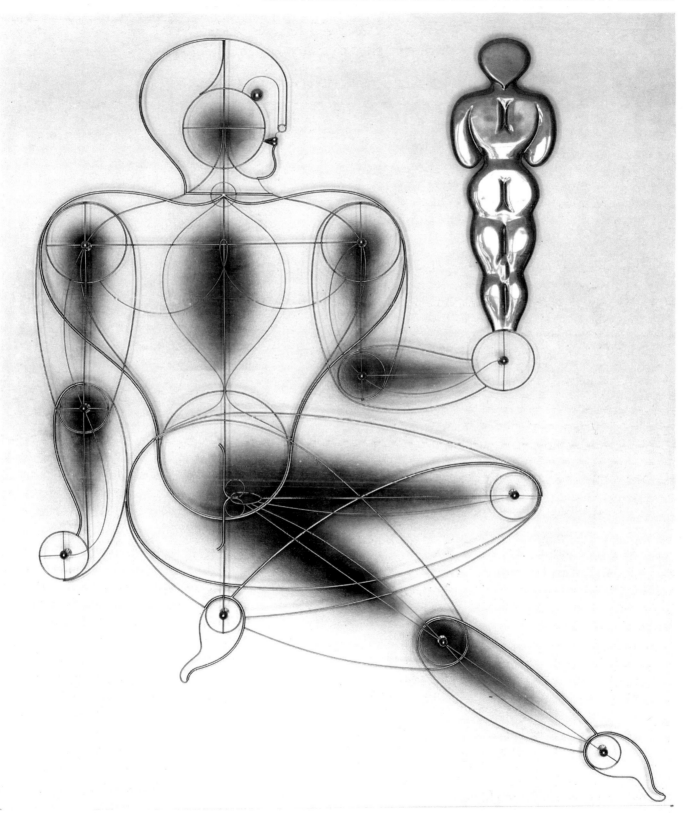

a jumble of influences, integrated by skilful painting. Brilliant, sensuous colour, like flowers. But not simple. Lacking the simplicity of true masterpieces. . . . This process, including its undigested and completely instinctual aspect, is everything in his pictures.

His friend's subjective, emotional abandonment to sense impressions, whether from nature or changing fashions in art, was alien to Schlemmer. His ideals were objectivity and simplicity, and he found these qualities pure in the forms of geometry, which are *a priori* products of the mind. He concluded, 'I think by representing nature objectively a profound mystique might be created. A mystique of painterly means! The symbolic power and significance of point, line, triangle, square, circle.'[4] From the study of nature a painting style would emerge which instead of depicting natural appearances would simplify them, reduce them to their basic elements, and reassemble these elements in accordance with an ideal. In Schlemmer's own terse phrase, his intention was 'To study nature, absorb it completely, and then reproduce my inner vision.'[5] This inner vision was his mental image of absolute order, of the cosmos.

Although he initially employed a Cubist approach in pursuit of his aim, Schlemmer's words emphasize a crucial difference between himself and his models. The French Cubists had arrived at their pictorial structure by attempting to create autonomous works of art, images independent of nature. Mystical union with the essence of nature was not their concern. Schlemmer, by contrast, felt a close affinity with the German mystic tradition. Not surprisingly, he repeatedly named Grünewald and Caspar David Friedrich as predecessors, adding that he wished to adapt their approach to the modern age. Picasso's art struck him as not being the 'manifesto of anything like a Buddhist conception of life' which appealed to him at that time, but merely 'a mystique of absolute form'. Cézanne fell into the category of 'absolute objectivity',[6] which did not suffice for Schlemmer either. His longing for a more profound understanding of nature took him beyond both 'absolute form' and 'absolute objectivity'. Endeavouring to combine the meditation of Buddhism with a modern 'mystique of means', Schlemmer pursued what he called the absolute idea, which was to express itself spontaneously, in metaphysically significant forms. Simplified, natural form and absolute idea were to meet in the work of art, the idea becoming form and the form becoming idea. A few years later he was to reduce this notion to the maxim: 'I would like to depict the most romantic of ideas in the most prosaic of forms.'[7]

A pictorial syntax derived from Cubism could not help him solve this problem. Strictly speaking, the forms and colours of Cubism possess significance only within the image and cannot convey statements about the essence of either man or nature. At best, they can record that reality is little more than the manner in which human beings perceive and depict it. But since Schlemmer expected more of art than self-sufficiency, since he was convinced that an artist was someone who created the harmony in art which he could not find in life, Cubism, that product of French reason, could not satisfy him.

The difficulties involved in finding and developing a form of expression more suited to his personality culminated in a profound inner conflict shortly before the outbreak of war. He longed for a liberating perception which daily life could not provide, and believed that true art arose from pain and suffering; and at the same time, he felt a strong need to end his isolation. In August 1913, he noted: 'Something has to happen. At any rate, I have to declare war on play and laughter, on grace, on the waves, and maybe even on modest happiness.'[8] Exactly a year later, something indeed happened—Schlemmer volunteered for ambulance service. However, he was transferred to the infantry as the lists were already full. He saw duty on the Western Front, was sent to hospital because of leg cramps and, granted a short leave, returned to Stuttgart. From there he wrote to his Swiss friend, Meyer-Amden:

> I would volunteer again, even if I could stay here. The situation here is that it's a shame for a young man to be running around free. Aside from that—it's the only right thing. . . . If there were only some better solution for my poor heart than the field—despite its being the field of honour![9]

It was not a longing to experience 'savage, cruel, glorious life' or the stupendous 'natural event' of war that encouraged Schlemmer to volunteer, but an unresolved conflict between form and content. The form was there, waiting for content, for the idea Schlemmer thought war might provide. He needed to find this idea at all costs, since it promised a solution not only to his artistic but to his personal problems. Art was a medium in which the meaning of life could be found and communicated, a religion whose prophet was the artist.

Schlemmer's readiness to consider the soldier's life a temporary solution did not last long. Already in January 1915, he confessed in a letter, 'I'm not the fellow who volunteered in August any more. Not physically, and especially not in terms of attitude.'[10] The mobile war of the first months had bogged down in the trenches, and the stirring phrases with which the newspapers greeted the capture of a few yards of ground had begun to sound hollow in Schlemmer's ears. The victories, as he had seen at first hand, stood in no proportion to the losses they entailed. In the field hospital one day, he shamefacedly wiped the word 'volunteer' off the identification board on his

bed. In March 1915, he summed his war experience up in his diary:

> At first, soldier through and through, a feeling of being part of the whole. The excitement of marching out, self-confidence with respect to those you're leaving behind—their protector, emissary, hero. Out here, due to the hardships, matter versus mind. Apathetic resignation to fate.[11]

And later: 'For me, being a soldier is not an end in itself, as it is for other lucky fellows. . . . I go into battle out of curiosity about the darkness of our destiny. I wonder what fate the great chaos of war holds in store for me?'[12]

Schlemmer was wounded on the Eastern Front in the summer of 1915 and, after his recovery, was granted leave until January 1916. During these months he searched intensely for new spiritual foundations for his life and art. As Karin von Maur concludes,

> The more the world around him disintegrated, and the more he realized the absurdity of a war in which each yard gained cost more blood and injury, the stronger became his need to stake out an underground region that would be indestructible.[13, 14]

Schlemmer now came to believe that the quintessence of indestructibility was the human form, which he began increasingly to depict in geometric terms. It may well be that a fear of being crippled, of losing a limb or the use of one of his senses, drove him to construct these perfect figures of abstract parts.

Schlemmer's new image of man began to take shape in his watercolours of 1916, with figures based closely on archaic torsos (Plates 90 and 91).[15] Schlemmer now re-created of geometric elements what in the course of centuries had proved indestructible despite breakage, fragmentation and crippling. Like the torsos, his figures were meant to embody an immutable conception of man, suppressing individual traits in favour of 'eternal' features symbolic of a fundamental, universal order. He once described the components of his image of man thus:

> A square for the rib cage, a circle for the belly, a cylinder for the neck, and cylinders for arms and thighs; spheres for the joints of the elbows, knees, and shoulders; a sphere for head and eyes; the nose a triangle; a line to connect heart and brain, the ornament that takes shape between body and the outside world and symbolizes their relationship to one another.[16]

A figure constructed of these elements would illustrate a human ideal without completely disregarding the visual facts.

And by lending the lineaments of his ideal constructs symbolic significance, Schlemmer raised them above the machine. Unlike machines, they had no utilitarian purpose to serve, being meant as images of a higher, meaningful, holistic order. A few years later, he would explain the difference between his conception and that of other artists he had seen at an exhibition:

> Works were on view that so resembled mechanical configurations that the only difference between them and machines was that they were not machines. By contrast to the usefulness of machines these works, in their romantic uselessness, appeared to be waiting for deliverance! I myself tend in this direction, and I'm worried about where it will lead.[17]

Yet Schlemmer's figures did not need to wait for deliverance. They were already free, liberated from the accidents of appearance, the vicissitudes of time, and the cycle of birth and death. They embodied an idea, though it was an idea portrayed with mechanical precision. 'If contemporary artists love machines and technology,' he wrote in 1926,

> if they want to convey precision instead of vagueness and blur, this is an instinctual attempt to save themselves from chaos and find forms for our time. These artists are prepared to recast the disadvantages and dangers of the machine age into the advantages of an exact metaphysics, to express the impulses of the present day and modern humanity and to lend them unique and unprecedented form.[18]

At this point, comparisons are in order. Max Beckmann viewed the machine as a symbol of the fatal mechanism of life, and therefore hated and despised it. Dix attempted to beat the machine by painting with extreme precision and adhering to his all-important 'idea'. Schlemmer, by constructing a unity of form and idea, attempted to turn the impetus of the mechanical onslaught back upon itself. Though he adopted the precision of machinery in the wiry, linear construction of his drawings and paintings, he confronted its soullessness with an idea of human lastingness and indestructibility. He attempted in his imagery to infuse the mechanical realm with metaphysics, and to employ its forms to overcome nature and its elemental forces.

An early example of Schlemmer's conception is the *Composition on Pink—Relationship of Three Figures*, of 1916 (Colour Plate 19). Two opposing forces and principles apparently confront each other here. A figure fragmented into geometric shapes moves in from the left towards a closed, silver-grey silhouette at the right. The principle of analysis confronts that of synthesis; parts stand opposed to a whole. Yet obviously the

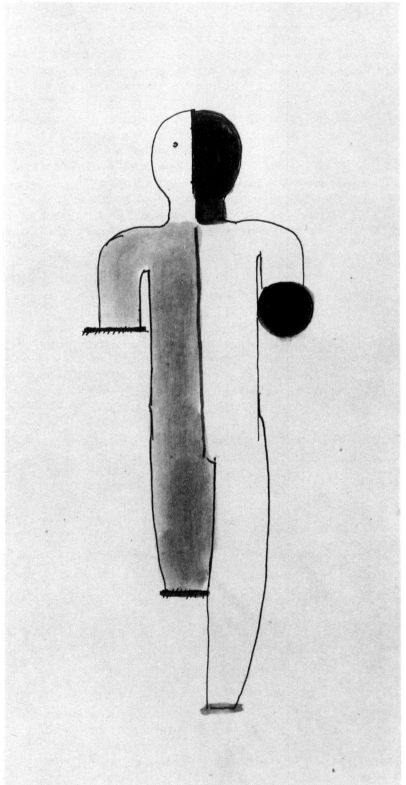

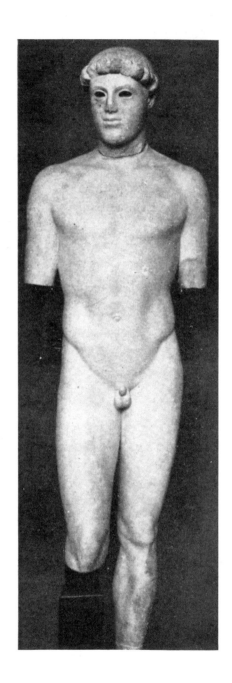

90. Oskar Schlemmer. *Standing Figure – Divided*, 1915. Ink, brush and pen, 28.6 × 14.2cm. Private collection.

91. *The Kritios-Boy*. Archaeological Museum, Athens.

figure on the right, its head thrust forward and fist clenched, offers something in the nature of resistance to the other figure. If this left-hand figure represents femininity, as the breast-like shape would seem to suggest, and the figure on the right symbolizes masculinity, then what Schlemmer has opposed here are the two poles of his view of the world. Both figures seem strangely alienated, yet each partaking of the other. Feminine, earth-coloured nature is divided into geometric parts, in a way similar to Schlemmer's pre-war, Cubist-orientated paintings. The figure on the right with its metallic sheen, resembles a man-made product; it may even symbolize the machine realm created by the male intellect—yet its contours seem natural by comparison to the first figure. If this is a paradox, then it is the paradox of modern culture *per se*—nature appears artificial and the man-made product natural.

The third figure, small, standing on the ground, and apparently propping the falling male figure, compensates the opposing forces in the image. It is seen direct from the front or back, and its sex is indeterminate. Its frontal pose and tranquil contour contrast with the tension-filled profile views of the other two figures. Its colour evokes organic life, while its outline suggests artificial abstraction from nature. The tensions between colours, forms, modes of depiction, and between the two sexes, are resolved in this image of an androgynous human being, the human 'in itself' which was to occur with increasing frequency in Schlemmer's later works.

Composition on Pink holds an important place in Schlemmer's development for another reason. It was the first time he had treated the tense relationships of several figures on a plane. Using the picture plane as a means to discipline his thoughts, he concentrated them on the two-dimensional medium, which offered welcome resistance to his burgeoning feeling for nature and mystical dreams. A limitation to the plane allowed him to depict his 'ideas', a static, unchanging idea that needed no front or behind, no before or after for its elucidation. This, precisely, was the source of his problem. To convey his 'idea', he had to represent it as the result of a process. Yet because knowledge can be conveyed only in terms of a process in time, Schlemmer was eventually forced to return to a depiction of space—without space, time cannot be depicted, and without time, there is no process of perceiving or knowing. Schlemmer's missionary zeal was basically incompatible with a strictly planar style of painting. When he wanted to use easel painting as a medium to convey his message, he therefore had to recreate the illusion of three dimensional space.

During his military service and several years thereafter, he more or less consciously accepted the unintelligibility of his art. The extreme discipline to which he subjected his thoughts and feelings actually prevented him from proclaiming his mission. Discipline helped him to survive mentally the tedious paperwork he had to do after being exempted from active service, and it also helped to protect his identity. Schlemmer hid his true feelings, even and especially from his fellow soldiers, to prevent being submerged in military life. 'I'm careful to veil my intellectual life in absolute incognito . . . ,' he wrote, 'They consider me a Schlemihl, a man without a shadow, though what they really see is a shadow without the man.'[19] He had still not discovered either himself or the final form in which to express his 'idea', as can be seen from the coded images of these years, among them the *K Painting* and *Composition on Pink*. And, as if to emphasize his remoteness from the everyday world, he even stylized his appearance, shaving his head, as he said, 'to drive out the romantic humbug'. He detached himself as far as possible from sense impressions and sensual experiences, writing, 'I have to keep a tight rein on myself to prevent impressions of nature from exciting me to paint them—because I know something better, and feel an inner duty to live for The New.'[20] The *Composition on Pink* might have been a visual expression of this programme.

Besides painting, Schlemmer was working in another art form which throughout his life remained perhaps even more important to him. He was an enthusiastic and excellent dancer and initially preferred the medium of dance to represent events through time, processes during which the protagonist goes from one state or place to another. In the winter of 1916, he performed parts of what later became the *Triadic Ballet* for the first time. Although exactly which sections and costumes from the series he chose are unknown, his basic approach to ballet has been recorded. In an early note of 1912 he already spoke of symbolically overcoming the Dionysian demon in dance,[21] and in his classic discussion of the *Triadic Ballet*, written in 1922, he spoke of it as 'a dance of trinity; variations on one, two, and three, in colour, form, and movement'. The stage, divided into geometric shapes which the dancers must follow, and the costumes which hinder natural movement, made the dancers into constituent parts of the cubic space of the stage and forced them into highly controlled and artificial movements (Plate 92). 'In this way,' he wrote, 'dance, by origin Dionysian and full of emotion, becomes Apollonian and austere in its final form, a symbol of a reconciliation of polarities.'[22] In dance, too, Schlemmer adapted the human form, even subordinated it, to the medium in which it appeared. Stylization and abstraction of the body and its motions served to control and integrate the physical excitement which he certainly experienced when dancing. In whatever medium, he allowed sensual experience to enter in highly distilled form only. His feelings and perceptions were reduced, encoded, and subordinated to a strictly calculated system. It was an attempt to save reasonable order from the general chaos of those troubled years.

The experience of war shocked Schlemmer as deeply as it

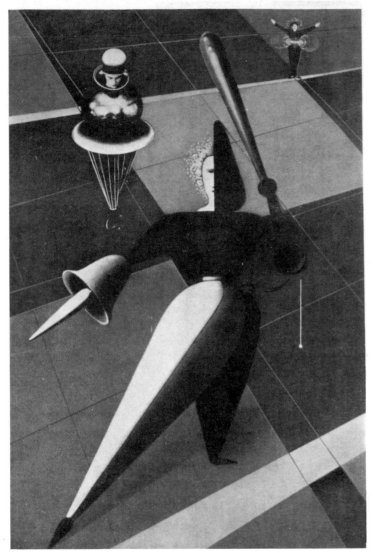

92. Oskar Schlemmer. *Study for the Triadic Ballet*, 1924. Gouache, collage and photomontage, 57.5 × 37.1 cm. Museum of Modern Art, New York.

because he had mistrusted nature from the start. Free, savage, untrammelled life was never for him. Nor did he meditate like Beckmann on the mystery of the corpse as he had never considered life the ultimate purpose of all being. Thus the material shell from which life had departed could not pose a philosophical problem to him. As he was never as deeply involved in those questions as Grosz, he neither exaggerated life's struggle nor saw any reason to oppose society's authorities.

Schlemmer naturally also longed for a change, a transformation of society and man, but did not place his hopes in a denigration of nature, in social or political revolution, or in a search for the meaning of existence. His path was the time-honoured way of the idealist—an attempt to bring about change through the message and the form of his art. He was a kind of missionary who expounded his doctrine with symbolic forms, forms in which he tried to distil the essence of both humanity and nature. With some perception of the essence shared by men with their own kind, with nature and with the universe, he hoped to project a world in which a life of spiritual harmony would be possible. This would be best achieved by abstracting elements from individual and natural appearances, and integrating the forms thus derived into the dominating plane, which, he later explained, was a sign and symbol of infinite, cosmic space:

> On the plane, which corresponds to cosmic space, I can . . . dispose figures so that they appear as visible functions of the forces of cosmic life and convey the great orderliness with which they fulfil its laws . . . Before we can paint the 'face' of things, we must recognize the typical, the impersonal.[23]

Schlemmer's task henceforth was to delineate the typical or general aspects of nature in various contexts. It is characteristic of his missionary zeal, however, that no one medium could satisfy him. Easel painting soon seemed inadequate to his purposes—to create ideal types, free of all contradiction, and to find as wide an audience for them as possible. Finding the scope of traditional painting limited, Schlemmer initially sought to express his ideas in dance and wall-painting.

In January 1919 he wrote to Otto Meyer-Amden, 'Moscow is apparently inundated with Expressionism. They say that Kandinsky and the moderns have dipped whole districts of the city in colour, with blank walls and the walls of buildings forming the surfaces of modern paintings.'[24] It may well be that this news encouraged him to plan projects on a similar, large scale. He built models of these 'architectural sculptures' which were to be far more effective than easel paintings despite their subordination to the architectural context. He wrote:

> these panels would overcome the picture frame to combine

did the artists already discussed, but his personality and the path he had chosen even before 1914 led him to different conclusions. Instead of complaining about the suffering and privations of war, he merely noted that out there, at the front, matter had apparently triumphed over the human spirit. He therefore increased his efforts to discover and formulate his idea, the vision which would reverse the process, and his search began for an eternal image of man. He attempted to disregard the horrors of the battlefield, not allowing them to become an issue for him. Rather than inquiring into the meaning or the absurdity of war, he accepted it as given. He abstracted from the world of appearances and from his own experience. After the war, he refused to blame natural causes

with the wall and become a part of the larger plane, a space larger than themselves, and thus part of a projected, desired architecture. They could compress and distil the forms and laws of their surroundings. A kind of tables of the law.[25]

The tables of the law again contained Schlemmer's image of man, the supra-individual and timeless shape of the human figure which would provide the measure and scale of architecture. One of Schlemmer's designs was a plane articulated in depth, a three-dimensional figure emerging from the plane which, solid and surface in one, anticipated the articulation of the façade on which it was to be installed (Plate 93). The figure consists of alternating and complementary positive and negative shapes like the projections and depressions of the front elevation of a building. It is not difficult to imagine the kind of building this sculpture would inspire. It would be a four-storey structure with flat roof and cornice, the storeys separated by horizontal projections, slightly set off from one another in the vertical, and their positions given by projecting and receding sections of wall. Under the roof-line a broad band of masonry would run, then curve around the corner and merge with a row of bulls-eye windows. If we think of Schlemmer's *Architectural Sculpture R* as a façade in a nutshell, it would repeat all the exterior elements of the hypothetical building, linking them with elements of the human figure and continually referring them back to this scale-determining centre.

It is apparent from a photomontage in which Hans Leistikow combined one of Schlemmer's paintings with a functionalist façade (Plate 94) that even Schlemmer's contemporaries thought in these terms. This, in fact, was very much in keeping with the artist's own intentions. He had written as early as 1922, 'I can't consider painting buildings. I can't consider building them, either, unless in the ideal form that can be derived from my paintings, which anticipate it.'[26]

Schlemmer was destined to consider both, however, in the context of a group endeavour to which his talents were perhaps better suited than any other artist of his generation—the Weimar Bauhaus. Not only did he provide the famous seal which became the school's official trademark in 1922; he also gave in his paintings a most classical formulation to the goals and ideas of the Bauhaus which was matched by neither Klee or Kandinsky, who had also joined the Bauhaus staff at that time. The head of the newly established school, Walter Gropius, had sent Schlemmer a copy of its programme fresh off the press in May 1919. Gropius envisaged a co-operation of all the disciplines in the arts and crafts towards a common goal—the unified work of art, the great edifice 'in which there was no border between monumental and decorative art'.[27] The basis for this unification was to be a course of training in craft skills, conducted in a great workshop by apprentices, journeymen

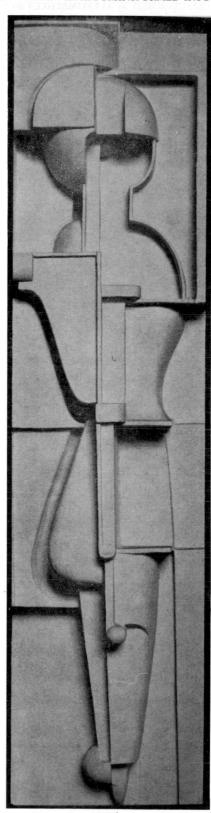

93. Oskar Schlemmer. *Architectural Sculpture R*, 1919. Aluminium, 110 × 35 cm. Staatsgalerie Stuttgart.

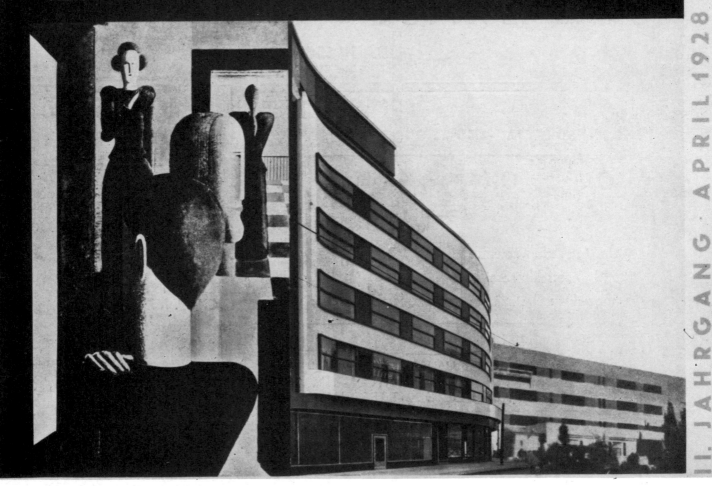

VERLAG ENGLERT UND SCHLOSSER IN FRANKFURT AM MAIN

4

DAS NEUE FRANKFURT

MONATSSCHRIFT FÜR DIE PROBLEME MODERNER GESTALTUNG / 2. JAHRG. 1928

II. JAHRGANG · APRIL 1928

and masters who kept in constant touch with the country's trades and industries. Included in this first Bauhaus brochure was a woodcut by Lyonel Feininger representing the 'great edifice' in quintessence, the goal of all the Bauhaus efforts, a Cathedral of Light.

A year before, Max Beckmann had spoken of a 'new church' which he intended to build with his paintings. In the Bauhaus programme, this church was to be not the work of an individual alone but a comprehensive and collective effort by representatives of all the arts and crafts. The isolation of artists in society was to be overcome by establishing an artistic community with an almost religious character. What Gropius envisaged in 1919 strongly recalls Mondrian's ideas quoted above, on page 13. Gropius hoped for an 'absolute resolution of all opposing tensions', and that the Bauhaus would 'lend form to the idea of the modern world'.[28] This might have been written by Schlemmer who, on this point, indeed, agreed with Gropius *a priori*. The only difference was that he attempted to place this idea on an ethical foundation, by making man the image and measure of all things. A short time later, Schlemmer expressed his aim in the term 'transcendental anatomy', an image of man based on the Platonic ideal which the modern artist would redefine and reshape for his own time. Beckmann, by contrast, called his programme 'transcendental objectivity', an approach which derived every statement about the absolute, the meaning of existence, from an arduous involvement with the visible world. Instead of reconciling tensions and opposites, Beckmann was willing to bear them, in order to experience more of the nature and destiny of mankind. The notion of absolutely resolving opposites would have struck him as antipathetic to life. These two positions, which emerged simultaneously, were fundamentally irreconcilable. The Bauhaus took no notice of Beckmann, nor he of the Bauhaus.

In November 1920 Schlemmer accepted the teaching post he had been offered at the Bauhaus and moved to Weimar. Gropius entrusted him with the fresco and wall-painting class, and later with life drawing. Characteristically, he used this hour to discourage his students from a spontaneous and sensuous reaction, and wrote, 'I shall preach objectivity and ask them not to let their expressions happen in the presence of the nude model.'[29] Study of the nude was to serve as an elucidation of his doctrine of harmony. A former student, Hans Fischli, a Zürich painter and architect, recalled those lessons in Weimar:

The archaic Golden Mean was rediscovered. Le Corbusier had just superimposed it on the façades of old and new

architecture, as a measure of value and scale, in his new book, *Vers une architecture*. He had yet to describe his module, which was derived from the harmony of human proportions. Oskar Schlemmer . . . already revealed this great theme to use in his courses. . . . And to make his approach clear, he demonstrated the systems of the human body in drawings until we could all see how his circles emerged from it. . . . After Schlemmer had proved to us that the construction and proportions of the human body were the most concrete illustration and proof of his theory of harmony, and when we believed him, he let us practise drawing the nude.[30]

The first opportunity to realize his ideas on a large scale, in a form approaching the comprehensive work of art which was the ideal of the Bauhaus, came with Schlemmer's decorations for the vestibule and stairwell of the school's shop building in Weimar. These wall-paintings and sculptures were painted over and destroyed in 1930.[31] Schlemmer now departed from his earlier planar style of representation, and turned to easel painting in the attempt to create a three-dimensional illusion. Characteristically, he filled this illusory space with content. Being more than an image of external reality, it provided him with a medium to represent the forcefield of a process of spiritual development.

The *Supper Party* (1923; Colour Plate 20) is one of the best examples of Schlemmer's style in the early 1920s. He had already explored the subject before the war, in a number of sketches iconographically closely related to the *Last Supper* or the *Emmaeus* scene where the gathering is smaller and more intimate. Schlemmer tentatively approached the theme in three watercolours (Plates 95–7) which are probably rejected studies for a wall-painting done in 1913–14. All three compositions show a room with a table parallel to its rear wall behind which are seated three figures. They are flanked at either end by two other figures.

The female figure at the right is surrounded by a halo in the shape of a pointed arch, probably a vesica. She sits upright, almost rigid, while the attitudes of the other figures express emotional states ranging from awe and astonishment to enlightenment. A vase or jug glows on the table, its illumination probably indicating that like a grail, it contains the divine spirit. Next to it lies a book, open in the expectation that an entry will be made. If the watercolours were indeed made in connection with the wall-painting Schlemmer executed for the 1914 Sonderbund exhibition in Cologne, their theme is clear. The six large paintings were devoted to legends of ancient Cologne, one of which tells of a master architect who had sought in vain to design the great cathedral until the Virgin Mary came to him in order to inspire him. It is not certain whether the watercolours illustrate this legend or not,

94. Hans Leistikow. *Photomontage*, 1928. It combines Schlemmer's painting *Roman Things* and the finance house Telschow in Berlin, built by the brothers Luckhardt and Alfons Anker.

95. Oskar Schlemmer. *Supper Party*, 1913–14. Watercolour, Pen and ink, 20.8 × 26.4 cm. Private collection.

96. Oskar Schlemmer. *Supper Party*, 1913–14. Black watercolour, 21.3 × 28.2 cm. Private collection.

97. Oskar Schlemmer. *Supper Party*, 1913–14. Black watercolour, 21.3 × 28.2 cm. Private collection.

and the final painting in the series indeed diverges from them. It may be assumed, however, that they were inspired by a related idea. The illuminated figure to the right exerts a strange, spiritual power over the others gathered at the table, who communicate not through bread and wine but through vessel and book—a Last Supper at which spirit or idea takes the form of a design or plan.

When in 1922 discussion at the Bauhaus again focused on the 'great edifice', this time in the shape of a Cathedral of Socialism, it was clear that the project was feasible, if at all, only in the distant future. Schlemmer consequently wrote in his diary an essay entitled 'Abkehr von der Utopie' (Utopia Abandoned) in which he demanded that machines for living be built, not cathedrals.[32] Later that same year, in another place, he expanded on this idea:

> God has come to inhabit men—their religion, which is enlightenment and belief in themselves; and their dwellings, which are their churches. Neither pictures of legendary Greek gods and heroes, nor Adorations of the Magi, nor sunsets at Nice, decorate the walls of my rooms, but my own intrinsic feeling of godliness, heroism, life, my worship of the mystical and unconscious, the sunrise and sunset of my soul—these are portrayals worthy of contemporary man. A transcendental human anatomy. . . . Our true subject now is to reveal the psychic aspect. . . .[33]

Schlemmer's *Supper Party* of 1923 probably depicts just such a room, consecrated to the religion of man, in which spirit and flesh would merge in mystic communion. What once would have taken place in a church service has now moved to an austere Bauhaus space—from which, however, saintly images and icons have not been completely banned. On the wall to the left hangs a tiny figure, perhaps an articulated doll, which calls for silence by placing a hand before its mouth and pointing with the other hand towards the illuminated, crystal-line figure in the background as if towards the apparition of an otherworldly spirit whose materialization requires absolute silence and tranquillity. The social environment for this material-ization is provided by the woman and child, and the vessel and book stand ready to receive the spirit or the ordained plan which will develop out of this confrontation of the two realms.

Schlemmer's catchphrases at that time were 'to make the metaphysical cohere'[34] or 'give it body'.[35] He took as an example from the past the great natural scientist and alchemist Paracelsus (1494–1541) whose works he was studying at the time. In a fictitious portrait of 1923 (Plate 98), Schlemmer depicted the great scholar in an attitude of iconic calm, and noted on the back of the picture 'Paracelsus' and 'lawgiver'. Karin von Maur has shown[36] that the position of the hands and

the frontal pose of this Paracelsus derive from both Dürer's *Self-portrait in a Fur Cloak* (Plate 65) and the figure of Giovanni Arnolfini in Jan van Eyck's *Marriage of Giovanni Arnolfini and Giovanna Cenami* (1434). The *Paracelsus* also has an important feature in common with both portraits in that all three figures express, in gesture and pose, something which is general and beyond the individual. Dürer depicts himself in imitation of Christ; Arnolfini is shown taking the Christian vow of marital faith before witnesses; and Paracelsus points to himself as knowing and embodying universal laws. An abstract and spiritual quality becomes flesh and blood in these three figures, assumes an individual form which, in the Arnolfini portrait, continues into the accoutrements of his dwelling.

Schlemmer varied this invocatory gesture in a self-portrait of 1931 (A 463). Here he appears to be ascertaining the midpoint of the image with his right hand, while with his left, placed over his mouth, he demands silence for concentration

98. Oskar Schlemmer. *Paracelsus*, 1923. Oil on canvas, 99 × 74 cm. Staats-galerie Stuttgart.

and meditation. In *Supper Party*, this same gesture was performed by the manikin on the wall, who points with his left hand to the glowing figure in the background, the embodiment of that all-pervading spiritual light which illuminates the austere, worldly room.

If this little artificial figure really can be linked with Paracelsus, the great synthesizer who attempted to prove that natural and universal laws were at work in all varieties of organic life, the process taking place in this room may be said to be pursuing the same ends. The apparition in the background, more light than matter, faces the child and woman frontally, as their opposite principle. They are like materializations of the figure on the rear wall (Schlemmer had married in 1920 and become a father for the second time in 1923), and seem to receive their spiritual complement from it, an illumination to which the perspective lines of the image lead the eye. Under the sign of the little lawgiver, who ornaments the wall of the room like the holy images in churches, the family seems to experience a mutual interpenetration of the physical and metaphysical. Its first product, of course, is the child, while the next will collect in the small vessel standing at the midpoint between the three figures. A further result of this union will probably be recorded in the open book lying next the woman. The number three and the colours blue, red and yellow in combination with black and white, exactly correspond to the canon which Schlemmer had described as being necessary to achieve complete synthesis.

Comparing this to earlier versions of the theme, it is interesting to see that here the spiritual force no longer emanates from a woman but from the background figure, which appears to be male. In two preparatory watercolours (A 132 and A 133) this figure has been more clearly characterized as a man. As in later versions of the subject, the woman tends to assume a protecting, conserving and perhaps even correcting and controlling role within the family. In 1920 Schlemmer wrote to his future wife, Tut,

> Tut will teach Osk what it means to be constant, because he is a terribly inconstant fellow. And he wants to learn it, especially in art, because it is a profound thing. Profundity—that's what counts, and continuity, which is constant development from a profound source.[37]

The emanations from this source collect in the woman, the vase, and in the open book—spiritual substance, illuminated by an aura like those surrounding the heads of the great founders of world religions. Before his marriage Schlemmer noted, 'The closer I am to my work . . . the farther away from people I am; Christ, Buddha and the Greats sacrificed their happiness on earth to their mission—and I have a mission.'[38] Woman, in the person of his wife, saved him from isolation and loneliness, linked him with life, yet without jeopardizing

118

his self-chosen role of emissary from a higher realm. As Schlemmer wrote to his wife the following year,

> I want to connect with the warmth of life and youth, as long as there's time—and I'm thinking of my art when I say this, too. I imagine a beautiful unity in the things to come, and want to set off the mathematical, constructed side of my art by a contact with life, so as not to wake up some fine day lonely among the icy peaks. I want to give my life a style, you know, and hope you will let me do the leading because everything has got to merge—hopes, ideas, dreams; they'll be beautiful, and you'll like them. Empathize with me, become a part of myself.[39]

Schlemmer projected this merger of different levels in the *Supper Party*. His 'transcendental anatomy' involved revealing the psychic or spiritual aspect of the figures through pose and colours, defining their position and function with respect to one another and to the universal order. He exalted a simple interior to the site of a ritual where the general and supra-individual entered into everyday acts. A family's living-room became their sanctum, just as he had envisaged in his contributions to the Bauhaus programme.

It is tempting to compare the *Supper Party* with Beckmann's *Night*, for the latter is basically a feast of love in the tradition of the Last Supper, at which Christ revealed Himself to His apostles and to all humanity in anticipation of His sacrifice. The ritual repetition of this sacrifice in church services is meant to strengthen the tie between God and men. In *Night*, the sacrifice takes place on a table set with plates and cutlery, and the victim is Beckmann himself, sacrificing himself to the world and devoting his pictures to the 'new church'. Like Schlemmer, Beckmann wished to found a new community, but with the difference that he forwent the protection of his family, whom he also sacrificed. He took the risk upon himself alone in order that he might not be forced back onto 'the rack of life'. What to Beckmann was a violent and painful sacrifice becomes to Schlemmer a mystical osmosis. If, in the first case, the family was destroyed, in the second it is constituted. While Beckmann attempted to liberate himself from life without condemning it, Schlemmer seemed able to enter life only through his family which instead of constricting him freed him from his isolation. Beckmann struggled with his essential being like Laocoon with the snakes; Schlemmer attempted from the start to fight down his sensual nature, allowing himself to dance only with shaved head and in rigid costume. He and most of the Bauhaus artists shared the fate of King Midas. If all the food and drink touched by Midas turned to gold, every organic form Schlemmer touched stiffened into geometry. The snakes Beckmann-Laocoon struggled with

shrank for Schlemmer to a thin wavy line drawn by preference with a pointed pen.

The description of Schlemmer's *Supper Party* of 1923 as a semi-religious, meditative chamber piece, also fits most of the easel paintings he was to do during the 1920s. His new programme may be gathered from an entry in his diary which notes his lack of interest in continuing the work on the wall-paintings of the vestibule and stairwell of the Bauhaus shop building. Now in 1925, he intends to develop his art in the direction of 'metaphysical spaces, metaphysical perspectives and metaphysical figures'. These qualities are to unfold in 'abstract spaces of the future' and are to be embodied in 'the multifarious figurations of man'.[40] And the models for these 'figurations' he again found in early Greek, archaic sculpture, which seemed to him the perfect embodiments of his central concern, a representation of 'nude and clothed figures, complementing one another, opposed to one another, overlapping, half right, left, and diagonal'.[41] All the expressiveness of the human body was to be distilled into its simplest, most rudimentary movements and gestures and positions—reclining, seated, standing and walking.

Schlemmer's intention is best illustrated in a painting such as *Retreat* (Plate 99) of 1925, the first in a series with this title. The motif of movement is suggested in the foreground, where the head of a woman walking by projects into the picture plane. From there to the next level of depth the image grows perceptibly more peaceful—a dark, male figure seen from the back intersects the bright field of the large window in the rear wall and projects beyond the top edge of the image. Though the figure has not yet entered the interior zone of the picture space, it is closer than the passing woman. The shimmering white figures in the middle ground are sharply separated from this front zone with its dark, heavy shadow, and their poses, seated and reclining, relate them more closely to each other than to the standing figures. The two white figures merge effortlessly with the surrounding space, no longer being held in thrall by any one field of the checkered floor. Compared to the figures in the foreground, they seem almost to hover above it. Even more important, they are closer to the light source, an illumination in which all contours and constrictions of the figures dissolve. If the interpretation is correct, the simple 'figurations' of *Retreat* represent the course of human life. The young will go their way oblivious of the light which marks the end of existence; then, as they grow older, they will confront it and gradually release their hold on life to merge effortlessly with the source. Light in Schlemmer's paintings very frequently symbolizes the Other Realm behind and beyond existence, as in *Supper Party*, with its illuminated figure in the background which, as it were, brings into the room what lies beyond the wall. Like Buddha or Christ, the figure is seated in

an aura, that part of the great, universal light possessed and brought into the world by an individual.

This first *Retreat* serves as a spiritual exercise on the path towards this universal light, to which the Bauhaus, whether in Schlemmer's sense or not, attributed an almost metaphysical significance.

In 1925 Schlemmer gave classical expression to his new programme in the painting *Five Figures*, which was subtitled *Roman Things* (Colour Plate 21). Here, instead of a closed and interrelated group as in the *Supper Party*, or preparations for an eternal merger with the bright focus of existence, he depicted the typical attitudes of the two sexes as they gradually realize their purpose in the world. The austere Bauhaus space, the 'space of the future', becomes the site of worldly rites of initiation.

The female figure, standing with her back to the spectator on the terrace outside, resembles, and probably not by chance, a similar figure by Caspar David Friedrich. It has already been noted that Schlemmer felt a peculiar affinity with the mystical attitude of the Romantic artist. The young woman in the

99. Oskar Schlemmer. *Retreat*, 1925. Oil on canvas, 111×90cm. Staatsgalerie Stuttgart.

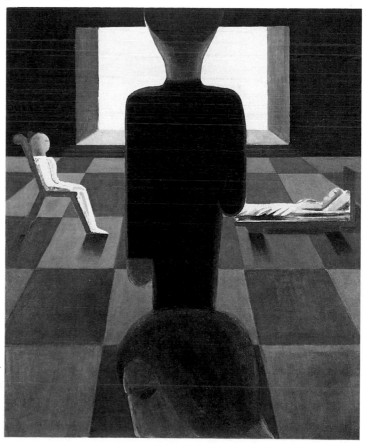

painting turns towards the open sky, which here certainly does not represent the sublime light but the blue-green of nature. The figure's long, flowing hair might lead us to conclude that she has not quite composed herself to face the others and attract their attention, but gives herself up to contemplation. The floor of the terrace which separates her from the railing implies that her receptive mood is not without detachment. She looks out upon nature from a certain distance.

The second female figure, standing within the room, embodies a quite different attitude. She faces the spectator and the two young men in the foreground, and unlike the first woman, she has arranged her coiffure carefully, prepared herself to face the men. Gazing straight in front of her, her hand on her heart, she appears to be in possession of something that she has carefully coveted up to now, knowing that someone might soon turn to her, or she to him. She stands expectantly near the door that leads outside, by no means ignoring the connection it offers to nature.

The male counterpart to the first female figure is found in the left foreground, where instead of nature he contemplates what might be his own image in a mirror, or a picture on the wall. This contains the fifth figure of the title. The significance of the figure on the wall is that it represents the young man's opposite, whether it be his reflection or a separate image. If the figurations of this painting represent the various stages of male and female self-identification and acceptance of sex-roles, then woman finds herself in nature while man turns to his own image or to an ideal image that anticipates the result of his search for identity. As we know from his diaries and work, Schlemmer himself took this path. Out of an archaic torso, between the poles of male and female, art and nature, he developed the small figure in *Composition on Pink*, which in turn appeared, as a patron of the synthetic process, in the family gathered in *Supper Party*. The shadow on the wall in *Five Figures* may well be essentially related to these preceding figures, which continue to appear in the background of many of Schlemmer's paintings. Finally, the male and female roles just described correspond to those already encountered in *Supper Party*. Here too, the woman waits, protects, gathers into herself. Her opposite is not art but nature.

While the male figure in the foreground is dressed in black and rests his right hand on his shoulder in a gesture of surprise or concentration, the other male figure represents a complete contrast in terms of colour, gesture and orientation. This man has turned away from the image on the wall and is striding towards the right, out of the picture, out of the room containing the others. Is his white glow a sign that he has recognized his mission, as Schlemmer would have put it? Has he become aware of his destiny, his path, the direction he must take? At all events, the colour white distinguishes him not only from the man before him but from the two women as well, and gives him a special position within the picture. If his upright posture and determined look are added, his light colour indeed separates him entirely from the context. The others may very well soon meet and merge as a result of natural attraction; they are already linked together by the red floor. The man in the middle, however, is going his own way, and it leads him out of the group.

This isolation of a single figure is, admittedly, very rarely found in Schlemmer's mature work. In general he was concerned to portray the interrelation of figures, a mutual attraction that leads them to form a group or community. This was how he had envisaged the Bauhaus, as a school in the widest sense, where not only would artistic means to reshape the world be devised but also new forms of human community and co-operation. And, as Schlemmer said, the new house, the dwelling of the future, was to be a church in which man was God. This ideal informed his work, particularly one of his most beautiful and well-known paintings, the *Stairs at the Bauhaus* of 1932 (Colour Plate 22). This was painted three years after leaving the Bauhaus, after the school had been closed by the National Socialists who had come to power in Thuringia in 1930. The image was a glance back to the key stage of his career; and at the same time, it was a vision of the ideal school, what the Bauhaus might have become if its theoretical programme could have been put into practice.

The picture takes us into the stairwell of the newly completed school in Dessau, designed by Walter Gropius in 1926. Almost ten years previously Schlemmer had decorated the vestibule and stairwell of the old Bauhaus in Weimar (by Henry van de Velde), with wall-paintings and sculptures which had since been destroyed. There he had conceived semi-mythical figures amongst which the students mingled, figures whose dignity and calm challenged emulation. Now, these qualities had become embodied in the students themselves. After years of concentrated effort, Schlemmer had succeeded in developing a type of figure that actually approached the dignity of archaic torsos while avoiding the lifeless rigidity to which the latter were so prone. He was saved from this danger by the variety of his 'figurations'.

At the foot of the stairs, in the foreground, a boy passes by. Only part of his head is visible, as the rest of the body has been cut off at the picture edge. Next to him appears a girl in white, who seems to hesitate for a moment. To her right a male figure, also intersected by the edge of the canvas, begins to climb the stairs, reaching out to pull himself up.

The principal motif of climbing upward, which can be understood in a more than literal sense, is developed in three other figures. Between one in red and another in black farther up, both of whom are caught in more or less stationary poses,

stands a boy in a red shirt or sweater. His movements are more extreme than those of the others. His protruding elbows repeat the motif of the turn in the stairs, and his head, turned away from the axis of his body, relates him to areas of the space invisible to the spectator. Despite the agitation of his upper body, he appears to stand still, as if not sure where to turn. Schlemmer may be alluding here to someone of a sensual and instinctual nature, who longs to experience everything around him, yet whose voracious perception prevents him from making a choice. He may be a vacillating personality, or, as Schlemmer described himself, a 'roamer'. Another figure, finally, hurries upward beyond the bend in the stairs.

The true theme of the painting, besides that of climbing and the differences which variations in temperament lend to this act, is the confrontation taking place between the central, upward-striving group and a boy in blue coming down—or rather, dancing down—to meet them. His pose reveals more concentration and self-control than any of the others seem to have. He walks erect, his left arm locked with his right behind his back for support, his pose echoing with apparent ease and nonchalant elegance the main axes of the building, horizontal and vertical. Poised on tiptoe, he gives the impression of having overcome the force of gravity. He would be an ideal dancer in Schlemmer's ballet, and indeed perfectly illustrates its conception: to put human beings in harmony not only with the laws of the universe, but with the modern, functional, mind-mastered world. Light on his feet, both freer and more self-possessed than the others, this dancer has been more strongly conditioned by the school, its ideals, and his surroundings than his fellow students. He is a living expression of the aims of the Bauhaus as Schlemmer conceived them. How stiff, awkward and inhibited the other figures in the painting seem by comparison. The boy in blue is an embodiment of all the artificial figures with which Schlemmer, as if with a leitmotif, had anticipated his ideal in his earlier work. He is the bringer of the new spirit, the light, bright colours of the school, descending from the upper floors of the building to show these hesitant beginners what work here might lead them to. Or might have led them to for by the time Schlemmer executed the painting the Bauhaus had long succumbed to inner frictions and had also been closed by the Nazis. His own demise in 1929 had marked the beginning of the end. He felt unable to continue teaching when Walter Gropius was replaced by Hannes Meyer as the new director in 1928.

Another wall-painting aptly illustrates Schlemmer's conception of art and, indeed, his conception of the world. It is not a painting in the narrow sense but a wall decoration in which painting plays a very secondary role. In 1930–1, Schlemmer designed three figures for the living-room wall of Dr Erich Rabe's residence in Zwenkau, near Leipzig (Plate 108).

Between the male figure on the left and the female profile on the right we again find a manikin, an artificial figure of the kind seen in the 1916 *Composition on Pink*, and, with variations, in other paintings. Wherever it appears, this figure signifies an ideal, an image anticipating a universal balance of opposing forces and principles. Yet nowhere is its significance and function so clearly defined as here, and nowhere has Schlemmer's philosophy of art found such lucid expression.[42]

The male figure on the left, formed of steel wire, is fastened eight centimetres from the wall. Contours, axes and joints of the figure are indicated, and Schlemmer has sprayed diffuse shadows on the wall along the axes of limbs and torso. This creates alternating patterns of light and dark that make the figure seem almost three-dimensional. Yet another effect is also achieved: the figure is illuminated by sunlight from the left (Plate 100), and as the sun changes its position, the shadows

100. Oskar Schlemmer. *The Wall-Piece in the House of Dr Rabe*. Photograph.

it casts move along the wall. These cast shadows are sharp, and their course can be easily followed—until they enter the spray-painted shadows along the figure's axes in the centre, where the actual shadows of the wires are lost in the obscurity of the artificially applied ones. In other words, while the contours of the figures are clearly perceived to move along the light-coloured wall, its axes, its interior structures, seem to adhere to the wall and to stand still. Hence the figure appears only partially subject to the laws of space and time which determine existence.

The smaller, voluminous metal figure, by contrast, always casts a precisely outlined shadow on the wall. It occupies a clearly defined space, and also exists in time, reflecting the impinging light and changing in appearance with the position of the sun.

The third element is a profile made of a thin metal ribbon with its edge to the wall. This casts a shadow whose inner edge is always slightly blurred, no matter at what angle the sunlight falls on it. The 'sundial effect' of which Schlemmer spoke when describing the composition as a whole, is hardly notice-able in this case. Finally, there is a pair of crossed axes, made of wire, located midway between the small figure and the profile. Its intersection has been expanded to a sphere which in turn is surrounded by three concentric circles. The cross, too, stands out from the wall about eight centimetres and casts a sharp shadow.

Herzogenrath assumes that Schlemmer's composition was inspired by Ricarda Huch's *Vom Wesen des Menschen* (On Human Essence), a book whose crucial sentences are these:

> The cosmos is a trinity of spirit, nature, and soul; these three essential components exist only in conjunction. Nature is physical and appears in the realm of space; spirit is intrinsic to nature and exists beyond space and time; soul is what links them, and it moves in the realm of time.[43]

It has already been noted that Schlemmer regarded the plane, in this case a wall, as a symbol of the cosmos. The crossed axes with their central sphere probably stand for that intrinsic, immutable system of universal order posited by the human mind for purposes of orientation. The symbol had already appeared, in simpler form, in the *Composition on Pink*. The large profile on the right may be interpreted as symbolizing the never-ending fertility of creation, nature, which Schlemmer associated with the feminine. The male figure to the left, constructed of wire, certainly represents the spirit which, partially subject to space and time but eternal in its basic lineaments, creates in accordance with universal and natural law. 'Soul' would be too narrow a term to describe the small metal figure between the two others, though it does serve to link them. It might be characterized as a product of the male

mind, which has placed it in the categories of space and time following the laws of nature and the cosmos. Indeed, as Ricarda Huch continues,

> Every work of art, like a human being, is a tripartite organism consisting of spirit, nature and soul; or to put it differently, emerging out of mind and nature as if from father and mother, it is unified through soul, the new-born person.[44]

Soul, work of art, and man born anew, are one and the same thing in this definition, which must have appeared concrete and convenient to Schlemmer. He had indeed achieved similar formulations in his early pictures. The small, androgynous figure in the work under discussion is basically a repetition of the little figure in *Composition on Pink*, placed in a more consciously designed symbolic context. It represents, moreover, a merger of child and wall-figure in *Supper Party* of 1923, and hence explains the essence and purpose of all of Schlemmer's artificial figures, another of which appears in *Roman Things* of 1925. Finally, the figure is the quintessence of all the meanings and functions which lend to the dancer in *Stairs at the Bauhaus* his attitude of ease and freedom and link his pose with the main axes of the building, the system of order of the New World; soul, artificial man, New Man.

It has been remarked that iconography could provide no clues to the significance of this composition, since the idea on which it was based was philosophic and literary and not artistic or visual.[45] Convincing as Ricarda Huch's hypothesis may appear, it certainly does not exclude the possibility of icono-graphic models. Two such models deserve mention; firstly, because they have not previously been detected, and secondly, because they provide an even more lucid explanation of Schlemmer's conception than that of Ricarda Huch.

The wire figure on the left, whose hieratic effect is derived from an austere profile head set on a frontal torso very much in the style in which the Egyptian pharaohs were depicted, goes back to 1916. In that year, Schlemmer worked out its basic features, developing them to classical form by 1919. In the drawing *Homo, Figure T* of 1919–20 (Plate 101), the figure's legs are pulled under its body, and its left arm is bent to the vertical. In the wall-painting, Schlemmer extends the figure's right leg and has its left hand proudly present its new creature. While *Homo* is a figure whose pride remains within narrow limits, a pride in being free of gravity and of nature, in the new version it becomes an active, self-confident creator. It is unlikely that, as many observers have thought, the larger format and different environment were alone responsible for the change. It is clear that a new conception has materialized here.

To begin with, the *Homo* of 1919 resembles the image of Adam familiar to us from Michelangelo's Sistine ceiling, as

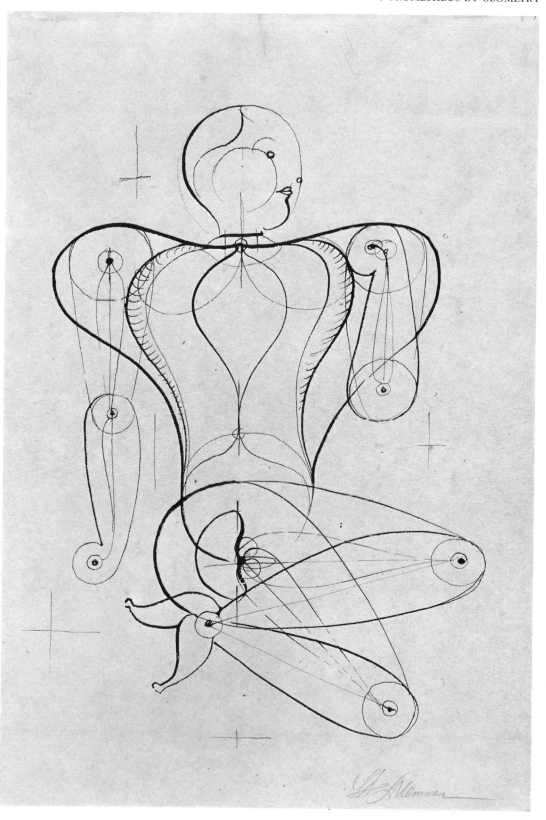

101. Oskar Schlemmer. *Homo, Figure T*
1919–20. Indian ink on transparent
paper, 41.2 × 29 cm. Staatsgalerie
Stuttgart, Graphische Sammlung.

102. Michelangelo. *Adam.* Detail from Sistine Chapel ceiling, St Peter's, Rome.

well as from many other examples of Christian iconography (Plates 102–4). This Adam is not merely a passive vessel but a conscious human being. At the moment he receives his soul from God, he reacts—he recognizes his Creator. This act of recognition raises him from the ground, and soon he will stand, master of the world. Yet for Schlemmer, a meeting with his Creator could not apparently be so direct as it was for Michelangelo. He had always said that God had to be shifted into men, implying that they themselves would become creators. He seemed even to mistrust the Christian God of Creation, for if he had not, he would never have spoken of the necessity to create a new world, a new church and a new man.

Since the composition itself anticipates these innovative new conceptions, its model must antedate Christian iconography. If we trace depictions of the process of creation farther back in time, we come to Prometheus, the teacher and shaper of men. A sarcophagus relief in the Capitoline Museum in Rome shows him holding one of his creatures on his knee (Plate 105). Athena approaches from the right to lend the figure a soul, in the shape of a butterfly, which transforms the

103. Adam. Detail from a relief by Jacopo della Quercia, *c.* 1430. S. Petronio, Bologna.

104. Adam. Detail from an ivory diptych, *c.*A.D.400. Museo Nazionale del Bargello, Florence.

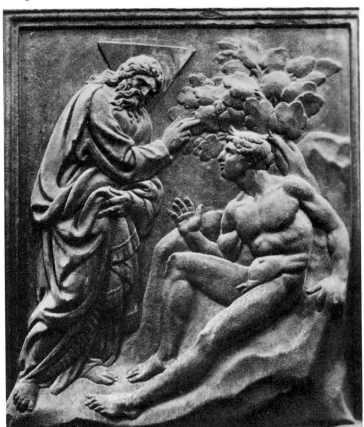

product of art into a human being. The pose of this Prometheus corresponds in many respects to Schlemmer's *Homo*, though the latter's similarity to Michelangelo's Adam is even greater.

Schlemmer is unlikely to have known of this depiction, but he was certainly familiar with the scheme. This is confirmed by a glance at Vollmer's *Wörterbuch der Mythologie* (1874), which appeared in several editions and was a standard work in most German libraries. Under the heading 'Prometheus' (p. 390), the group of three figures appears with a clarity that leaves nothing to be desired, reproduced from a Roman oil-lamp (Plate 106). And in Roscher's *Ausführliches Lexikon der Griechischen und Römischen Mythologie*,[46] we find the same group again in a slightly different version (Plate 107). Comparison shows that in this case, too, Schlemmer's figure is orientated more closely to Adam. In it he links the antique myth with the biblical story of the Creation, making a creator of the creature represented as the male spirit in the wall-piece.

His product, a product of the mind, emerges in a dialogue with nature yet independent of it. Instead of representing nature as raw material, Schlemmer gives it a shape, a face, conforming with his belief that spirit, mind and idea were inherent in nature. And in giving the profile in the piece such obviously classical features, Schlemmer may be relating the work to the model of Athena, who in turn was the goddess of moderation and order. This face confronts the masculine

105. *Prometheus*. Detail from a Roman sarcophagus, A.D. 290–330. Museo Archeologico, Naples.

106. *Prometheus*. Roman oil lamp. Museo Capitolino, Rome.

107. Roman oil lamp. From Roscher's *Ausführliches Lexikon der Griechischen und Römischen Mythologie*.

108. Oskar Schlemmer. *Design for the House of Dr Rabe*, 1930. Pencil and coloured pencil on cardboard, 56.4 × 66.5 cm. Private collection.

mind, whose bright substance had already longed for materialization in *Supper Party*—a longing to create a work that could be stilled only by union with woman. These two opposite forces and principles, complementing each other and merging, would finally bring forth a new human being, animated with a soul, whose image the work anticipates. Schlemmer's wall-piece, as a work of art, embodies the entire process and its

essential factors. It challenges the residents of the house to participate, at least in thought, in a process that would make them creators of art and new life. Their living-room becomes a sanctum in which God is shifted into creative man and Adam, His creature, becomes Prometheus the creator (Plate 89). The wall-piece describes its spectator's task in all essential details; as soon as the sun rises, the challenge that must be met with every new day becomes clear. And when the light eventually falls on the little, shining figure, Phainon will appear, the Glowing

126

One, Prometheus' most famous creature whom the gods exalted to the stars.

If this conception is compared with that of Max Beckmann, which sent the latter on a search for his true self, the difference becomes obvious. Like Schlemmer, Beckmann thought of himself as a creator, a god, though he included his own, sensuous nature in the task this idea entailed. Schlemmer's god-man is the human spirit or mind which sees its perfection in a harmony with the eternal laws of the cosmos. Schlemmer defined these laws with the help of a symbolic geometry, and they seemed absolute and given to him. Beckmann searched for the same laws throughout his life, without ever being certain he had found them. He lived through the torments of an imperfect world in an attempt to find himself. Schlemmer denied in his images the imperfection of both the world and man. While Beckmann's symbol was the artist crucified, Schlemmer's seal was the androgynous torso, man made whole by geometry.

The consequences of these divergent conceptions are equally clear. By ignoring human imperfection and with it his own human reality in favour of spirit, mind and idea, Schlemmer limited the effect of his work to a few people who shared his belief in the feasibility, or at least the validity, of his utopia. When this group of like-minded people was dispersed, the artist and his utopian conception fell into that same bottomless black pit that had gaped before Beckmann's eyes during the war. Schlemmer had refused even then to countenance it. Beckmann would very probably have described Schlemmer's approach as belonging to that pile of philosophical junk which he, Beckmann, was about to jettison for good.

After leaving the Bauhaus in 1929, Schlemmer went first to the Academy of Art in Breslau. An emergency act of the Prussian government led to the closure of the school on 1 April 1932. Schlemmer accepted a position at the United National Schools of Art in Berlin. Under pressure of political events he was first given compulsory leave of absence in April 1933, and then, in August, dismissed without further notice. He retired with his family to a house near Badenweiler. Depressed by financial troubles, he was forced to look on as the Nazis attacked his work. He suffered terribly from his isolation and the criticism of his art. In June 1933 he noted:

> Painting is in crisis, like the entire present day. At times I've lost my faith in it, considering the times in which we are living. Who is it addressed to now? The small, select group has been terribly decimated. The great link with the people we once had no longer exists.[47]

Schlemmer wrote to Gottfried Benn, who publicly supported the Nazis in 1933, asking for help in dealing with the harassment of the Nazis:

> Disillusion and uneasy doubt have settled on artists' idealistic hopes, and the number is increasing of those who have lost all hope, who see the ideals in which they believed and for which they fought obstructed for a long time to come. . . .[48]

He felt unable to emigrate, since his ties with Germany and its culture were too strong. The erosion of his ideals and his increasing isolation were accompanied by a weakening in his art. His painting became more emotionally coloured, and agitated—but the approach was basically foreign to his nature, and the result unsatisfactory.

Only once, shortly before his death, did Schlemmer achieve new heights with a new motif. This was in his series of *Windows* (Colour Plate 23). In his diary, he wrote of the inner change that led him to the world of appearances, which he attempted to capture to a greater degree than previously in these paintings:

> Now that I can no longer believe in the sole saving grace of an abstraction like Picasso's and no longer find the courage to repeat the modernisms of yore, the visible world is beginning to dawn on me in a strange way, in all its compression and surreal mystique.[49]

Schlemmer painted the *Windows* in 1942, in Wuppertal where in 1940 he had managed to find relative security working in a paint factory. The images record his actual situation, showing glimpses through the windows of neighbouring apartments from whose life he felt excluded and which, as he said, revealed 'the miracle of the visible' to him. This revelation might well have shown him a new path for his art. However, in early 1943, Oskar Schlemmer died, worn out by material cares, and heartbroken in his struggle for artistic and spiritual survival in a period of terror, lack of recognition, and loneliness.

NOTES

Notes to Chapter I

1. *Berliner Tageblatt*, 16 April 1912.
2. Klaus Gallwitz, 'Beckmann vor Beckmann', *Max Beckmann—Die frühen Bilder*, exhibition catalogue (Bielefeld and Frankfurt, 1982), pp. 147–55.
3. Günther Rühle, 'Wie geheuer ist die Welt?', *Frankfurter Allgemeine Zeitung*, 26 January 1983.
4. On the influence of Nietzsche's philosophy on Beckmann's early work, see, Ernst Gerhard Güse, *Das Frühwerk Max Beckmanns. Zur Thematik seiner Bilder aus den Jahren 1904–1914* (Frankfurt and Berne, 1977). Also, by the same author, 'Das Kampf-Motiv im Frühwerk Max Beckmanns', *Max Beckmann—Die frühen Bilder*, op.cit., pp. 189–201.
5. Wassily Kandinsky, *Über das Geistige in der Kunst* (Berne, n.d.), pp. 37–8.
6. Ibid., p. 43.
7. Ibid., p. 127.
8. Wassily Kandinsky, 'Über die Formfrage', *Der Blaue Reiter* (Munich, 1912; documentary reprint ed. Klaus Lankheit, Munich and Zurich, 1979), p. 148.
9. Carl Einstein, *Die Kunst des 20. Jahrhunderts* (Berlin, 1926), p. 104. Einstein was one of the most important promoters of modern art in Germany before the First World War.
10. Quoted in Peter Beckmann, *Max Beckmann* (Nuremberg, 1955), p. 16.
11. Max Beckmann, *Briefe im Kriege* (Munich, 1955), p. 15.
12. In her investigation of the battle motif in Beckmann's work, Barbara Buenger has shown that for him and many other men of his generation war was a particularly male form of 'self-articulation, self-determination, and self-definition'. With regard to his *Amazonenschlacht*, she concludes that 'For him, too, the Amazonomachy was a virile struggle with female dynamos in which man—in the costume of civilisation—is implicitly linked with the creative artist and culture, and woman with the lower, natural "vital forces".' Artist and warrior are one and the same in this struggle to achieve self-determination. See Barbara Buenger, 'Max Beckmann's "Amazonenschlacht": Tackling "die große Idee"', *Pantheon* XLII, 2 (April, May, June 1984), pp. 142 and 148.
13. Thomas Mann, 'Gedanken im Kriege' (1914), *Essays*, vol. 2 (Frankfurt am Main, 1977), p. 23.
14. Ibid., p. 25.
15. Ibid., p. 26.
16. Carl Einstein, op.cit., p. 87.
17. F.T. Marinetti, 'Gründung und Manifest des Futurismus' (1909), manifesto, point no. 4, in, *Futurismus 1909–1917*, exhibition catalogue (Kunsthalle Düsseldorf, 1974), unpaginated.
18. Ibid., note 9.
19. F.T. Marinetti, 'Zerstörung der Syntax—Drahtlose Phantasie—Befreite Worte—die Futuristische Sensibilität' (1913), ibid., point no. 10.

20. F.T. Marinetti, 'Technisches Manifest der futuristischen Literatur', ibid.
21. E.L. Kirchner, 'Über die Malerei', *Chronik KG Brücke* (1913), p. 6. Quoted in *E.L. Kirchner*, exhibition catalogue (Berlin, Munich, Cologne, Zurich, 1979), p. 67.
22. Quoted in Hans von Brescius, *Gerhart Hauptmann—Zeitgeschehen und Bewußtsein in unbekannten Selbstzeugnissen* (Bonn, 1977), p. 53.
23. Carl Einstein, op.cit., pp. 112–13.
24. Klaus Lankheit, *Franz Marc Schriften* (Cologne, 1978), p. 204.
25. Quoted in Hans von Brescius, op.cit., p. 68.
26. Ernst Jünger, 'Der Kampf als inneres Erlebnis' (1922), *Werke*, vol. 5 (Stuttgart, n.d.), pp. 14–15.
27. Max Beckmann, *Leben in Berlin, Tagebuch 1908/09*, ed. H. Kinkel (Munich, 1966), p. 34.
28. Sigmund Freud, 'Zeitgemäßes über Krieg und Tod' (1915), *Gesammelte Werke* X, 1913–17 (Frankfurt am Main, 1963), p. 331.
29. Ibid., p. 354.
30. Ibid., p. 336.
31. In her study *Painters and Politics—The European Avant-Garde and Society, 1900–1925* (New York and Amsterdam, 1976), Theda Shapiro puts the question thus: 'Why were German painters so wrenched by the experience of war, while the French, no less enthusiastic at first and disenchanted later, remained untouched, at least psychically?' (p. 157). She sees the tendency of German artists to seek underlying meanings as one reason for the difference between the artistic traditions of the two countries. Also, unlike their French counterparts, they had not seen military duty before the war and were therefore entirely unprepared for the horrors they witnessed. Finally, many German artists served in the medical or ambulance corps and experienced war from its worst side 'without the thrill of the fight' (p. 157).
This would seem to be confirmed by the difference between Dix's and Beckmann's drawings, which will be considered later. Theda Shapiro also points out that the French army employed many visual artists in its camouflage division, adding that a Cubist-influenced painter was even credited with inventing French camouflage schemes. This was Victor Lucien Guirand, who later recalled: 'In order to deform objects totally, I employed the means cubists use to represent them. This later permitted me, without giving reasons, to engage in my [camouflage] section some painters with an aptitude—because of their particular vision—for denaturing any sort of form.' By the end of the war, some 3,000 artists were working on camouflage for the French army. (Theda Shapiro quotes the passage above from *Simple histoire de la grande guerre* [Hachette: Paris, 1962], pp. 510–11 and p. 139.)
32. Quoted in Theda Shapiro, op.cit., p. 141 (the translation is hers).

33. Quoted in Donald E. Gordon, *E.L. Kirchner* (Cambridge, Mass., 1968), pp. 26–7 (translation slightly amended. J.G.).
34. Ernst Jünger, *Der Arbeiter* (1932; reprinted Stuttgart, 1982), p. 109.
35. Sigfried Giedeon, *Die Herrschaft der Mechanisierung* (Frankfurt am Main, 1982), pp. 62–3.
36. 'Many people nowadays seem to think that the terms "Neue Sachlichkeit" and "Magischer Realismus" were coined to describe two different types of the new objective painting, and trouble their brains about what fits into which category. Their sleepless nights, I believe, might be put to better use—this particular dilemma is not one. Roh's term [Magischer Realismus] and Hartlaub's term [Neue Sachlichkeit] are different names for the same whole. One need not even make the qualification that Roh's category is the larger, since the term Neue Sachlichkeit was also originally applied to the entire European phenomenon. . . . 'It is . . . quite immaterial whether the objective impulse to paint realistically was one form or another of a critique of conditions, or expressed a devoutly poetic, romantic or melancholy feeling towards reality. The impulse might just as well have been one of pure reportage.' Fritz Schmalenbach, *Die Malerei der Neuen Sachlichkeit* (Berlin, 1973), p. 73 and pp. 31–2.
37. Piet Mondrian, 'Die Neue Gestaltung in der Malerei', *De Stijl* (Delft), vol. 1, no. 1, 1917; reprinted in *Tendenzen der zwanziger Jahre*, exhibition catalogue (Berlin, 1977), part I, pp. 85–6.
38. Quoted in Sibyl Moholy-Nagy, *Laszlo Moholy-Nagy—ein Totalexperiment* (Mainz and Berlin, 1972), pp. 30–1.
39. Henryk Berlewi, 'Mechano-Faktur', *Der Sturm* (Berlin), vol. 15, no. 3, 1924; reprinted in *Tendenzen der zwanziger Jahre*, op.cit., part I, pp. 177–8.
40. Franz Roh, *Nachexpressionismus—Magischer Realismus* (Leipzig, 1925), pp. 37 and 39.
41. Curt Glaser, 'Otto Dix', *Kunst und Künstler* (Berlin), no. 25, 1927, p. 131.
42. Ernst Jünger, 'Das Abenteuerliche Herz' (first version, 1927), *Sämtliche Werke*, vol. 9 (Stuttgart, 1979), p. 87.
43. Raoul Hausmann, *Am Anfang war Dada*, eds. G. Kämpfe and K. Riha (Giessen, 1972), p. 56.
44. Willi Wolfradt, 'Berliner Juryfreie Kunstschau/ Sezession', *Der Cicerone* (Leipzig), vol. 16, 1924, pp. 144–5.
45. Christopher Green, *Léger and the Avant-Garde* (London, 1976), p. 245.
46. Ibid., p. 249.
47. On the regional isolation of these artists, see Fritz Schmalenbach, op.cit., pp. 14–16 and Wieland Schmied, *Neue Sachlichkeit und Magischer Realismus in Deutschland 1919–1933* (Hanover, 1969), which treats the style from the beginning as a regional phenomenon.

48. Jean Clair, 'Chronos und Mnemosyne', in *Giorgio de Chirico der Metaphysiker*, exhibition catalogue (Munich, 1983), p. 81.
49. Giorgio de Chirico, *Hebdomeros* (Paris, 1929; Berlin, 1969), pp. 122–3.

Notes to Chapter 2

1. The Löffler numbers refer to Fritz Löffler, *Otto Dix 1891–1969 Oeuvre der Gemälde* (Recklinghausen, 1981).
2. Dietrich Schubert, *Otto Dix* (Reinbeck, 1980), p. 24. Schubert's doubts are not shared by other writers.
3. Interview with Otto Dix, *Über Kunst, Religion und Krieg* (December 1963). Quoted in Diether Schmidt, *Otto Dix im Selbstbildnis* (East Berlin, 1978), p. 237.
4. Friedrich Nietzsche, preface to *The Joyous Science*, vol. 6 (Munich, 1886; Collected Works, 11 vols.) p. 21.
5. Nietzsche, *The Joyous Science*, op.cit., p. 22.
6. Dix is believed to have planned a bust of Nietzsche as late as 1966, during his last visit to Dresden. The plan was never realized. See Fritz Löffler, *Otto Dix in Dresden, Ansprache zur Eröffnung der Galerie der Stadt Stuttgart* (Hans Thoma Gesellschaft: Reutlingen, 1981), unpaginated.
7. Diether Schmidt, *Ich war—ich bin—ich werde sein* (East Berlin, 1968), pp. 43–4.
8. Diether Schmidt, *Otto Dix im Selbstbildnis*, op.cit., p. 37.
9. Dietrich Schubert, op.cit., p. 24.
10. Ernst Jünger, 'Der Kampf als inneres Erlebnis' (1922), in *Werke*, vol. 5 (Stuttgart, n.d.), p. 39.
11. Ibid., p. 18.
12. Nietzsche, op.cit., 'Wille zur Macht', no. 1066, *Nietzsches Werke* vol. XV. (Leipzig, 1904).
13. Jünger, op.cit., p. 40.
14. Otto Conzelmann, 'Ein grosser Zeichner', *Otto Dix*, exhibition catalogue (Städtische Galerie Albstadt, 1976), unpaginated.
15. Karl Heinz Bohrer, *Die Ästhetik des Schreckens* (Munich and Vienna, 1978), p. 1.
16. The Karsch numbers refer to Florian Karsch (ed.), *Otto Dix, Das graphische Werk* (Hanover, 1970).
17. Ernst Jünger, *Feuer und Blut* (Berlin, 1929), p. 81.
18. Otto Conzelmann has shown that Nietzsche not only had a great influence on Dix's work in general but even determined his choice of motifs right down to the late landscapes. See Otto Conzelmann, 'Nietzsches Nachklang in den Landschaften', in *Der andere Dix—Sein Bild vom Menschen und vom Kriege* (Stuttgart, 1983), pp. 224ff.
19. Ibid. Conzelmann is certainly justified in maintaining, in contrast to those who see Dix's work primarily in terms of social criticism, that Nietzsche's influence remained predominant through the 1940s. He denies, however, that Dix's attitude to Nietzsche changed. I believe that prior to the First World War Dix took Nietzsche's philosophy to be a kind of doctrine of salvation, as indicated by the motif of the Dionysian hero which occurred in his work so frequently before 1914 (*St Sebastian, Self-portrait as Mars*) but disappeared from it after 1918. Though Dix may have found

fauns, satyrs and nymphs in post-war society, he found no Dionysus. His use of religious motifs from 1943 bears witness to his continual search for a plan of redemption or salvation of some kind.
20. Hans Kinkel, *Vierzehn Berichte* (Stuttgart, 1967), p. 75.
21. Quoted by Otto Conzelmann, op.cit., p. 133.
22. Ibid.
23. Ibid.
24. Fritz Löffler, 'Otto Dix—Der Krieg', in *Otto Dix*, exhibition catalogue (Städtische Galerie Albstadt, 1976), p. 14.
25. See Schubert, op.cit., p. 70.
26. See Lothar Fischer, *Otto Dix—Ein Malerleben in Deutschland* (Berlin, 1981), p. 30.
27. In his autobiography, George Grosz describes a veterans' meeting that took place annually at Marburg which was probably typical of Germany as a whole. It was a traditional drinking bout during which the disabled men sang patriotic songs and, when the right pitch had been reached, unstrapped their artificial limbs, took potshots at them, and raised three cheers to their glorious army days. See George Grosz, *Ein kleines Ja und ein großes Nein* (Reinbek, 1974), p. 102.
28. Bernd Weyergraf, 'Otto Dix, Krieg und Nachkriegszeit', in *Otto Dix—Zwischen den Kriegen*, exhibition catalogue (Haus am Waldsee: Berlin, 1977), p. 20.
29. Manuscript by Felixmüller, January–February 1920, archive of the Germanisches Nationalmuseum, Nuremberg. Quoted in Lothar Fischer, *Otto Dix—Ein Malerleben . . .*, op.cit., p. 28.
30. Eberhard Roters, 'Aspekt Großstadt', exhibition catalogue (Berlin, 1977), unpaginated.
31. Paul Westheim, 'Otto Dix', *Das Kunstblatt*, no. 10, 1926, p. 145.
32. Otto Dix, 'Gedanken zum Porträtmalen', *Internationale Bodensee–Zeitschrift* (Amriswil), March 1955, pp. 59–60.
33. Maria Wetzel, 'Otto Dix—Ein harter Mann, dieser Maler', *Diplomatischer Kurier* (Cologne), vol. 14, no. 18, 1965, pp. 731–45.
34. Paul Westheim, 'Otto Dix', *Das Kunstblatt*, no. 10, 1926, p. 145.
35. Ibid., p. 143.
36. Interview with Dix, quoted in Schmidt, op.cit., p. 237.
37. Rom Landau, *Der unbestechliche Minos* (Hamburg, 1925), pp. 38–9.
38. Fritz Löffler, *Otto Dix* (Munich and Vienna, 1967), p. 75.
39. Quoted in Lothar Fischer, *Otto Dix—Ein Malerleben in Deutschland* (Berlin, 1981), p. 66.
40. Carl Einstein, 'Otto Dix', *Das Kunstblatt*, vol. 7, 1923, p. 97.
41. See Conzelmann, op.cit., p. 202.
42. Quoted in Conzelmann, op.cit., p. 205.
43. See Conzelmann, op.cit., p. 209.

Notes to Chapter 3

1. George Grosz, introduction to *Drawings* (New York, 1944). Quoted in Lothar Fischer, *George Grosz* (Reinbeck, 1976), note 235, p. 111.

2. George Grosz, *Briefe 1913–1959*, ed. Herbert Knust (Reinbeck, 1979), p. 173. Letter of 18 May 1933.
3. Ibid.
4. Ibid., p. 175. Letter of 6 June 1933.
5. Ibid., p. 176.
6. George Grosz, *Ein kleines Ja und ein großes Nein* (Reinbeck, 1974), p. 101.
7. Ibid.
8. Ibid.
9. Grosz, *Briefe*, op.cit., p. 29.
10. The son of a poor weaver, Karl May (1842–1912) was blind until the age of five, small and physically weak. After seven years in prison for theft and fraud, he wrote about travels to the Far West of the United States, and the Far East, setting himself up as the hero of fantastic adventures. His books influenced generations of growing boys in Germany, and were also translated into twenty languages. Grosz's somewhat disappointed impression of him as an old man in a neatly petit-bourgeois house was 'like a faded photograph'.
11. Grosz, *Ein kleines Ja . . .*, op.cit., p. 22.
12. Karl Hubbuch, letter of 19 February 1970. Quoted in Lothar Fischer, op.cit., p. 21.
13. Wieland Herzfelde, *Immergrun* (Berlin, 1949), p. 139.
14. Walter Mehring, *Berlin Dada* (Zurich, 1959), pp. 27–8.
15. Grosz, *Briefe*, op.cit., p. 30. Undated letter of 1915.
16. Ibid., pp. 42–3 and 44. Letter of the turn of the year 1916–17.
17. Ibid., pp. 44–5.
18. Ibid., p. 45.
19. Ibid., p. 48. Letter of 15 March 1917.
20. Grosz, *Ein kleines Ja . . .*, op.cit., p. 110.
21. Ibid., pp. 113 and 114.
22. Grosz, *Briefe*, op.cit., pp. 56–7. Letter to Otto Schmalhausen of 15 December 1917.
23. Werner Hofmann, 'Einschränkende Bemerkungen', in *Zeugnisse der Angst in der modernen Kunst* (Darmstadt, 1963), pp. 52–3.
24. In his letters of 1918 Grosz refers several times to J.V. Jensen's novel *Das Rad* (The Wheel). He had known the author since 1913, so it is safe to assume that he read the novel at an early date. The book is full of references to the necessity of overcoming, or dominating, Woman, the only way in which a man could 'make himself . . . master of Nature and Fate' (*Das Rad*, Berlin, 1921, pp. 297–8). The main character in the novel, Lee, becomes leader of the masses (!) by resisting his antagonist or opposite number, Cancer. In short, his *alter ego* tempts him in vain, and Cancer turns into a woman-hater and murderer in Lee's place.
25. See Alexander Dückers, *George Grosz, Das druckgraphische Werk* (Berlin, 1979), pp. 142–3.
26. Grosz, *Briefe*, op.cit., p. 44. Letter of 1916–17.
27. Willi Wolfradt, in *Der Ararat. Erstes Sonderheft George Grosz* (Munich, 1920), p. 3.
28. Grosz, *Briefe*, op.cit., p. 31. Letter to Robert Bell, late September 1915.
29. Ernst Kallai, 'Dämonie und Satire', *Das Kunstblatt* (Berlin), no. 11, 1927, pp. 100–1.
30. Richard Huelsenbeck, 'Erinnerungen an George Grosz', *Neue Zürcher Zeitung*, no. 2191 (evening edition), 14 July 1959.

31. Grosz, 'Abwicklung', *Das Kunstblatt* (Berlin), no. 2, 1924, pp. 33–8 (38).

32. Grosz, *Briefe*, op.cit., p. 76. Undated letter to Otto Schmalhausen of (?) May 1918.

33. See Walter Mehring, *Berlin Dada. Eine Chronik mit Photos und Dokumenten* (Zurich, 1959), pp. 85–6.

34. Grosz, *Briefe*, op.cit., p. 216. Letter to Bertolt Brecht of 23 May 1935.

35. Grosz, 'Zu meinen neuen Bildern', *Das Kunstblatt* (Berlin), no. 1, 1921, pp. 10–16 (14).

36. Grosz, *Ein kleines Ja . . .*, op.cit., p. 167.

37. Ibid., pp. 219 and 220.

38. Harry Graf Kessler, *Tagebücher 1918–1937* (Frankfurt am Main, 1961), pp. 466–7.

39. Grosz, *Briefe*, op.cit., p. 102. Letter to Otto Schmalhausen of 1927.

40. Ibid., p. 108. Letter to Otto Schmalhausen of September 1927.

41. Ibid., p. 125. Letter to Eduard Plietzsch of 23 August 1931.

Notes to Chapter 4

1. Max Beckmann, *Leben in Berlin. Tagebuch 1908/09*, ed. Hans Kinkel (Munich, 1966), p. 12.

2. The possibility that Beckmann may have depicted Landauer's murder in his lithograph *The Street* (print 2 of *Hell*) was pointed out by Christian Lenz ('Das Martyrium', *Jahrbuch der Berliner Museen*, (new series) vol. 16, 1974, pp. 185ff, and p. 198). Landauer, however, unlike Kurt Eisner, was not shot down in the open street (see A. Dückers, *Max Beckmann, Die Hölle 1919* [Berlin, 1983], p. 84). It is nonetheless conceivable that memories of Landauer may have entered the image.

3. Quoted in Beckmann, *Leben in Berlin*, op.cit., p. 48, note 20.

4. Ibid., p. 12.

5. Ibid., p. 13.

6. Ibid., p. 34.

7. Ibid., p. 35.

8. Ibid.

9. Ibid., p. 22.

10. Max Beckmann, 'Gedanken über zeitgemäße und unzeitgemäße Kunst,' *Pan II*, March 1912, pp. 499–502. This was his reply to an essay by Franz Marc, 'Die neue Malerei', *Pan II*, March 1912, pp. 468–71. Marc in turn replied to Beckmann with 'Anti-Beckmann', *Pan II*, March 1912, pp. 555–6. The dispute was reprinted in *Max Beckmann—Die frühen Bilder*, exhibition catalogue (Bielefeld and Frankfurt, 1982–3), pp. 28–35, p. 83.

11. Beckmann, 'Gedanken . . .', ibid., p. 34.

12. Beckmann, *Briefe im Kriege* (Munich, 1955), p. 6.

13. Ibid., p. 50.

14. Ibid., p. 11. Letter of 28 September 1914.

15. Ernst Gerhard Güse, *Das Frühwerk Max Beckmanns—Zur Thematik seiner Bilder aus den Jahren 1904–1914* (Frankfurt and Berne, 1977).

16. Ibid., p. 34.

17. Ibid., p. 36.

18. Ibid., p. 52.

19. Barbara C. Buenger, 'Kreuztragung', in *Max Beckmann—Die frühen Bilder*, exhibition catalogue (Bielefeld and Frankfurt, 1982–3), pp. 203–12, esp. p. 211–12.

20. See Güse, op.cit., p. 52.

21. Ibid., p. 50.

22. Adolf von Harnack (1851–1930) was, without doubt, the most popular representative of the new, liberal Lutheranism in pre-war Berlin. In his book *Das Wesen des Christentums* (1900), a collection of lectures he had given before large audiences, Harnack advocated a straightforward, pragmatic faith. He abhorred every form of mysticism and the notion of sin, and fought dogma in whatever guise it appeared.

23. See F.W. Fischer, *Der Maler Max Beckmann* (Cologne, 1972), p. 11.

24. Güse, op.cit., p. 50.

25. Beckmann, *Briefe im Kriege*, op.cit., p. 8. Letter of 18 September 1914.

26. Ibid., p. 15. Letter of 11 October 1914.

27. Ibid., p.37. Letter of 18 April 1915.

28. Ibid., p. 38. Letter of 18 April 1915.

29. Stephan von Wiese, *Max Beckmanns zeichnerisches Werk 1903–1925* (Düsseldorf, 1978), p. 68.

30. Beckmann, *Briefe im Kriege*, op.cit., p. 34. Letter of 5 April 1915.

31. Ibid., p. 60. Letter of 21 May 1915.

32. Ibid., p. 48. Letter of 4 May 1915.

33. Stephan von Wiese, op.cit., p. 63.

34. Beckmann, *Briefe im Kriege*, op.cit., p. 55. Letter of 11 May 1915.

35. Ernst Jünger, 'Über den Schmerz', *Werke*, vol. 5, (Stuttgart, n.d.), p. 155.

36. Beckmann, *Briefe im Kriege*, op.cit., p. 63. Letter of 24 May 1915.

37. Stephan von Wiese interprets this figure as representing Death. Op.cit., p. 106.

38. Peter Beckmann, 'Verlust des Himmels', *Blick auf Beckmann, Dokumente und Vorträge*, Schriften der Max Beckmann Gesellschaft II, ed. Hans Martin Freiherr von Erffa and Erhard Göpel (Munich, 1962), p. 24.

39. Max Beckmann, *Bekenntnis*, pub. 1920 in *Schöpferische Konfession*, ed. K. Edschmidt. Quoted in Uwe M. Schneede, *Die Zwanziger Jahre* (Cologne, 1979), p. 114.

40. Ibid., p. 114.

41. Christian Lenz, 'Max Beckmann—Das Martyrium', *Jahrbuch der Berliner Museen*, XVI, 1974, pp. 186ff., esp. p. 190.

42. Karl Barth, 'Der Christ in der Gesellschaft', address given at Tambach in Sept. 1919. Reprinted in *Anfänge der dialektischen Theologie*, ed. J. Moltmann (Munich, 1962), p. 3.

43. Beckmann, *Bekenntnis*, op.cit., p. 114.

44. Karl Barth, op.cit., p. 14.

45. Ibid.

46. Ibid., p. 11.

47. Beckmann, *Bekenntnis*, op.cit., p. 114.

48. Quoted in the catalogue to a Beckmann exhibition at J.B. Neumann Gallery (Berlin, 1917), unpaginated. The last three artists are well known; Gabriel Mälesskirchner (*c.*1425–95), painted portraits and altar-panels in southern Germany and Switzerland.

49. Beckmann, *Bekenntnis*, op.cit., p. 112.

50. Karl Barth, op.cit., p. 3.

51. Beckmann, *Bekenntnis*, op.cit., p. 112.

52. Karl Barth, op.cit., p. 17.

53. Beckmann's notes of 1925–30, quoted in Mathilde Q. Beckmann, *Mein Leben mit Max Beckmann* (Munich and Zürich, 1983), pp. 185–6.

54. Reinhard Piper, *Nachmittag* (Munich, 1950), p. 33.

55. Christian Lenz, *Max Beckmann und Italien* (Frankfurt, 1976), p. 17.

56. See F.W. Fischer, *Max Beckmann—Symbol und Weltbild* (Munich, 1972), pl. 2 and p. 20.

57. Stephan von Wiese, op.cit., p. 156.

58. Ibid., pp. 158ff.

59. Beckmann, *Briefe in Kriege*, op.cit., p. 36.

60. Günther Franke to Erhard Göpel, letter of 13 April 1956. Quoted in Erhard and Barbara Göpel, *Max Beckmann—Katalog der Gemälde*, 2 vols. (Berne, 1976), p. 134.

61. Stephan von Wiese, op.cit., p. 158.

62. Beckmann, *Briefe im Kriege*, op.cit., p. 69. Letter of 8 June 1915.

63. Quoted in Stephan von Wiese, op.cit., pp. 171–2, note 125.

64. The authors who have come closest to this interpretation are: M. Franciscono, 'The Imagery of Max Beckmann's "The Night"', *Art Journal*, 1973, XXXIII/1, pp. 18–22; and F.W. Heckmanns, 'Zu den Entwurfszeichnungen "Die Nacht" von Max Beckmann', in *Max Beckmann—Frankfurt 1915–1933*, exhibition catalogue (Frankfurt), p. 27. During his recuperation in 1915 Beckmann possibly saw newspaper advertisements in which a woman consoles and entertains a wounded soldier by playing His Master's Voice records on a Gramola gramophone.

65. Reinhard Piper, *Erinnerungen eines Verlegers* (Munich, 1950), p. 29. In March 1919, shortly after completing *Night*, Beckmann repeated this statement verbatim in a letter to Julius Meier-Graefe, the art historian. See Klaus Gallwitz, *Max Beckmann in Frankfurt* (Frankfurt, 1984), pp. 102–3.

66. Friedhelm W. Fischer, op.cit., p. 219, note 831.

67. Max Beckmann, *Tagebücher 1940–1950*, ed. E. Göpel (Munich and Vienna, 1979), p. 168.

68. Christian Lenz, *Max Beckmann und Italien*, op.cit., pp. 18–19.

69. Millard Meiss supposes the female figure of Death in Traini's fresco to have been influenced by Petrarch's *Trionfo della Morte*. See M. Meiss, 'The Problem of Francesco Traini', *Art Bulletin*, XV, 1933, pp. 169–70. The different gender of 'Der Tod' and 'La Morte' would seem to indicate that Beckmann must have been quite aware of the ambiguity not only of death but of woman.

70. Quoted in A. Dückers, *Max Beckmann—Die Hölle 1919*, exhibition catalogue (Berlin, 1983), p. 76.

71. Peter Beckmann had picked up these hand-grenades in the street believing them to be tin cans. His father added sticks to them in his drawing, and gave Peter his steel helmet. Conversation with Peter Beckmann, March 1983.

72. Compare Güse's interpretation of the painting *Drama*, Güse, op.cit., pp. 49–50.

73. Quoted in the preface of the catalogue to a Beckmann exhibition at J.B. Neumann Gallery (Berlin, 1917), unpaginated.

74. Beckmann, *Bekenntnis*, op.cit., p. 112.

75. Beckmann, *Briefe im Kriege*, op.cit., p. 42. Letter of 24 April 1915.

76. A. Dückers was the first to point out that Beckmann experienced a kind of symbolic rebirth after painting *Night*, in *Max Beckmann—Die Hölle 1919*, op.cit., pp. 97ff. Dückers shows that Beckmann depicted himself as a child in his mother's arms, dreaming of a new day, in the etching *Night*, 1922 (pl. 122 of that catalogue). The second wife of the painter M. Kaulbach confirms that Beckmann believed in reincarnation, even as early as 1923, when she met him. Cf. Mathilde Q. Beckmann, *Mein Leben mit Max Beckmann* (Munich and Zürich, 1983), p. 139.

Notes to Chapter 5

1. Oskar Schlemmer, *Briefe und Tagebücher*, ed. Tut Schlemmer (Stuttgart, 1977), p. 9.
2. Ibid., p. 12.
3. Ibid., p. 12. Entry of April 1913.
4. Ibid., p. 12.
5. Ibid., p. 14. Entry of July 1913.
6. Ibid., p. 17. Entry of March 1915.
7. Ibid., p. 21. Entry of 2 September 1915.
8. Ibid., p. 14. Entry of August 1914.
9. Ibid., p. 15. Letter of 9 November 1914.
10. Ibid., p. 17. Letter of 5 January 1915.
11. Ibid., p. 17. Entry of mid-March 1915.
12. Ibid., p. 18. Entry of 20 March 1915.
13. Karin von Maur, *Oskar Schlemmer, Monographie* (Munich, 1979), p. 71.
14. Karin von Maur, *Oskar Schlemmer Oeuvrekatalog* (Munich, 1979). All subsequent references with numbers and letters (G = Gemälde, paintings;

A = Aquarelle, watercolours; P = Plastiken, sculptures) are taken from this catalogue raisonné.
15. Herzogenrath assumes that models for Schlemmer's *Standing Figure, Divided* were the statue of Cleobis at Delphi, the Apollo of Tenea, and the Apollo from the west pediment of the Temple of Zeus at Olympia. A comparison with the Kritios boy from Athens, however, I think clearly shows that Schlemmer must have based his figure on this late *kouros*. See W. Herzogenrath, *Oskar Schlemmer—Die Wandgestaltung der neuen Architektur* (Munich, 1973), p. 23, plate.
16. Schlemmer, *Tagebücher*, op.cit., p. 22. Entry of 22 October 1915.
17. Schlemmer, *Tagebücher*, op.cit., p. 50. Letter of 14 June 1921.
18. Ibid., p. 87. Note of April 1926.
19. Ibid., p. 27. Entry of November 1917.
20. Ibid., p. 26. Entry of summer 1917.
21. Ibid., p. 10. Entry of December 1912.
22. Ibid., pp. 60–1f. Entry of September 1922.
23. Lothar Schreyer, *Erinnerungen an Sturm und Bauhaus* (Munich, 1956), p. 183.
24. Schlemmer, *Tagebücher*, op.cit., pp. 33–4. Entry of 19 January 1919.
25. Ibid., p. 36. Entry of 19 November 1919.
26. Ibid., p. 63.
27. Programme of the Staatliches Bauhaus in Weimar, April 1919. Quoted from the reprint in U.M. Schneede, *Die zwanziger Jahre*, op.cit., pp.166–7.
28. Ibid., p. 166.
29. Schlemmer, *Tagebücher*, op.cit., p. 52. Entry of 23 June 1921.

30. *Hans Fischli*, exhibition catalogue (Kunsthaus Zürich, 1968), p. 59.
31. Wulf Herzogenrath, *Oskar Schlemmer—Die Wandgestaltung der neuen Architektur, mit einem Katalog seiner Wandgestaltungen* (Munich, 1973), pp. 40ff.
32. Oskar Schlemmer, 'Abkehr von der Utopie', *Tagebücher*, op.cit., p. 59. Entry of June 1922.
33. Oskar Schlemmer, 'Hausbau und Bauhaus' (1923), in Karin von Maur, vol. 1, op.cit., p. 337.
34. Schlemmer, *Tagebücher*, op.cit., p. 57. Letter to Otto Meyer-Amden of March 1922.
35. Schlemmer, 'Tendenz Kunst', in Karin von Maur, vol. 1, op.cit., p. 338.
36. Karin von Maur, *Oskar Schlemmer*, vol. 1, op.cit., pp. 150–1.
37. Schlemmer, *Tagebücher*, op.cit., p. 44.
38. Ibid., p. 38. Entry of 12 November 1919.
39. Ibid., p. 44. Letter of September 1920.
40. Ibid., p. 77.
41. Ibid., p. 78. Entry of 22 May 1925.
42. Herzogenrath, op.cit., pp. 100ff.
43. Quoted in Herzogenrath, op.cit., p. 105. The writer Ricarda Huch (1864–1947), was also a poet and novelist, well-known for her books on the Thirty Years' War.
44. Quoted in Herzogenrath, op.cit., p. 105.
45. Ibid., p. 105.
46. Published 1897–1909, vol. III, 2.
47. Schlemmer, *Tagebücher*, op.cit., p. 140. Benn (1886–1956) was a German Expressionist poet, writer and critic whose work influenced disillusioned German writers after World War II.
48. Ibid., p. 143.

INDEX

Abstraction, 3, 4, 6, 106
Acht-Uhr-Abendblatt, 70
Adam, 124–6, Plates 102–4
Andromacite, 18
Arnold, Galerie, Dresden, 22
Art Nouveau, 5
Athena, 125, 126
Athena Lemnia, 63, Plate 59
Attila, 22

Bach, Johann Sebastian, 106
Barbusse, Henry, 52
Barth, Karl, 89–90, 91
Bauhaus, the Weimar, 13, 19; Schlemmer's connection with, 113–15, 117–21, 127
Baumeister, Willi, 106–7
Beardsley, Aubrey, 64
Beckmann, Max, 1–4, 19, 22, 65, 73–7, 84–5, 88–9, 91, 92–4, 98–9, 101, 103, 105, 106, 112, 115, 118, 127; Christian ideology, 77–82, 89–99, 103; *Confessions*, 89, 103; *Ebbi*, 105; New Objectivity, 15–16; and technology, 1, 77, 109; 'Titanic', 1–5, 8–10, 77; transcendental objectivity, 88, 105, 115; Weimar Bauhaus, 115; *Max Beckmann in his Studio*, Plate 2, 2, 4, 5; *The Grenade*, Plate 6, 10, 11; *The Sinking of the Titanic*, Colour Plate 1, 1–4, 8–10, 77, 84; *Scene from the Destruction of Messina*, Colour Plate 14, 8, 70, 73, 77, 82–4, 99, 103, 105; *Resurrection*, 1916–18, Colour Plate 15, 71, 88, 89, 91, 96, 98; *The Night*, Colour Plate 16, 74, 89, 91–92, 94–105, 118; *Self-portrait as a Clown*, Colour Plate 17, 75, 92, 105; *Battle*, 76; *Deluge*, 76; *Christ carrying the Cross*, Plate 63, 77, 91, 103; *Self-portrait with Red Scarf*, Colour Plate 18, 78, 92, 94; *Self-portrait with Raised Hand*, Plate 64, 77, 80; *Resurrection*, 1909, Plate 66, 77, 81, 88, 98; *Théâtre du Monde-Grand Spectacle de la Vie*, Plate 67, 84; *Self-portrait, Drawing*, Plate 68, 85, 99; *Hell*, 88, 89, 99; *Martyrdom*, Plate 69, 89, 90, 99, 103; *Night*, 89, 92, 99; *Last Stand*, Plate 83, 99, 100; *The Family*, Plate 75, 94, 95, 99; *Nightmare*, 92; *Lamentation*, 92; *The Morgue*, Plate 76, 92, 93; *Deposition from the Cross*, Plate 72, 92, 93; *Christ and the Woman taken in Adultery*, Plate 74, 92, 94; *During an Operation*, Plate 76, 94, 96; *Large Death Scene*, Plate 77, 1, 96, 97, 103; *Nude Dancer*, Plate 79, 97, 98; *Tightrope Dancers*, Plate 82, 99; *Peter with a Pointed Cap*, Plate 84, 99, 101; *Children Playing*, Plate 85, 99, 101; *Women's Bath*, Plate 86, 99, 102; *Drama*, Plate 87, 96, 103; *The Ideologues*, Plate 88, 103, 104
Beckmann, Minna, 1, 73, 84–5, 88–9, 92–4, 99, 103
Beckmann, Peter, 1, 73, 89, 92–4, 99
Benn, Gottried, 127
Berlewi, Henryk, 13
Berlin Secession Show (1913), 1; (1909), 74
Berlin United National Schools of Art, 127
Berliner Lokal-Anzeiger, 70, 73
Berliner Zeitung, 68
Biedermeier, 15
Blaue Reiter, Der, 3
Boccioni, Umberto, 5; *Power of a Street, The*, Plate 2, 5, 6

Böcklin, Arnold, 5, 18; *Odysseus and Calypso*, Plate 16, 18
Braque, Georges, 6, 50, 52
Brecht, Bertolt, 64
Breslau Academy of Art, 127
Brueghel, Pieter, 90
Buddhism, 108, 118, 119
Burroughs, Edgar Rice, 8
B.Z. am Mittag, 70

Callot, Jacques, 39
Capitalism, 16, 19, 42, 65, 106
Carrà, Carlo, 5, 17, 65
Cassirer, Bruno, 50
Cézanne, Paul, 108
Chirico, Giorgio de, 5, 17–19, 65; *Hebdomeros*, 18; *Triton and Mermaids*, 5; *Autumn Meditation*, Plate 15, 17, 18; *The Great Metaphysician*, Plate 17, 18; *Hector and Andromache*, Colour Plate 4, 18, 24
Christ, 52; in Beckmann's work, 76–7, 80, 88–9, 91–2, 96–8, 103; in Schlemmer's work, 117–19
Christian iconography, 48, 92, 103, 124
Christian ideology, 33, 77, 80, 82
Christian Passion, the, 52, 77, 89, 91–2, 97–8, 105
Communist Party, the German (KPD), 16, 42; *Die Pleite*, 43, 61; and George Grosz, 54–6, 64, 71, 72
Constructivism, 10, 12, 13
Constructivists, 12, 13, 52
Cooper, James Fenimore, 55
Corinth, Lovis, 46
Cubism, 5–7, 9, 50, 52, 106–8, 111
Cubists, 5–8, 14, 108

Dada, 10
Darwinism, 37
Deutsche Zeitung, 70
Die Pleite, 42, 61
Dionysian principle, 27, 30, 44, 77, 103, 111
Dix, Otto, 22–31, 41, 48, 52, 54, 59–61, 68, 73, 77, 84–5, 103, 105, 106, 109; and technology, 15, 16, 19, 37–8, 42–4, 46, 48, 109; Passion pictures, 52; photography, 13–14, 46, 48; portraits, 49, 50; war, 8, 9, 15, 22, 27–33, 37–48, 52–3; *Skull*, Plate 18, 23, 39, 41, 44, 45, 46, 48; *Self-portrait as a Soldier*, Colour Plate 5, 22, 25, 27; *Self-portrait with Artillery Helmet*, Plate 19, 22, 26; *Bust of Friedrich Nietsche*, Plate 20, 27; *Self-portrait as Mars*, Colour Plate 6, 27, 28, 30, 41, 61, 73; *Prague Street*, Colour Plate 7, 29, 44, 59; *Hand-to-hand Fighting*, Plate 21, 30, 31; *Lovers on Graves*, Plate 22, 30, 31; *Going Over the Top*, Plate 23, 31, 37; *Dying Warrior*, Plate 24, 31; *Portrait of the Art Dealer Alfred Flechtheim*, Colour Plate 8, 32, 50; *Flanders*, Colour Plate 9, 30, 32, 52; *Grave (Dead Soldier)*, Plate 25, 31, 34; *Shellhole with Flowers*, 1917, Plate 26, 31, 35; *Trench with Flowers*, Plate 27, 31, 35; *Direct Hit*, Plate 28, 31, 35, 37; *Falling Ranks*, Plate 29, 31, 35, 37, 59; *War Triptych*, Colour Plate 10, 36, 52, 105; *Scene on the Bluffs at Cléry-sur-Somme*, 37; *Mad Woman of Ste. Marie-à-Py, The*, 37; *Soldier*, 37; *Grace*, 37; *Dr Hans Koch*, 38; *Dr Meyer-Hermann*, 38; *Trench, The*, 38; *War*, 31, 38; *Crouching Man*, Plate 30, 31, 38; *Charging Infantryman*, Plate 31,

31, 37, 38; *Dead Sentry*, Plate 32, 39, 41; *Feeding-time in the Trench*, Plate 33, 39, 41, 84; *Blossoming and Decaying*, Plate 34, 39, 41; *Shellhole with Flowers*, 1924, Plate 35, 40, 41; *Rape and Murder*, Plate 36, 40, 41, 59; *Death and Resurrection*, 41; *Sex Murderer (Self-portrait)*, Plate 37, 41, 42, 60; *This is How I Looked as a Soldier*, Plate 38, 38, 41, 43, 59, 105; *Prostitute and War Cripple – Two Victims of Capitalism*, 42; *Disabled Man Playing Cards*, 42; *War Cripples*, Plate 39, 14, 15, 42, 44, 46; *Match Vendor*, Plate 40, 42, 45; *Sleeping Woman*, Plate 41, 44, 46; *Dancer*, Plate 42, 44, 46; *Gretel*, Plate 42, 44, 47; *Nude*, Plate 44, 44, 48; *Girl before a Mirror*, Plate 45, 16, 44, 48, 49; *Self-portrait as a Prisoner of War*, Plate 46, 51, 52; *Resurrection*, 1943, Plate 47, 52, 53; *Resurrection*, 1948, Plate 48, 52, 53
Dresden Art Academy, 22, 45, 55, 56, 63
Duchamp, Marcel, 14; *Nude descending a Staircase*, 14
Dürer, Albrecht, 15, 22, 77, 117; *Self-portrait*, Plate 65, 77, 80, 117

Einstein, Carl, 4, 52
Eisler, Hans, 64
Eros, 97
Expressionism, 7, 10, 46, 106, 112
Expressionists, 5–7, 10, 15
Eyck, Jan Van, 117

Fauves, the, 7
Feininger, Lyonnel, 115
Felixmüller, Conrad, 42, 44
First World War, the, effect on Beckmann, 76–7, 82, 84–5, 89, 94, 98–9, 103–5; effect on Dix, 22, 27, 30–45, 50; effect on German artists, 7–10, 14–16, 48, 52; effect on Grosz, 54–7, 62, 65, 68, 72; effect on Schlemmer, 106, 108–9, 111, 112; outbreak of, 4, 106
Fischer, Friedhelm W., 97
Fischli, Hans, 115
Flaubert, Gustave, 106
Flechtheim, Alfred, 50, 52
Fohr, Carl Philip, 15
Freud, Sigmund, 8, 15, 22, 38, 76
Friedrich, Caspar David, 108, 119
Functionalism, 10, 12, 113; see *Neues Bauen*
Futurism, 7, 22
Futurists, the, 5–9, 14, 27

Gaea (Magna Mater), 1, 97
Gauguin, Paul, 76
Genghis Khan, 22
Gericault, Théodore, 1; *Raft of the 'Medusa'*, 1
Giedion, Sigfried, 12
Glaser, Curt, 14
Goethe, Johann Wolfgang von, 1
Gogh, Vincent van, 22, 27, 90
Golgotha, 52, 91, 105
Goltz, Gallery, Munich, 65
Goya y Lucientes, Francisco José, 39
Graf, Urs, 39
Gris, Juan, 50
Gropius, Walter, 113, 115, 120–1
Grossberg, Carl, 14; *Dream-Painting Rotor*, Plate 9, 14, 15

Grosz, George, 16, 19, 50, 52, 54, 57–61, 62, 65, 68, 72, 103, 104, 105, 106, 112; *Abrechnung Folgt*, 54; and Marxism, 64; and the Nazis, 54; effect of war on, 54–5, 56–7, 68; *Face of the Ruling Class*, 68; pseudonyms, 60, 63, 64, 72; and technology, 65; photograph of, Plate 58, 62; *Republican Automatons*, Colour Plate 11, 16, *40*, 65; *Mouse in a Trap*, Plate 49, 55; *Passed—The Faith Healers*, Plate 50, 57; *Funeral Procession (Homage to Oskar Panizza)*, Plate 51, 57, *58*; *When it was all over they played Cards*, Plate 52, 59; *Sex Murder on Ackerstrasse*, Plate 53, 59, 60; *Jack the Ripper*, 59; *The Adventurer*, Plate 54; *60*, 61, 62, 64; *Cheers Noske! The proletariat has been disarmed*, Plate 55, 60, 61, 63; *Cheers Noske!*, second version, Plate 56, *61*; *The Gold-digger*, Plate 57, 61, *62*; *Diabolo Player*, Plate 60, 65; *Dreary Day*, Colour Plate 12, *66*, 68; *The Pillars of Society*, Colour Plate 13, *66*, 68, 71; *We meet to pray to the Just Lord*, Plate 61, 67, 68; *Self-portrait as Admonisher*, Plate 62, 16, *69*, 72; *Eclipse of the Sun*, 68; *Max Hermann Neisse*, 72; *Eduard Plietsch*, 72
Grünewald, Mathias, 15, 52, 90, 108
Güse, Ernst, 77, 80

Handel, George Frideric, 106
Hauptmann, Gerhart, 6, 8
Hausmann, Raoul, 14
Heartfield, John, 14
Hector, 18
Hercules, 77
Herzfelde, Wieland, 54, 64
Herzogenrath, Wulf, 122
Hindenberg, President, 71
Hitler, Adolf, 54
Hoerle, Heinrich, 15, 16; *Machine-Men (The Home-Comer)*, Plate 14, 15, *16*
Hofmann, Werner, 57
Hogarth, William, 68, 92
Holbein, Hans, 15
Homer, 18
Hubbuch, Karl, 56
Huch, Richarda, 122
Huelsenbeck, Richard, 64
Hugenberg, Alfred, 54, 60, 68, *70*

Impressionists, the, 14, 46
Ingres, Jean-Auguste-Dominique, 9

Junger, Ernst, 8, 9, 14, 18, 22, 27, 30–3, 37, 54, 85

Kallai, Ernst, 63
Kandinsky, Wassily, 3, 4, 6, 13, 112, 113; *On the Spiritual in Art*, 3; 'On the Question of Form', 3
KDP, see Communist Party
Kirchner, Ernst Ludwig, 5, 6, 9; *The Street*, Colour Plate 2, 5, *20*
Klee, Paul, 13, 113
Klinger, Max, 22
Kritios-Boy, The, Plate 91, 109, *110*

Landauer, Gustav, 73
Langemark, battle of, 9, 37
Laocoon, 118
Last Judgement, 2, 4, 81, 98
Le Corbusier, 115
Léger, Fernand, 8, 9, 14, 15, 38; *The Card Players*, 8, 15; *La Femme*, Plate 11, 15, 16; *Illustration from Omnia*, Plate 12, *16*; *Mècanicien*, Plate 13, 15, *16*

Leistikow, Hans, 113, *Photomontage*, Plate 94, 113, *114*
Lenin, Vladimir Ilyich, 64
Lenz, Christian, 89, 98
Liebermann, Max, 46
Luxemburg, Rosa, 89, 99, 103

Magic Realism, 14
Magic Realists, 12
Mäleßkirchner, Gabriel, 90
Mann, Thomas, 4, 6
Mantegna, Andrea, 92
Marc, Franz, 8, 76
Marinetti, Emilio Filippo Tommaso, 5, 6
Marne, battle of the, 8
Mars, 27, 61, 99
Marxism, 64, 72
Mary Magdalene, 103
Maur, Karin von, 109, 117
May, Karl, 55
Mehring, Walter, 54
Meidner, Ludwig, 6, 7; *Apocalyptic Landscape*, Plate 3, 7
Mementi mori, 39, 48
Messina, 73, 84, 92, 103, 105
Meyer, Hannes, 121
Meyer Amden, Otto, 108, 112
Midas, 118
Michelangelo, 124–5, Plate 102
Moholy-Nagy, Laszlo, 13
Mondrian, Piet, 12–13, 115
Müller, Otto, 22

Napoleon, 1
Nazis, 16, 54, 121, 127
Neoclassicism, 9, 15
Neo-Plasticism, 13
Nerlinger, Oskar, 14
Neue Sachlichkeit, 4, 9, 10, 12, 65; see New Objectivity
Neues Bauen, 10, 12; see Functionalism
New Dawn, the, 72
New Design, see Neo-Plasticism
New Objectivity, 4, 12–17, 19, 22, 48; see *Neue Sachlichkeit*
Nierendorf, Karl, 41, 50
Nietzsche, Friedrich, 3, 22, 27, 30–1, 37–8, 42, 77, 80, 82
Nolde, Emil, 5
Novecento, 9
Nude, the, 1, 2, 44, 115

Odysseus, 18

Paracelsus, 117–18; Schlemmer, *Paracelsus*, Plate 98
Pechstein, Max, 5
Phainon, 127
Phidias, 63
Photography, 6, 13–14, 46
Picasso, Pablo, 6, 9, 50, 52, 108, 127; *Portrait of Ambroise Vollard*, Plate 5, *10*
Pietà, 1450, Plate 73, 92, *93*
Piper, Reinhard, 96
Piscator, Erwin, 64
Plato, 90, 115
Prometheus, 1, 124–7; Plates 105–6

Rabe, Dr Erich, 121–2
Räderscheidt, Anton, 12, *Self-portrait*, Plate 7, *12*
Raphael, 15
Realism, 3, 4, 6, 9

Realists, the, 13, 14, 17
Reichswehr, the, 62, 63, 71, 72
Remarque, Erich, 33, 37
Renaissance, the 15, 48
Resurrection, the, 2, 52, 80, 88
Rilke, Reiner Maria, 7
Roh, Franz, 13
Roscher, *Ausführliches Lexikon der Griechischen und Römischen Mythologie*, Plate 107, 125

St John the Apostle, 92
St Michael, 80
St Paul, 90
St Sebastian, 52, 97
Salvation, Doctrine of, 2–3, 52
Schad, Christian, 12–16; *Self-portrait*, Colour Plate 3, 12, *20*; *Schadograph*, Plate 8, 13, *14*
Schiller, Johann Christian Friedrich, 2
Schlemmer, Oskar, 'Abkehr von der Utopie', 117; and the Bauhaus, 19, 113–15, 117–21, 127; 106, 109, 112, 115, 118, 127; and Cubism, 106, 108, 111; and dance, 111, 112, 121; form and design, 9, 112, 113; geometric form, 108–9, 118, 127; religion, 117–19; sculpture, 112, 113, 115, 120; and technology, 13, 109; *Triadic Ballet*, 111; 'Transcendental anatomy', 115, 117, 118, *Wall Painting*, 112–13, 115, 119–23; watercolours, 109, 115–18; *Homo, Wire-figure*, Plate 89, 106; *Standing Figure—Divided*, Plate 90, 109, *110*; *K Painting*, 111; *Study for the Triadic Ballet*, Plate 92, 111, *112*; *Architectural Sculpture R*, Plate 93, 113; *Last Supper*, 115; *Emmaeus*, 115; *Supper Party, 1913–14*, Plate 95, 115, *116*; *Supper Party, 1913–14*, Plate 96, 115, *116*; *Supper Party, 1913–14*, Plate 97, 115, *116*; *Composition on Pink*, Colour Plate 19, *79*, 109, 111, 120, 121, 122; *Supper Party, 1923*, Colour Plate 20, *82*, 115, 117–19, 120, 126; *Five Figures—Roman Things*, Colour Plate 21, *83*, 119–20, 122, *Stairs at the Bauhaus*, Colour Plate 22, *86*, 120–2; *Window-Painting, Women standing in a Room*, Colour Plate 23, *87*, 127; *Paracelsus*, Plate 98, 117, 118; *Retreat*, Plate 99, 119; *The Wall-Piece in the House of Dr Rabe*, Plate 100, 121, 122; *Homo, Figure T*, Plate 101, 122, *123*, 124, 125; *Design for the House of Dr Rabe*, Plate 108, 125, *126*
Schlemmer, Tut, 118
Schlicter, Rudolph, 52
Schmidt, Diether, 27
Schulz, Georg, 14, 15; *Flesh and Iron*, Plate 10, 14, *15*
Schongauer, Martin, *St Sebastian*, Plate 78, 97
Schrimpf, Georg, 15
Second World War, the, 50, 52
Seiwert, 16
Severini, Gino, 5, 9, 17; *Maternité*, Plate 4, 9, *10*
Sheeler, Charles, 14
Socialism, 13, 42, 56, 71, 117
Socialists, 99, 105, 120
Spartacist revolt, 61
Spartacus group, 89
Somme, battle of, 41
Sonderbund exhibition, 115
SPD, see Socialism
Stirner, Max, 30
Stuttgart Academy of Art, 106
Surrealism, 12
Surrealists, the, 17
Symbolism, 5

Tannenberg, battle of, 4

INDEX

Technology, and Beckmann, 1, 77, 109; and Dix, 38, 42, 46, 109; and Grosz, 65; and Schlemmer, 109; effect of war on, 10, 31, 37; German artists, view of, 4–9, 19; New Objectivity's view of, 12–17
'Titanic', the, 1, 3–5, 8, 10, 77
Trecento, 15
Triani, Francesco, 98, 99; *Triumph of Death* (Detail), Plate 80, *98*; *Triumph of Death* (Detail), Plate 81, *98*
Tube, Frau, 80, 82, 88–9, 99
Tube, Martin, 76, 84

United National Schools of Art, Berlin, 127

Valori Plastici, 9
Vanitas, 45, 48
Velde, Henry van de, 120
Verists, the, 12
Virgin Mary, the, 92, 98, 115
Vogeler, Heinrich, 68
Völker, Karl, 14
Vollmer, *Wörterbuch der Mythologie*, 125

Wagner, Richard, 106
Weimar Republic, 10, 16, 19, 54, 63, 68
Westheim, Paul, 48, 50

Weyden, Roger van der, 92, 98; *Lamentation of Christ*, Plate 71, *93*, 98
Weyergraf, Bernd, 42
White Terror, the, 73
Wiese, Stephan von, 84, 92, 94
Wolfradt, Willi, 61

Zarathustra, 27, 77, 80
Zeus, 1